SPORTS PHOTOGRAPHY
HOW TO CAPTURE ACTION AND EMOTION

PETER SKINNER

ALLWORTH PRESS
NEW YORK

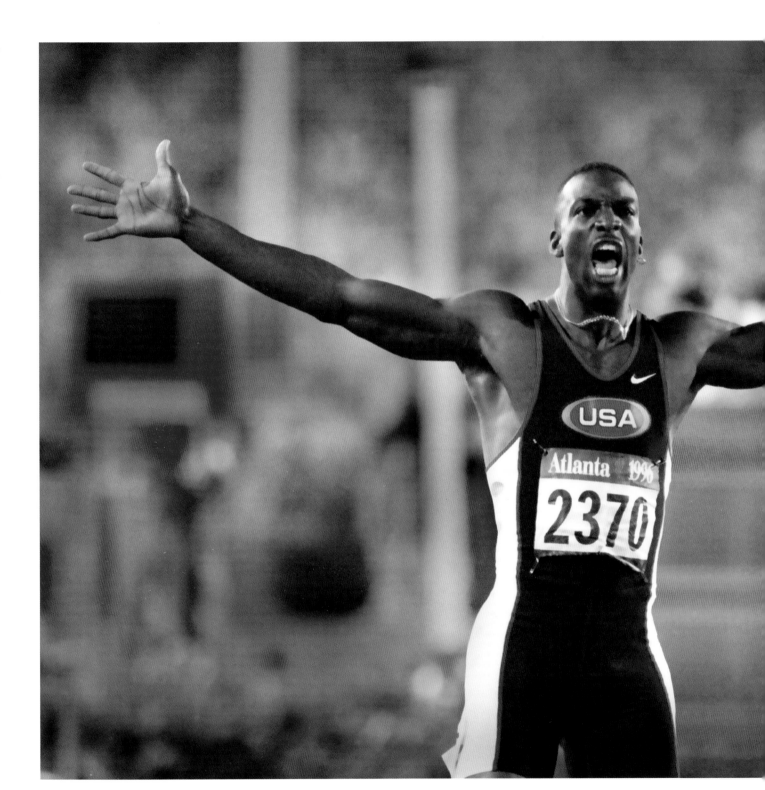

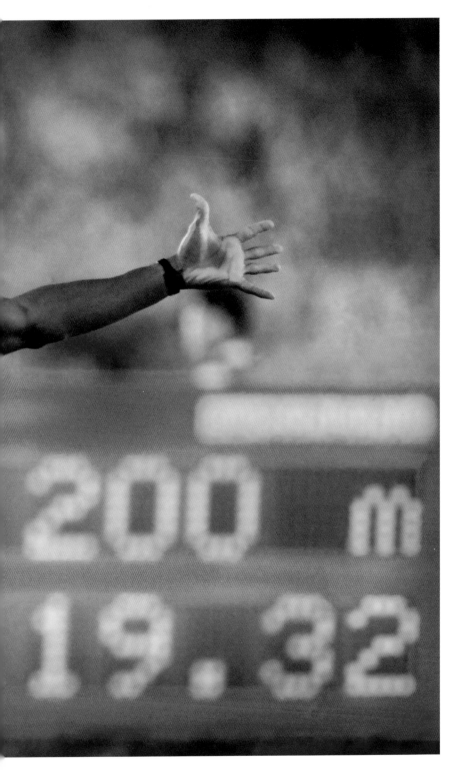

One of the truly magnificent slices of track and field history is captured in this classic example of a definitive image. Duane Hart knew that U.S. 200-meter and 400-meter champion Michael Johnson invariably threw his arms wide when crossing the line. Hart also knew that Johnson had an excellent chance of setting a world record in the 200-meter final of the Atlanta Olympic Games in 1996. He hoped—and planned—to capture that defining moment on one dramatic frame. To do so, he staked out his spot eight hours before the event! Johnson scorched to victory, and Hart made the shot of the jubilant champion and the story-telling scoreboard. One great moment; one great image. Canon 1N, Fujicolor 800, 200mm f1.8 lens, handheld, 1/1000 at f4. © Duane Hart

12 11 10 09 08 6 5 4 3 2

Published by Allworth Press
An imprint of Allworth Communications, Inc.
10 East 23rd Street, New York, NY 10010

Cover design by Derek Bacchus
Interior design/page composition/typography by Mary Belibasakis
Cover photo © Ben Chen (for details see page 45)

ISBN-13: 978-1-58115-480-1
ISBN-10: 1-58115-480-1

Library of Congress Cataloging-in-Publication Data

Skinner, Peter.
 Sports photography : how to capture action and emotion / Peter Skinner.
 p. cm.
 ISBN-13: 978-1-58115-480-1 (pbk.)
 ISBN-10: 1-58115-480-1 (pbk.)
 1. Photography of sports. I. Title.

TR821.S58 2007
779'.99796—dc22

 2006100739

Printed in Thailand

ACKNOWLEDGMENTS

A project such as this is essentially a team effort, and I have been very fortunate to have an excellent team of people contributing in many ways to help get the job done.

The photographers whose images are published here have been a magnificent resource, and to all of them I say a very big thank you. Their work represents a vast and diverse collection of sports photography, covering subjects from backyard and street games through Little League and high school sports, to the major leagues, the Olympic Games, and the great outdoors. To Ben Chen, Bob Gomel, Duane Hart, Walter Iooss, Mark Johnson, Bruce Kluckhohn, Diane Kulpinski, Brian Robb, Steve Trerotola, and Bob Woodward: my heartfelt thanks for your wonderful images and for sharing your vision. Special thanks must go to Bob Woodward, an enthusiastic supporter from the outset, who not only provided images but also scrutinized initial drafts and made numerous helpful suggestions.

Other friends and colleagues who provided invaluable assistance were Bill Hurter, editor of *Rangefinder* magazine; John Russell, a veteran photojournalist and former assistant photography editor at the *Daily Telegraph* in Sydney, Australia; Ken Newton, an eminent Australian media and public relations consultant; Julianne Kost, digital imaging evangelist with Adobe Systems and a leader in her field; photographer and author Mikkel Aaland, who has written numerous highly regarded books on digital imaging and software applications; two colleagues from my years with the American Society of Media Photographers, Dick Weisgrau, former executive director, and Victor Perlman, general counsel; John Rettie, author/photographer and a columnist for *Rangefinder* magazine; Michael Verbois, a principal of Santa Barbara–based Media 27; Ron Pownall, an editorial and commercial photographer who also shoots youth sports; Aidan Bradley of Santa Barbara, who specializes in golf course photography; and photographer Christian Iooss. Also, I'd like to express my gratitude to my friend and colleague of many years, Ernie Brooks, a well-known marine photographer and educator, who has always encouraged creative and adventurous projects—mine and those of numerous other authors and photographers.

My appreciation also goes to the good folks at Allworth Press—Tad Crawford, Bob Porter, Nicole Potter-Talling, Jessica Rozler, Allison Caplin, Nana Greller, and Derek Bacchus—for suggesting this book and taking it through to completion.

And my biggest thank you goes to my wife, Priscilla, who has handled numerous tasks such as chapter formatting, filing images, checking image quality, updating changes, making insightful recommendations, and attending to all the associated logistics to ensure we stayed on deadline. Without her talent and expertise, producing this book would have been very challenging indeed.

To all of you, my sincere thanks.

Peter Skinner
Golden Beach, Queensland, Australia

Contents

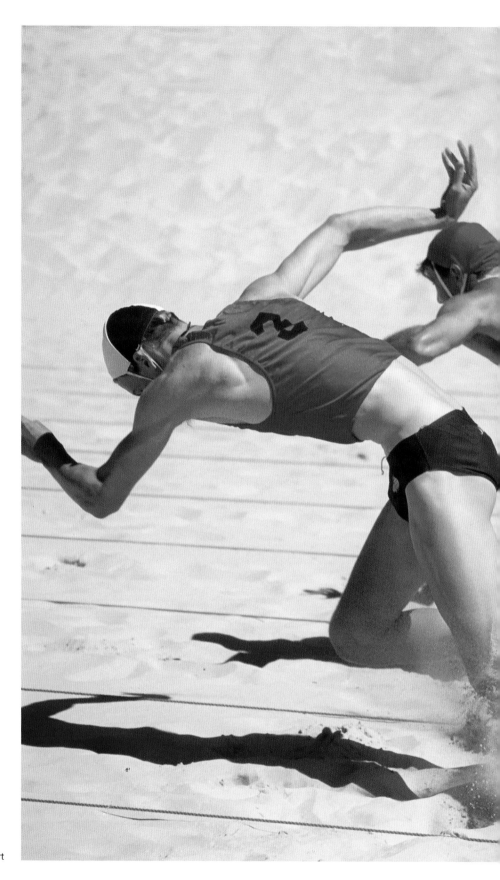

They're away! Sand flies as contestants in an Australian surf-lifesaving beach sprint accelerate from the start. Tight composition and timing the shot so the sprinters' arms are in unison strengthen the image. Nikon 801, Tamron 300mm f2.8 manual focus, Fujichrome Velvia, 1/1000 at f4. © Duane Hart

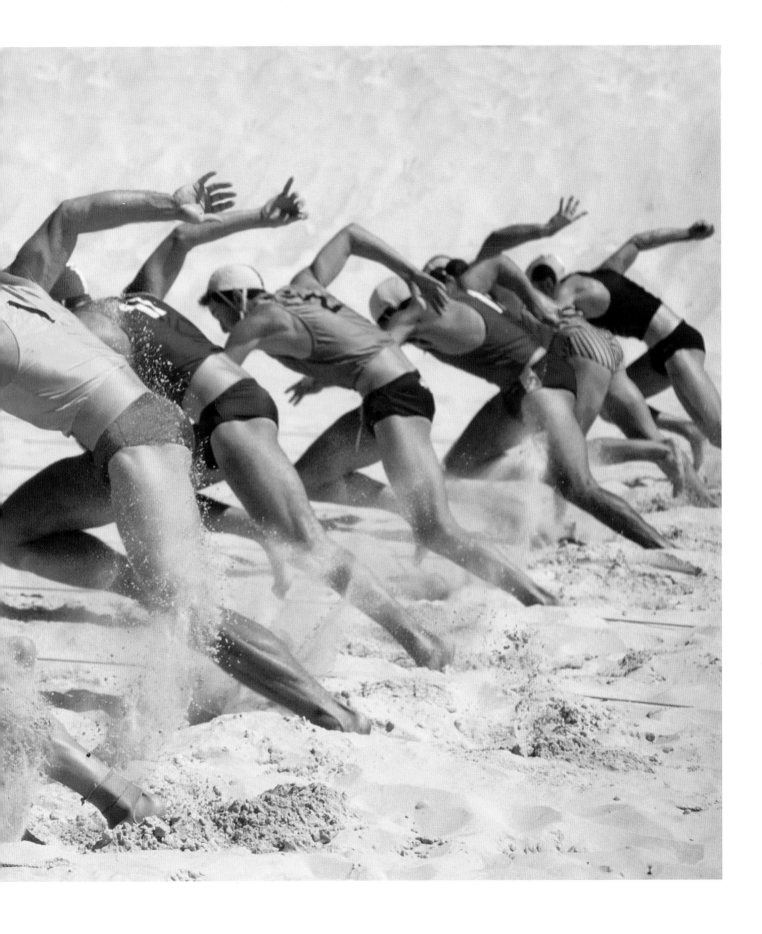

INTRODUCTION

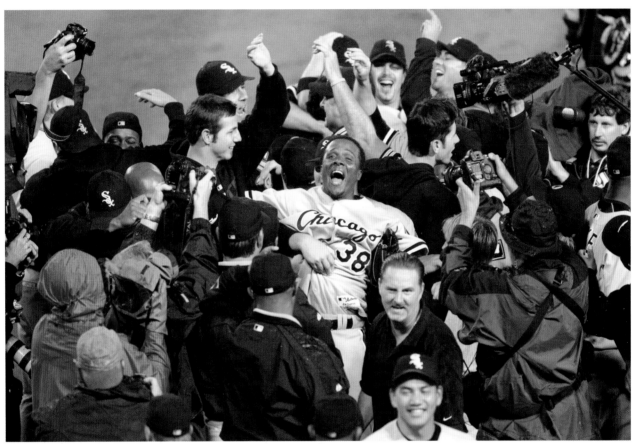

Experienced sports photographers are always ready for the jubilation images like this of the Chicago White Sox going wild after winning the 2005 American League Championship Series. Canon 1D MKII, 400mm f2.8 lens with 1.4X extender, ISO 1600, 1/1000 at f4. © Ben Chen

Few other pursuits or activities bond people together—or pit them against each other—as much as sport, whether at the local Little League level or in major international competition. Sports can draw out the best in people, and at times also the worst. So the range of action on the field, and emotion on and off of it, is huge. Regardless of the level of competition, at any sporting event we are likely to be treated to displays of camaraderie, team spirit, heroics, jubilation, and dejection. The games we play at all levels are an important part of our communities—local, national, and international.

Most of us are familiar with the words "the thrill of victory; the agony of defeat" and the majority of sports fans have indelible images of sporting moments those words describe. Often as not, those unforgettable slices of time in sports history—especially if at a major event—have been documented by a key person in the world of sports: the sports photographer. Essentially,

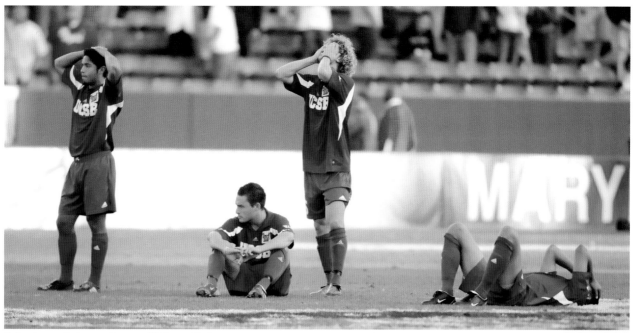

Dejection and dismay show as UC Santa Barbara soccer players react to losing after an overtime penalty kick by the Indiana Hoosiers. Canon 1D, 400mm f2.8 lens, ISO 640, 1/3200 at f2.8. © Ben Chen

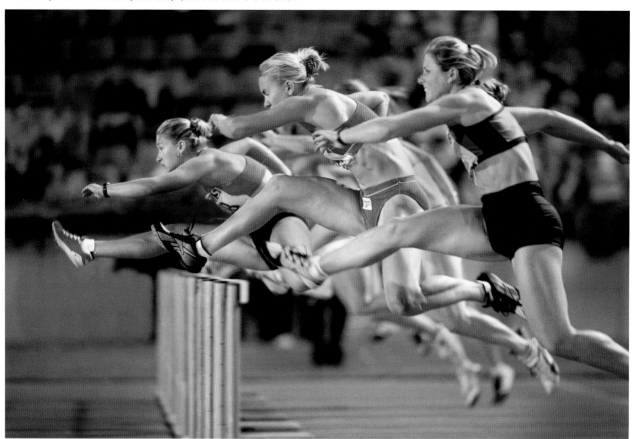

Perfect timing, great composition, knowing the sport, and panning with the action contribute to this wonderful shot of women hurdlers midway through a race. Note the red shoe leading the way! Canon 1N, 400mm f2.8 lens, Fuji 800 film, 1/1000 at f2.8. © Duane Hart

professional sports photographers are photojournalists whose prime role is to make pictures that capture the key or defining moments of any event. Additionally, these photographers strive to convey the intense emotion of the contest—in victory or defeat. Top sports photographers, those who consistently produce great images of action, emotion, and of sports people are a combination of many professions and talents. They are technically proficient artists, storytellers, empathetic, and, to a large extent, psychologists who can identify with and understand the psyche and nature of those involved with sports. How else could they get the access and have the interpersonal and technical

The big grin says it all as this Little Leaguer heads for the dugout after crossing home plate. Capturing special moments like this is the key to shooting youth sports. Canon EOS 3, ISO 400 Fujicolor, 100–400mm f4.5/5.6 lens, maximum aperture. © Diane Kulpinski

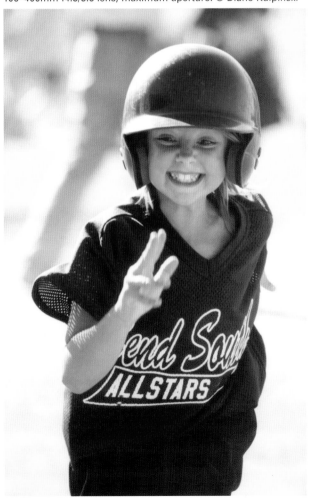

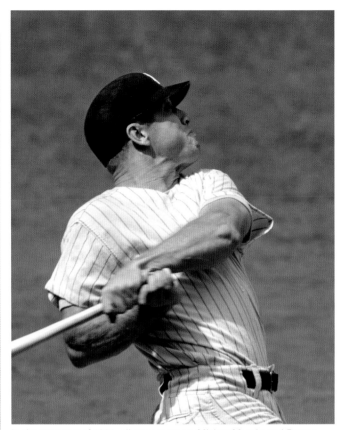

In the summer of 1961, all eyes were on Mickey Mantle and Roger Maris as the dynamic duo from the New York Yankees closed in on Babe Ruth's home run record. Bob Gomel was assigned to document the historic moment and used a 70mm, 50 frames per second, camera built by legendary inventor Charlie Hulcher, fitted with a 2000mm f10 Astro Berlin lens. Although this iconic shot of Mickey Mantle was not "the" one, it has stood the test of time. © Bob Gomel

skills to get the cooperation of elite sportsmen and -women and so make great images? There is more to being a great sports photographer than merely being on the spot and clicking a shutter.

Most photographers have tried their hand at shooting sports, and those who have will appreciate that it's not as easy as it might look. If you love sports, photographing them will add a new dimension to your involvement whether as a participant, supporter, or a parent whose children play sport. Even if you do not aspire to reach the top echelon of sports photographers, we hope this book will help you make the pictures you want and also encourage you to take your sports photography to higher levels.

The range of sports that people play is vast,

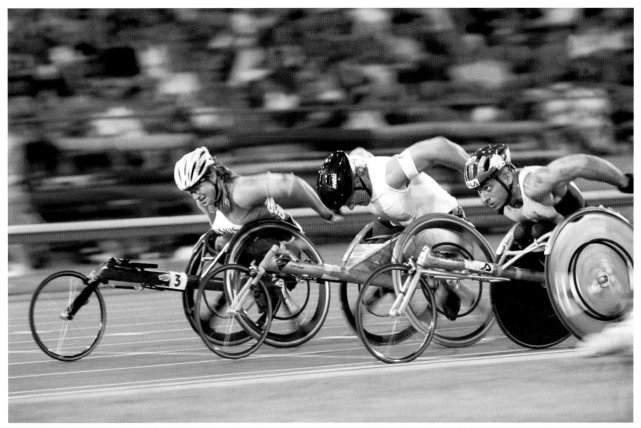

Strength, speed, and determination are personified as wheelchair athletes power down the straight. A low angle and panning enhance the shot. Canon 1N, 400mm f2.8, Fuji 800 film, 1/60 at f8 © Duane Hart

too vast for them all to be included in this publication. However, the examples of the sports featured here and the insights of the photographers whose pictures capture their essence should provide food for thought and inspiration. Not all sports involve teams and spectators. Many are individual sports, such as surfing or climbing, where the participants pit their skills against waves or mountainous terrain and other elements of nature. They are sports, nonetheless, and photographing them requires many of the skills associated with shooting the games played on fields or courts with defined boundaries and strict rules. There is no getting away from the fact that the top pros use the best equipment available. For most amateurs, the cost of that equipment is prohibitive. However, as Walter Iooss, one of the truly great sports photographers, emphatically points out, the camera is only a tool between the mind and the eye. Great pictures come from great vision. So, whether you

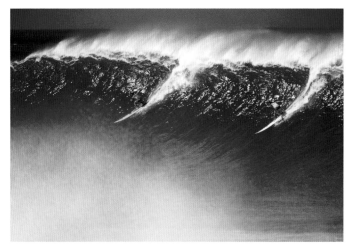

This classic image of surfers outracing a huge wave at Waimea Bay, Hawaii, during the annual Eddie Akau Memorial Big Wave contest was made with a 600mm f4 lens. Nikon F100 on a tripod, ISO 100 film, 1/500 at f5.6. © Mark A. Johnson

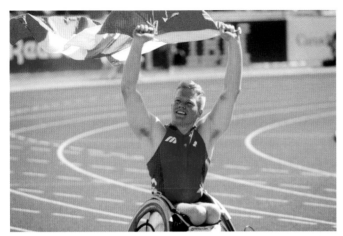

Jubilation and pride come to the fore as wheelchair athlete Jeff Adams of Canada celebrates victory at the Commonwealth Games in Victoria, Canada. Nikon FE2, Ektachrome 100, 80–200mm f2.8 lens, 1/1000 at f5.6. © Peter Skinner

are using a simple point-and-shoot camera, either film or digital, or a more sophisticated single-lens reflex camera with a range of lenses, don't be discouraged from trying to make the pictures that you can visualize in your mind's eye.

Being able to consistently make good photographs—sports or any other kind—takes practice, practice, and more practice. So, if your initial efforts are not what you hoped for, don't be discouraged. Keep in mind that to a large extent, sports photographers are like their subjects. They have to be well-trained, expert in their craft, have the right attitude, and have that innate sense of timing to make it happen at the right moment. Luck can play its part, but invariably good luck favors the well-prepared person, athlete and photographer alike.

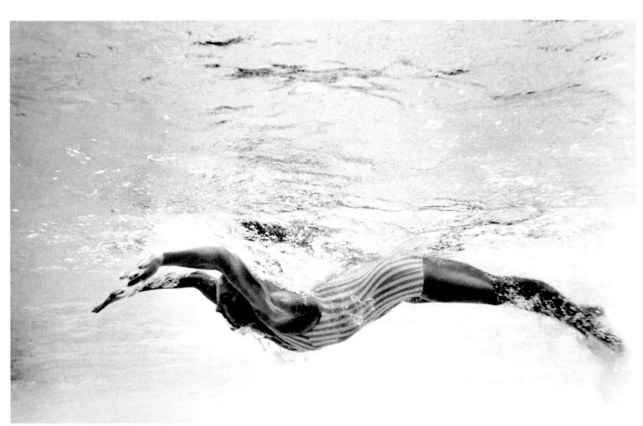

Poetry in motion underwater is an apt description for this stylish image of a butterfly swimmer training with the U.S. Olympic team. Bob Gomel used a motorized Nikon with a 250-frame film magazine in a custom housing, and Tri-X film. © Bob Gomel

Knowing the Sport

Ask any sports photographer what he considers the main prerequisites to be an accomplished shooter; "know the sport" will be near the top of the list. Your chances of success are increased when you are familiar with such things as being in the right spot, being able to anticipate the action, and knowing the rules and nuances that enable you to create those definitive images.

If you have played a sport, regardless at what level, you have a decided advantage because you know the objectives of the game and the skills needed to achieve them. You will also understand the rules and what's likely to happen following an umpire's or referee's decision. Each sport has those critical moments when key plays are needed to win the game. Knowing what options the athletes have will enable you to prepare for the shot. It might not always come off, but at least you'll be prepared.

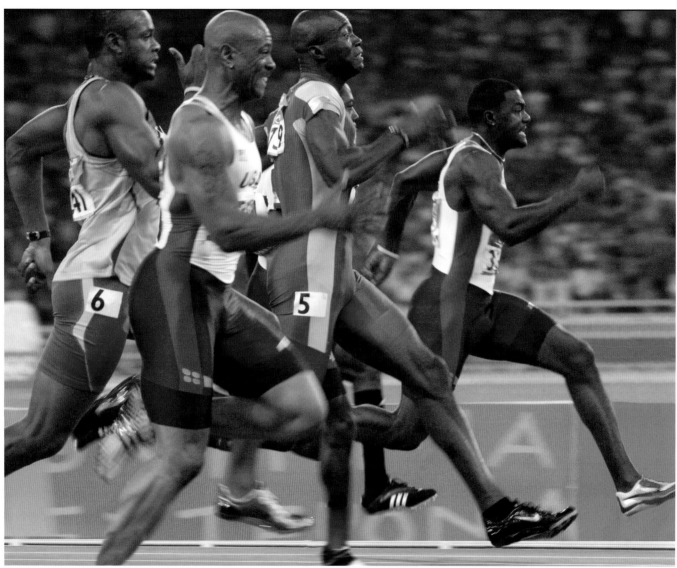

Few events match the explosive power of a men's sprint. Duane Hart's image captures every ounce of that power as athletes in the 2004 Olympic 100-meter final charge to the finish. Canon 10D, ISO 800, 200mm f1.8 lens, pattern metering, 1/250 at f8. © Duane Hart

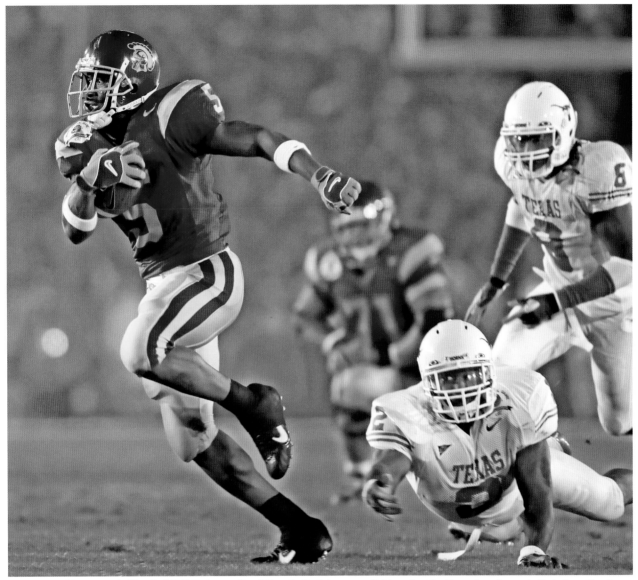

University of Southern California (USC) Trojans tailback Reggie Bush bursts upfield against the Texas Longhorns in their Rose Bowl game. Canon 1D MKIIN, 400mm f2.8 lens, ISO 1250, 1/800 at f2.8. © Ben Chen

Shooting a Sport for the First Time

If you are shooting a sport for the first time and are not conversant with its finer points, ask for help from an authoritative person—someone who's fanatical about a game will only be too glad to help you. In that situation, it's not likely you'll be covering pro sports, but if you have a child involved in a sport you've never played and want to photograph him or her in action, ask someone about what to look for. Similarly, if you see an unfamiliar game being played in a park and would like to photograph it, ask a spectator or official about the more interesting points of the game— from a visual aspect at least. It won't take long before you know what to look for.

Just make sure you have mastered the basics of your photographic equipment before you set out to photograph an event. You don't want to be "winging it" at the kickoff. Also, don't make the mistake of

taking every lens or gadget you own. Pick a basic outfit and exploit the full potential of what you take. You'll be able to refine equipment for future events once you have a better idea of what's involved.

Research the sport and study photographs that have been made by the professionals. Get a good grasp of what to look for. If you have access to a coach or club in your local area, ask them for advice on the rules and etiquette of photographing that sport. For instance, it's not considered good etiquette to fire off a series of shots when a golfer is about to swing at a ball—unless you are well out of hearing range.

Plan Ahead

Sports photography is all about planning and being prepared. Don't overlook things such as checking out the lighting situation. This is not a huge problem if it's an outdoors event, provided you have an idea of the direction of the light at relevant times.

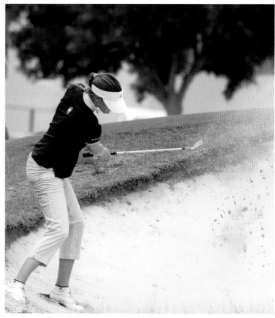

Sand erupts as a golfer blasts out of a bunker. Waiting until the shot is made is the wise thing to do—photographically and ethically. Nikon D1X, ISO 200, 300mm f4 lens, 1/1000 at f5.6. © Peter Skinner

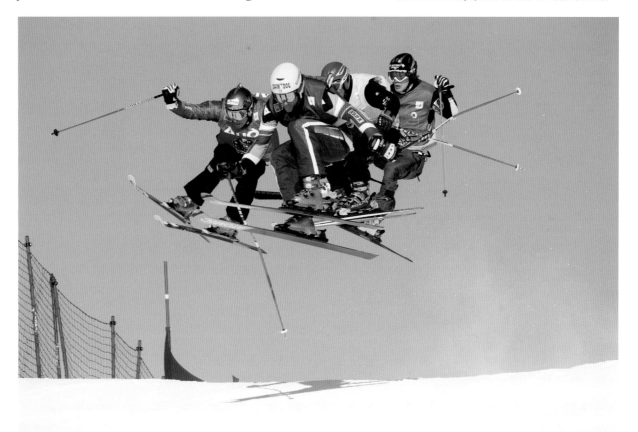

This bundle of arms, legs, skis, and poles, is a group of contestants in a ski-cross event at the 2005 freestyle world championships in Finland. Brian Robb used servo auto focus to track the action and shot as the group became airborne. Canon 1D Mark II, ISO 100, 70–200mm f2.8 lens at 200mm, 1/1300 at f5.6. © Brian Robb

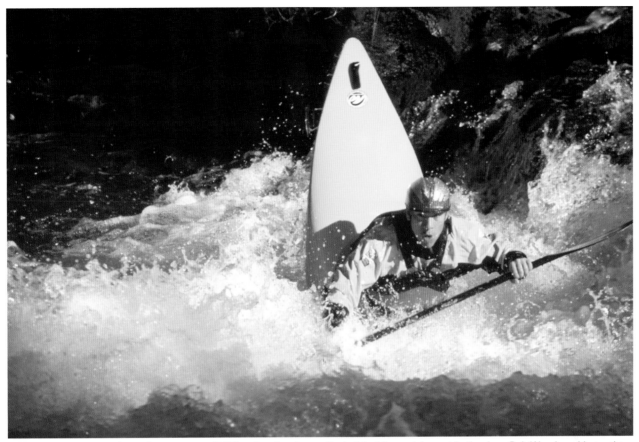

This shot is the result of knowing a sport well. When kayaker James Fredericks hit a certain spot in the river, Bob Woodward knew the bow would get sucked down. Canon EOS 1-N, 70–210mm f 2.8 lens, Fujichrome Provia 100, 1/500 at f8. © Bob Woodward

For your first outing, having the sun behind you is best. You can get more adventurous with other directions of light once you've become more confident. If it's an indoor event, see whether you can determine beforehand what the lighting is and take the right speed film (if you're using a conventional film camera). Get to the event early, set up ahead of the start, and take your time. Go with an open mind but have a plan and shoot to that plan. You can always change the way you're doing things, but far better to have a game plan than simply go in blind and try to wing it.

Go Out and Shoot

Regardless of your goals in sports photography, we hope you will find this book entertaining, informative, and motivating. And remember: you won't get great photographs every time you venture out with a camera in hand. Don't expect miracles, especially the first time. You might get lucky and score the winning shot but more likely you'll come away with a learning experience and a foundation on which to build. But if you don't venture out, you won't get any photographs at all. So, go out, shoot pictures, and have fun doing it. Enjoy the book, and good luck!

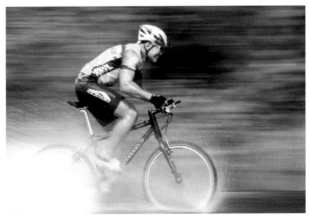

Panning with the action and using a slow shutter speed make this shot of a mountain biker racing through a shallow stream at Waialua on Kauai, Hawaii. A key is to follow through after taking the picture. Nikon F100, ISO 100 film, 20–35mm f2.8 lens, 1/30 at f22. © Mark A. Johnson

CHOOSING THE RIGHT EQUIPMENT

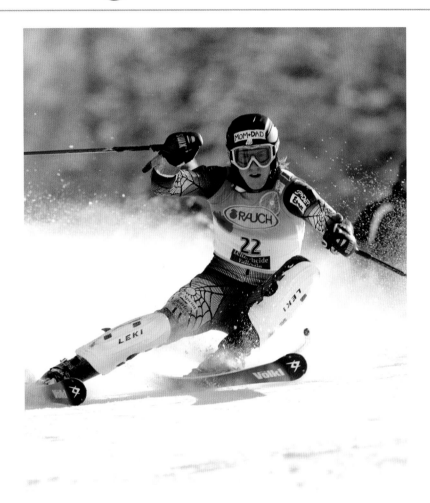

Anticipation and split-second timing are essential in making shots like this. American slalom racer Ted Ligety, competes in the 2005 World Cup finals in Switzerland. Canon ID Mark 11, ISO 125, 300mm f2.8 lens with 1.4X extender, 1/1300 at f5. © Brian Robb

There are no hard and fast rules about what equipment will work best for you, and ultimately, it comes down to what sports you are going to photograph; how much you are prepared to spend; what will the images be used for; your skill levels; and other things such as how much weight you want to carry.

Photographers tend to be equipment junkies, so don't be surprised if your basic starter outfit spills over from one bag or shelf to suddenly taking over entire closets. Weigh up the advantage of the extra lens, flash, or other accessory you "simply can't live without" with the disadvantages of the extra space it takes and its weight.

Don't underestimate the damage you can do to your back, neck, and shoulders by trying to heft heavy equipment around. Most veteran photojournalists can relate painful stories about lugging

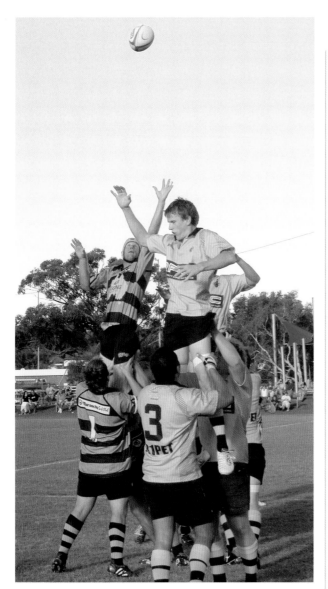

Compact cameras can be used for capturing sports action provided you know how to work around their limitations. This rugby lineout was shot with a Nikon Coolpix 5000, ISO 200, 21.4mm (85mm in 35mm equivalent), aperture priority, auto white balance, 1/1250 at f5.6. © Peter Skinner

photo stuff around over the years. Traveling light is worth considering and minimalism has its benefits.

The Right Camera for You

The best camera for sports photography is the single-lens reflex, SLR, whether film or digital. Today's professional sports photographers at almost every level use digital equipment. The

nature of their work, the deadlines they must meet and the speed with which digital images can be transmitted from an event into publication make digital photography a natural for pro sports photographers. Film SLRs, however, could still be worth considering by amateur photographers for a variety of reasons, as outlined in chapter 2.

POINT-AND-SHOOT CAMERAS

Compact cameras of the point-and-shoot variety with zoom lenses can be used for sports photography but may be limited in their capability. However, if you simply want to try your hand at shooting sports as a hobby before investing in more sophisticated equipment, don't shy away from using a point-and-shoot camera. Probably, you will have to get closer to the action and be prepared to cope with such things as slower focusing and, probably, with digital cameras, shutter lag or delay. These limitations, however, could encourage

A long, fast lens and anticipation are needed for baseball action like this of Baltimore Orioles first baseman B.J. Surhoff breaking up a double play. Canon 1D MKII, 400mm f2.8 lens, ISO 1600, 1/3200 at f2.8. © Ben Chen

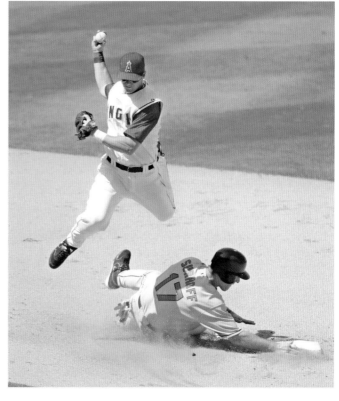

SPORTS PHOTOGRAPHY

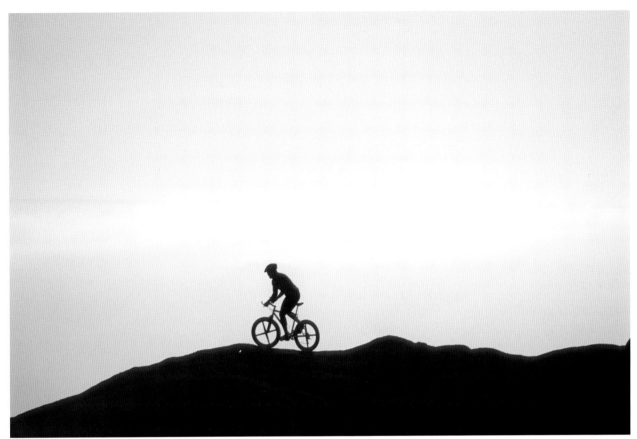

Exposure for the silhouette of a mountain biker on the rim of Hawaii's Waimea Canyon was based on the background. Nikon F100, ISO 100 film, 70–200mm f2.8 lens, 1/500 at f8. © Mark A. Johnson

you to look for better, different angles and thus produce more interesting images. (*Note*: Shutter lag or delay is the time between when the shutter is pressed and the image is actually made and written to the flash or memory card. Although relatively short, shutter lag does affect taking pictures of fast-moving subjects.)

There is a relatively simple way to compensate for shutter delay, and while not perfect, it's worth trying. Most digital cameras have a *continuous* mode, and this facilitates taking a sequence of shots when the shutter is pressed. My Nikon Coolpix 5000, for instance—a relatively "old" but still excellent camera—can be set on continuous high and the camera records about three frames per second to a maximum of three shots. On continuous low, it captures about three frames every two seconds. The continuous mode won't work on an image-quality setting of high but works well on fine or lower quality settings. (See Selecting Image Quality in chapter 2.) The capabilities of the continuous mode will vary with different makes of cameras.

People ask why the smaller compact cameras with superb image quality and other great features operate more slowly than the DSLRs, which in some cases are only a few hundred dollars more expensive. The simple answer is scale or size: there is more space in the bigger cameras to build in more and faster electronics. Fortunately, the capabilities of digital compact cameras are constantly being improved and refined, and so such things as shutter lag could well become a non-issue. Many sophisticated functions, once available only at the high-end professional level, are now incorporated into consumer digital cameras. So, if you don't need an SLR camera, a fast-focusing digital point-and-shoot with a good zoom range could be sufficient. Check the features for SLR cameras (see below) and include them in your criteria for a

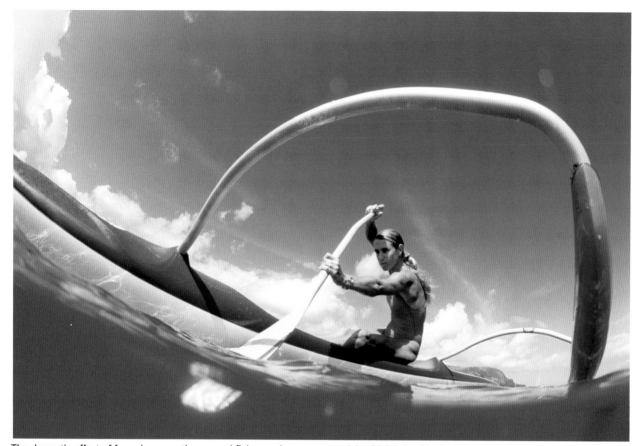

The dramatic effect of forced perspective—a real fish-eye view, so to speak is—highlighted in this photograph that includes most of the canoe's outrigger. Nikon N90S, water housing, 16mm lens, ISO 100 film, 1/400 at f8. © Mark A. Johnson

compact camera. Many of those features could be available in the latest point-and-shoot models. The range of digital cameras on the market is huge. Also, with the continuing evolution of digital technology, today's breakthrough model that sets the benchmark will, in all likelihood, be superseded quite soon. That, however, should not stop you from buying the best camera that you can afford if it meets your current needs. (*Note*: The Internet is a great resource for comparing latest cameras. See the Resources Section.)

On the other hand, traditional film SLRs will probably not change much and while I can only speak from experience with models I have used for years—such as the Nikon N90S and F100 in the auto focus range and before them models such as the venerable Nikon F, Nikkormat, FM and FE2s—it seems there could be some bargains to be had if you choose to shoot film.

With the increasing popularity of digital photography, manufacturers will undoubtedly focus their resources on producing new lines of digital products and reduce production of film cameras. But there will still be photographers who want to use film cameras, and buying an SLR camera and lenses has its advantages.

What to Look for When Buying an SLR System

The manufacturer should be well-established and offer a wide range of accessories from lenses to electronic flash units and even more sophisticated accessories if your ambitions go beyond basic shooting. The good news is that all the major companies make excellent equipment.

Keeping the elements out of your equipment is a challenge and, generally speaking, the seals of the

more expensive cameras are better than consumer models. You can take steps to protect your gear, and we will talk about that in another section, but you're ahead of the game if your camera is built to withstand water and windblown matter such as sand and dirt.

Before buying, research your options thoroughly. Numerous resources provide reviews and equipment tests. Magazines and the Internet are two excellent sources of up-to-date information. If you are a member of a photography group or organization, ask your colleagues. If you get the chance, quiz a newspaper or magazine photographer—just don't bother them while they're actually shooting. Most will be happy to share information. Professional camera stores also are excellent resources, but don't rely on store sales personnel to make your decision for you. Know what you want, and when you go into a camera store—preferably one specializing in professional equipment—confirm that the camera system you have in mind meets your needs. If your budget will stand it, select what the pros use and you'll be in good company.

What to Look for in a Camera

The following features may be applicable to either film or digital cameras but obviously some pertain only to a specific type.

FILM CAMERAS

- Ease of handling and access to controls— the camera should feel comfortable

- Construction—rugged enough for your anticipated usage

- Rapid film advance—built-in motor drive— and several frames or shots per second

- Range of modes including manual—as distinct from fully automatic with no manual override

- Shutter speed for flash synchronization— higher speed is better for outdoor fill flash

- ISO range

- Shutter speed range

- Fast auto focus but also a manual option

- Accurate through-the-lens metering system

- Range of accessories

DIGITAL CAMERAS

- Ease of handling and access to controls—the camera should feel comfortable

- Construction—rugged enough for your anticipated usage

- Capability of shooting several images per second

- Range of modes including manual—as distinct from fully automatic with no manual override

- Image quality and resolution—number of pixels, usually expressed as megapixels: 3MP, 5MP, 8MP, and so on

- Buffer capacity—how many images can be shot until the camera's memory is full and images have to be transferred to the memory or flash card?

- Shutter delay or lag time—in digital cameras especially, there is a delay between pressing the button and the picture being taken. Not so evident in high-end models, more prevalent in less-sophisticated cameras

- File formats supported—JPEG, RAW, TIFF (see Selecting Image Quality, chapter 2)

- Shutter speed for flash synchronization—higher speed is better for outdoor fill flash

- ISO range

- Shutter speed range

- Fast auto focus but also a manual option

- Image stabilization, or vibration reduction—

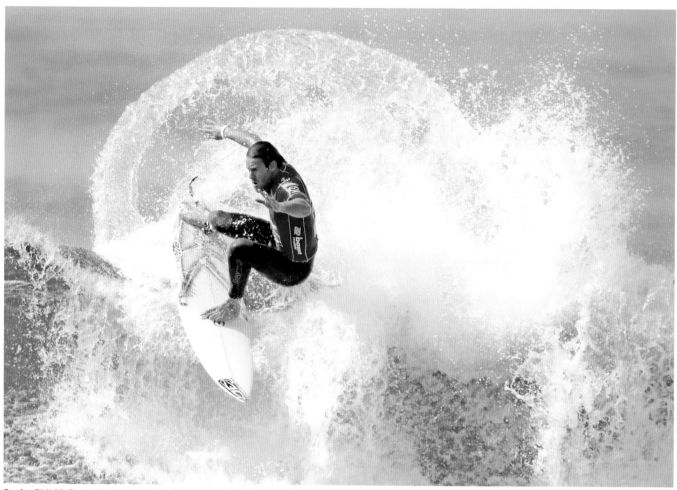

Surfer Phil McDonald has a curtain of spray as a backdrop while competing in a contest at Lower Trestles, San Clemente, California. Telephoto lenses are needed for most land-based surfing shots. Canon 1D MKII, 600mm f4 lens, ISO 600, 1/4000 at f4. © Ben Chen

many later models of consumer and prosumer cameras have this feature

- Accurate through-the-lens metering system
- Range of accessories

(*Note*: Two excellent sources for information on digital camera comparisons are: *www.dpreview.com* and *www.nikonians.org*. See Resources Section.)

Lenses

The optical quality of most modern lenses will be good to excellent. Today's lenses are computer designed, have high-transmission, low-dispersion glass—they transmit light

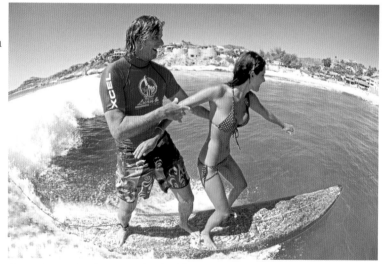

A great example of extreme depth of field with a fish-eye lens. Mark Johnson was riding a surfboard beside the tandem surfing couple and looking through the lens. Nikon N90S in a water housing, 16mm lens, ISO 100 film, 1/500 at f5.6. © Mark A. Johnson

more efficiently—and are multi-coated. This also applies to zoom lenses, so there is little optical quality difference between fixed focal length prime lenses and high-quality zoom lenses. The main difference can be construction. Materials used for the barrel and other components in high-end pro lenses are usually better quality and the equipment more ruggedly built.

Also differentiating more expensive lenses is the maximum aperture or f-stop. A 300mm f2.8 lens will be much more expensive than another of the same focal length but one or more f-stops slower—i.e., whose maximum aperture is f4 or f5.6. Professional sports photographers usually shoot at the fastest shutter speed possible and as they are often working in relatively low stadium light, need lenses with bigger maximum apertures (also referred to as fast lenses).

Consider buying lenses from companies such as Sigma, Tamron, and Tokina, which are among those offering a wide range of professional quality but less expensive lenses compatible with the leading SLR cameras. Many lenses are designed specifically for digital cameras and probably will not be compatible with film SLRs. While you might be able to mount the lenses on your camera, vignetting (when the corners or edges of an image might be darkened or cut off) will probably occur because of the lenses' design. On the other hand, most film SLR lenses will work with digital cameras but not all will give optimal quality when matched with digital cameras and there might be a lack of sharpness or color shifts in the image. Check the lens compatibility with your digital SLR before buying a lens designed for film cameras, especially if it's a different make from the camera. (See the Crop Factor below.)

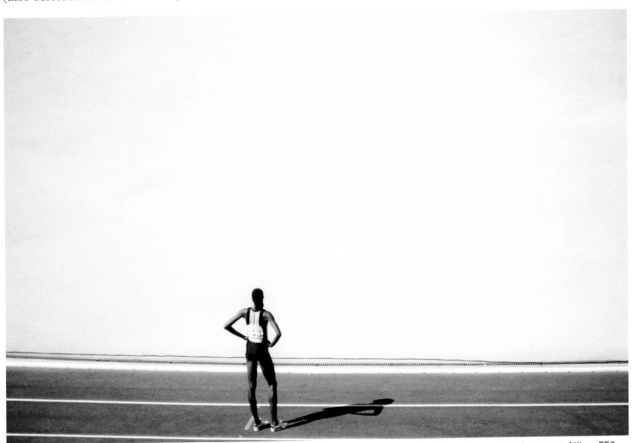

A long lens isolated this athlete from all the activity in the adjacent area before the start of an Olympic Games relay event. Nikon FE2, 300mm f2.8 lens, Kodachrome 64, 1/500 at f5.6. © Peter Skinner

CHOOSING LENSES

The simple advice is: buy the fastest lens you can afford. Conversely, the faster the lens—i.e., the bigger the maximum aperture—the more internal glass and the heavier the lens is. So, cost and weight become significant factors.

Zoom lenses are an excellent option. Check that the selected aperture remains unchanged through the range of the zoom. A zoom lens might be 80–400mm f4.5–f5.6. So, at 80mm, its maximum aperture is f4.5 but at the top end of the range, 400mm, the maximum aperture is f5.6. An 80–200mm f2.8 lens, on the other hand, will retain a maximum aperture of f2.8 throughout the zoom. If you are shooting wide open and need a consistently fast shutter speed, the variable aperture could pose a problem at the high end of the zoom. The aperture will close down and your photograph could be underexposed unless you change shutter speed, or blurred by movement, because a slower shutter speed will be needed for accurate exposure.

Auto focus is a huge bonus for sports photographers, but it is not always ideal and some pros occasionally still rely on manual focus. However, auto focus on high-end systems is extremely fast, so not surprisingly, many photographers use the feature all the time. Having both options is best, but learn how to focus manually so you won't have to rely on auto focus all the time. Image stabilization or vibration reduction is more common in professional and high-end consumer and prosumer digital cameras and lenses. This facilitates hand holding at slower shutter speeds.

WHICH FOCAL LENGTHS?

An excellent all-round lens will be in the 70–200mm or 80–200mm range, which is very popular with professionals. Other often-used focal lengths are 300mm and 400mm. The super telephoto lenses, 600mm and longer, are specialist lenses. Most amateur photographers will probably be able to cover most subjects with lenses up to 300mm. A good basic outfit would include a zoom lens in the 24–70mm range; a 70– or 80–200mm lens, and perhaps a 300mm or 400mm lens.

The focal length can be increased with tele-extenders, and while these do expand the versatility of a long lens they also cause a loss of light. For example, a doubler or 2X extender will turn your f2.8 lens into an f5.6 version; a 1.4X extender will cause a one-stop loss of light—i.e., f2.8 will become f4. The 1.4X or similar extender will usually provide better quality than a doubler. Some extenders are not compatible with all focal lengths, so specify the lens you are going to use with the accessory.

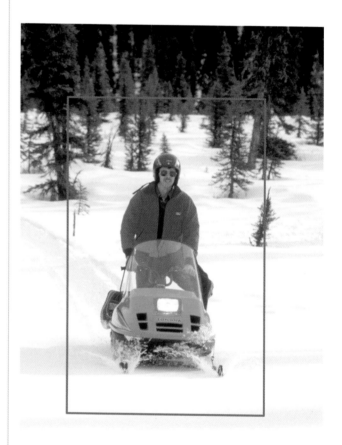

The cropped section approximates the section of an image that would be captured on the sensor of a digital SLR if a 35mm SLR camera lens were used. The whole scene is what you would get with the same lens on 35mm film. © Peter Skinner

The Crop Factor—
Film Camera Lenses
on Digital Cameras

Focal lengths for digital cameras are different from what we became accustomed to with conventional 35mm film cameras. For example, the "normal" focal length for a digital point-and-shoot—normal being the angle or field of view of the human eye—is much shorter than the traditional 50mm lens that was considered normal for 35mm film cameras.

And when used with digital SLRs, the focal length of a film camera's lens will vary depending on the size of an individual digital camera's sensor. This is known as the multiplier or crop factor. The sensors on most digital SLRs—some of the more expensive ones are the exceptions—are smaller than a 35mm film frame. A digital SLR's sensor image might measure approximately 24mm x 16mm while 35mm film measures 36mm x 24mm. So a 35mm camera lens used with a DSLR will give a narrower field of view than on the film camera. While the subject image size will be the same on both cameras, the scene will be cropped on the digital camera, giving the impression that the subject has been magnified.

As an example, if you were photographing a baseball pitcher with a 300mm lens on a digital SLR camera with a sensor smaller than 35mm film, you might almost fill the entire frame with the subject. Using the same lens from the same distance, on a conventional 35mm film SLR camera there would be more space around the principal subject but the actual size of the pitcher in both images would be the same. This is simply because the digital sensor is smaller than the 35mm film frame and the subject fills more of the picture area. The photograph of the snowmobile rider on the previous page illustrates the point.

When selecting lenses for a digital camera keep this in mind and be aware that a 300mm lens, for instance, will give an angle of view about the equivalent of a 450mm lens on a film SLR camera. The crop factor varies with different makes of cameras but is in the 1.5X to 1.6X range. Actually, many photographers like this effect with longer lenses as it gives a tighter shot of the principal subject. Also, with wider lenses, less of the scene will be included. For example, a 28mm film camera lens on a digital SLR will become equivalent to about a 42mm lens.

Tripods and Monopods

Don't ruin your pictures with camera shake—buy a tripod or a monopod. The latter is often more convenient when shooting sports. Some photographers can hand hold shorter lenses at very slow shutter speeds but not without practice and intense concentration. Image stabilization lenses that have built-in motors and electronics to minimize vibration do make hand holding a more viable option.

Generally, when it comes to longer lenses, a support is essential. If you're going to be stationed at one location and there's sufficient room around you, a sturdy tripod is ideal. Many quite solid lightweight models are available, but try before you buy and check for ease of operation and construction. The same advice applies to monopods.

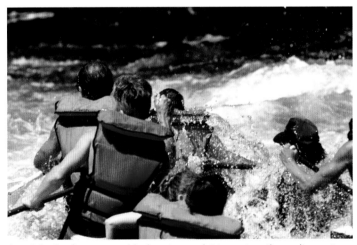

A rock in the river was an ideal vantage point to capture the excitement of river rafting. Full-frame matrix metering determined exposure. Canon EOS 1N, 200mm f2.8 lens, Fujichrome Provia 100, 1/250 at f16. © Bob Woodward

BALL HEADS

A ball head attached to the top of the tripod or monopod will facilitate smoother panning and other movement. Make sure it can be tightened securely. Some photographers don't like ball heads, claiming they are not secure enough. For many others, it is a wonderful aid.

Flash

Use of flash is prohibited at many indoor facilities, and the range of most flash units is usually limited. The throw of light can be increased if the flash has a special Fresnel lens unit attached, an accessory popular with nature photographers, especially for bird photography, but that might not be permitted for your sports subject. However, it is handy for the times when flash is permitted—ask an official or coach first—and you can get close enough to the action. Also, there will be times when a flash is necessary, such as when you need to photograph trophy presentations or make portraits of players or other personnel. Fill flash, to balance flash with outdoor light to reduce shadows, is also ideal for editorial portraits on location.

Minimalism is a Good Idea

By its nature, photography demands some essential equipment, but unless you are a professional covering a World Series or an NFL game the chances are you won't need a huge arsenal of gear or the specialized equipment that pros rely on. Bob Woodward of Bend, Oregon, an experienced photojournalist—especially shooting sports in the great outdoors—advocates minimalism.

"Travel light—you don't need the entire kitchen sink of lenses, filters, and other accessories if you know how to work creatively. My 'normal' kit is a 70–200mm lens, a 17–35mm, and a 14mm. That's it! And when I go ultra light, I work with the 17–35mm and a 100mm lens exclusively. Carrying minimal gear makes you learn how to

work around the subject matter more effectively to get the images you want," he said.

Camera Bags and Jackets

The ideal universal size or configuration of camera bags for all photographers or situations does not exist. There are too many variables—such as how many camera bodies, lenses and other accessories will be needed? But a camera bag that is comfortable to carry, and with shoulder straps that facilitate its being carried like a backpack, will be appreciated by your body. Other useful equipment carrying accessories are the multi-pocketed photographer's vest or jacket and a fanny pack.

Looking After Your Equipment in the Field

Water, spray, dirt, dust, sand, snow, ice, and various other natural elements seem to conspire to get into your camera equipment. It gets worse if you are actually shooting in the rain, on or near water or a beach, on a ski slope or in some desert or outback location where wind and dust are common. And it always seems to blow when you're changing lenses or film, or removing flash cards from a digital camera. At some time or other, a foreign object is going to get into your camera or lens. Make regular cleaning part of your regimen; you can minimize the chances of stuff getting into your gear.

Cover the camera and lens with a waterproof cover—something as basic as a sheet of plastic to a specially designed and fitted rain shield. Throw a chamois cloth over your camera and lens, and use the cloth to regularly wipe the equipment clean. A light cotton towel will also work. Spray, either from fresh or saltwater, should be wiped off immediately. Salt spray is the worst, and minute particles of salt can corrode equipment, causing irreparable damage. If your gear has been exposed to salt spray, professional cleaning by an authorized

source is recommended. Professional photographers regularly get their cameras and lenses serviced and cleaned—for a good reason.

When changing lenses, film, or flash cards, shield the equipment from the elements. Get out of the weather, if you can. Otherwise, turn your body against the wind or rain and cover the equipment with a jacket or raincoat. And be careful—a dropped lens, or lens or camera body cap, could ruin your day.

Cleaning the DSLR Sensor

At some stage, you will get foreign matter such as specks of dust on the low-pass filter that protects the sensor in your digital SLR camera. Annoying spots will appear on your images, especially in clear areas such as sky, so the sensor will have to be cleaned. You can send the camera to the manufacturer or an appointed tech rep; take it to a pro camera store that offers a cleaning service; or do it yourself. In the field, the DIY option is the most practical and you should learn how to do basic cleaning. Your camera's manual will have instructions on holding the mirror up to give you access to the filter and other advice. This is a very fragile component of the digital camera, and it should be cleaned very carefully.

Using a large blower brush is a common cleaning method. While this will remove the dust from the filter, it might not clear it from the camera. Point the camera downwards during the cleaning operation. Make sure the brush bristles are clean and dry, and not contaminated, even with something like oil from your fingers.

Some photographers use a blower brush as a small vacuum—remove the brush, depress the bulb, and suck the offending particles out. Special small vacuums are also made for this task. Other methods include swab and liquid cleaners such as methanol; this is popular with professional cleaning facilities.

If you feel uncomfortable cleaning the filter, have it done professionally. Excellent online resources for advice on cleaning digital

sensors—and what not to do—are *www.cleaningdigitalcameras.com* and *www.micro-tools.com*.

Points to Ponder

- Think minimalism. A good starter kit will include an SLR camera body (a second body is handy as a backup and also to have fitted with a lens to save having to change lenses at an event); 24–70mm lens or similar; 70–200mm or 80–200mm lens; and perhaps a 300mm or 400mm telephoto.

- Be aware of the crop factor when using film camera lenses with digital SLRs or buying a DSLR you intend to use with film camera lenses.

- Support your camera with a monopod—perhaps fitted with a ball head—or a tripod if you will be working from a fixed location most of the time.

- Carry a small flash, as there will be times when fill flash will improve your photos.

- Buy a camera bag and/or multi-pocketed photographer's jacket that is comfortable and spreads the load of your equipment to reduce the risk of back or shoulder pain.

- A waterproof cover for your camera and lens is essential in bad weather.

- A chamois or similar cloth such as a small towel is ideal for wiping moisture off equipment or as a temporary dust cover.

- Don't forget extra film, memory cards, spare batteries (and a charger if you're going on an extended shoot), lens cleaning tissues, and blower brush.

- Learn how to clean your DSLR camera's sensor in the field.

- The extras you take will be determined by the amount of shooting you plan on doing and the duration of your assignment.

DIGITAL OR FILM

2

The majority of photographers who specialize in shooting for publication use digital equipment. Obviously, there are those photographers who use both digital and film, but the percentage of use is inexorably moving in the direction of digital. And then there are the professional photographers who still use only film because they are not faced with tight deadlines and they simply like working with a medium they are comfortable with and have mastered. Invariably, however, even these photographers are using digital technology to scan their images to deliver digital files, thus taking advantage of both film and digital.

Digital images are made up of small elements called pixels. Millions of pixels, usually referred to as megapixels, combine to make a digital photograph. Often you will see the word "noise" used in reference to digital capture. This is simply the digital equivalent of grain in film. Sensor sensitivity to light is expressed as ISO, as is the speed of film. And just as lower speed film, in the order of 100, is fine grained, so is a lower digital ISO. As ISO increases in film, so does its grain. In digital photography, at higher ISOs noise becomes more evident—especially in cameras with smaller image-capturing sensors—and your digital images can take on a grainy or pixelated look. As an exercise to get an idea what this looks like, zoom in on a digital image in an imaging software program and enlarge the shot up to 200 percent or more. The pattern of pixels will become evident. A relatively fast and noiseless ISO is 200, and this seems a good standard setting—it's one I use most frequently for general shooting with a Nikon D1X. In higher quality cameras with larger sensors, even settings as high as ISO 800 seem to produce little noise.

The Digital Advantage

A major benefit is the instant feedback. Seconds after taking the shot, you can see the result. "Chimping"—that is, scrutinizing the shot on a camera's LCD screen—has become a common sight at media events, as photographers make sure they've got the shot. Following are some other advantages of digital capture.

You can edit on location, deleting unwanted pictures. (*Note*: Don't be too ruthless in on-site, in-the-camera editing. Pictures that don't appear perfect on the camera LCD might look great on a larger screen, or can be enhanced with manipulation.)

Changing light is handled more easily with digital without having to "change film." Quality, resolution, ISO speed, and white balance can be changed to suit conditions—on the one flash card. (See Selecting Image Quality in this chapter.)

Digital images can be tweaked, enhanced, retouched, or otherwise manipulated in imaging software programs.

Memory cards with multiple gigabytes of memory can store thousands of images without taking up as much space as rolls of film. And they can be taken through X-ray machines without apparent damage. Digital photography takes film processing out of the equation. However, having prints made still costs money.

Digital images can be downloaded to a computer or another storage device for viewing and editing, printing, or e-mailing. Images can then be deleted from the memory card so it can be re-used. (*Note*: After deleting pictures from a flash card, always reformat the card to remove any latent images to ensure you get optimum quality.)

File information is automatically recorded with digital images. Having exposure information, ISO setting, lens used, time, date, and various other data can be extremely useful. Captions and other detailed notes can be written to each image.

Wireless transfer of files or images is a huge bonus for professional sports photographers.

Digital Drawbacks

Considerable time is needed at the back end of the process. While this may be seen as an advantage because of the control photographers have, many will not relish the prospect of spending hours at a computer.

Be prepared to invest time mastering the camera equipment and imaging software to process images. It can get complex, time-consuming, and addictive.

Going digital can be expensive. Cheaper cameras at the lower end of the huge range of compact point-and-shoot cameras are not ideal for sports photography. The best cameras for shooting sports are the DSLRs with their vast array of interchangeable lenses and other add-ons. Many photographers going to digital have discarded most of their old equipment and bought completely new systems. Others have made a more gradual transition. Regardless of how the change is made, it is a serious investment. Fortunately, excellent middle-of-the-range DSLR cameras that are far less expensive than the top-of-the-line models are being produced.

Other additional start-up expenses can include a computer, a card reader, extra re-chargeable batteries, an external CD/DVD burner, adding more computer memory, buying external hard drives, imaging software, microdrives, flash cards, and upgrades as technology changes. Every few years it's likely the serious digital photographer will be faced with considerable and ongoing upgrading expenses.

Losing pictures, slides, or negatives has always been a potential problem. With digital, it seems to be easier to press the wrong button and the image is gone. So backing up is necessary, and copies

should be made for manipulation—never work on an original.

On Using Film

You hear it all the time: "My XYZ camera is now a paperweight." Or, "The film in my freezer will probably become ballast for my boat." These are the comments of film photographers who have made the transition to digital, have not shot film for years, and don't intend to again. On the other hand, devotees of film whose workflow is efficient and whose clients' needs are met with film are unlikely to be swayed. Being able to examine slides on a light table and pull sheets of slides from file cabinets for speedy scrutiny still holds great appeal to many.

Amateur photographers who own film cameras and can live without the instant feedback of digital technology probably can now upgrade to better systems or acquire additional camera bodies and new lenses for less than the cost of going digital to an equivalent level. And for those who want to buy their first SLR camera system, now would be a great time to pick up excellent professional quality gear, especially second-hand equipment. Also keep in mind that the film cameras of today are tried and tested, and will more than likely last for many years.

The fine-grain films made by major manufacturers such as Fuji and Kodak are of unsurpassed quality, especially in the area of high-speed emulsions in both negative and slide film. Those films in the 400 and 800 ISO range will deliver superb pictures.

You do not have to invest in a lot of new computer equipment. Online facilities such as Snapfish provide relatively inexpensive film processing, and your film can be digitized onto a CD for e-mailing. One-hour processing labs usually provide this service. Once those pictures are in hand, the bulk of the back end process is complete. Put the best shots in your album, mail some prints to the grandparents if they don't have e-mail, or e-mail them from the CD if they do.

DISADVANTAGES OF FILM

The cost of film and processing, the delay between taking pictures and seeing the result, not being able to delete images you don't want in-camera, shooting more pictures than you really need—just to be safe—and having to change film mid-roll for different lighting conditions and other technical reasons, are all valid considerations.

Unexposed film does age, although if it is stored in cool, dry conditions—or better yet, kept in a freezer—until use, this should not be a real issue. Also, film is susceptible to X-ray damage but seasoned traveling photographers are used to carrying film and having it inspected by hand; or buying what they need at their destination.

Film negatives, prints, and slides have to be filed and stored in cabinets, all of which take space. But ultimately, whether to shoot digital or film is a personal decision to be made after considering all aspects. It used to be a matter of quality—that is now not the case, as digital technology has more than passed the quality test. It all boils down to what you feel is best for your uses.

Selecting Image Quality

The word "quality" in this context is different from traditional photographic quality involving lighting, exposure, sharpness, composition, and other visual aesthetics of the image. Digital image quality is determined by the file formats you select and the pixel resolution of the camera. Many, but not all, digital cameras give you the option of capturing images in RAW, TIFF, or JPEG formats, with JPEG (Joint Photographic Experts Group) probably the most used format. The JPEG format compresses files in order to reduce file size, and with this compression there is a loss of information and thus, quality. Simply put, the smaller the file, the lower the quality of the image. The advantage of the smaller file size is the increased number of images you can store on your memory card. The disadvantage is that the smaller file size limits what you can do with the image. In the JPEG format, you usually have the option of selecting the file size from a large file, with little compression, to a small file, with a lot of compression.

The quality of the image is usually based on the intended use of the photograph. In other words, a photograph that will appear in a magazine or which will be made into a large print should be captured at a higher quality than one to be e-mailed or placed on a Web site.

In many cameras, you also have the option of selecting the number of pixels used and thus the actual dimensions or size of the image measured in pixels. Smaller sizes—on the order of 640 x 480 pixels—require less storage space and are suitable for e-mailing or Web use. On the other hand, larger images—such as 2,560 x 1,920 pixels—are more suited to making larger prints. The larger the image size, the bigger the print that can be made without becoming grainy or pixelated.

But a word of warning on the file format you use for image capture, and it comes from Julieanne Kost, digital imaging evangelist with Adobe Systems, a highly respected authority in this field. "If the photographer doesn't know the intended use of the image, or if the image will or may be re-purposed for many uses, even in the future, capture as much information as possible. That is, use the maximum number of pixels and compress the images as little as possible. Once the image is compressed at capture, and not in the post processing, there's no going back to the uncompressed image," she said. So, capture at a higher quality—a larger file—and be able to downsize for things such as e-mailing and Web use, rather than trying to increase file size after the fact.

A typical digital compact camera probably has image quality settings such as high, fine, normal, and basic; or large, medium, and small. These represent quality settings in different file formats such as:

High: TIFF—Tagged Image Format File, is an uncompressed file that gives maximum image quality for reproduction in publications or for large prints.

Fine, Normal, and Basic (Large, Medium, Small): JPEG—These will be different image quality versions

of JPEG files ranging from high quality or large files, suitable for enlarged photographs and publication, to files for smaller prints (normal/medium) and e-mail or Web use (basic/small).

At those settings, which are also available in DSLRs, the camera's computer processes the information and makes the various color and quality adjustments. Obviously, further manipulation can be done in computers, but the camera has done the bulk of the work, which is all that's needed by many photographers.

Also available in professional and many prosumer cameras is the RAW image format, often referred to as being the equivalent of a film negative. Capturing in RAW is popular with many professional photographers, especially if they want to have complete control in manipulating their images to ensure optimum quality. Images captured in RAW can be adjusted in numerous ways before being converted to TIFF, JPEG, or other file formats while the RAW file can be retained as an original.

Julieanne Kost points out that RAW files have many benefits, including the potential for capturing better quality images. She emphasized that working with RAW files is like being able to develop your own negatives. Also, you have complete control over conversion settings (to JPEG, TIFF, etc.) rather than letting the camera do it automatically. Another benefit is being able to modify many key camera parameters—exposure, color, and even white balance—after the image is captured. The subject of working with RAW is complex, and the numerous writings by Kost and her Adobe Systems colleague Daniel Brown are well worth digesting. (See *www.adobeevangelists.com* and other resources in the Resources Section.) Two books well worth reading are *Real World Camera Raw* by Bruce Fraser, and *Photoshop CS2 RAW: Using Adobe Camera Raw, Bridge, and Photoshop to Get the Most out of Your Digital Camera* by Mikkel Aaland.

But RAW is not for everyone. Many photographers, most of the time, simply don't need it. Sports photographers working on tight deadlines usually don't have the luxury of working with RAW files. They will shoot according to the quality and resolution needs of their clients. And with the multi-megapixel sensors now used in high-end cameras, the quality of JPEG has vastly improved. Also, being a compressed file, it is rapidly processed in the camera and written to the memory card almost instantly. In some systems, RAW and JPEG can be captured simultaneously, but this dual system does eat up memory storage. (*Note*: I always shoot in RAW, and when outdoors use a color temperature setting of 6300K. I can fine-tune this after the fact but have found that 6300K generally is ideal. From RAW, I convert to TIFF or JPEG but always save the original RAW file as shot.)

Your digital camera's manual will explain the different resolutions, file sizes, and image sizes at the various quality settings. The higher the quality of the image, the more space it will take on the camera memory card, and the longer the camera's computer will take to process the information and write the file to the memory card.

There are many specialized books on the subject of digital imaging and all its technological intricacies. One that I highly recommend, and that has been used with permission as a resource for some of the technical information here, is *Shooting Digital* also by Mikkel Aaland. Numerous excellent resources on digital photography, including the Web sites of trade associations, are available online.

Color Temperature and White Balance for Digital Cameras

Different light sources vary in color when "seen" by film or digital camera sensors. On the other hand, the human eye compensates and adjusts well for these variations. For example, while we will see a white object as white, regardless of the light illuminating it, the camera might not. This is because color is measured in degrees of color temperature, most commonly on the Kelvin scale, with red or warm colors at the lower end, and blue or cool colors at the high end of that scale. The range goes from

about 2,000K for warm candle light to about 10,000K or even higher for clear blue sky on a bright day, especially at altitude.

Sunlight/Daylight is normally calculated at about 5,200–5,500K, but it can range from around 3,500K to 10,000K, depending on time of day, cloud cover, altitude, and various other natural factors. To make the color in our pictures look normal, we have to ensure that the color of the light source is compatible with the film or sensor.

With digital photography, this means setting the camera's white balance to match the color temperature of the light. The manufacturers have simplified this to a large extent by incorporating a range of settings, that will get you in the ballpark, and those settings, and the approximate color temperatures for each will be described in your camera's manual. To get a feeling of what incorrect white balance looks like, shoot a series of images in daylight with the whole range of white balance settings in your camera.

If you are capturing in TIFF or JPEG, the white balance selected is applied to the image so it's important to get it right. On the other hand, if you shoot in RAW, you can change white balance after the fact with imaging software.

Customizing White Balance

Your camera's manual will explain how to determine or customize white balance. It simply involves photographing a gray or white card—or some object of similar tones—making sure it fills the frame, under the lighting conditions you'll be shooting in. This is the usual method of customizing white balance for a specific situation.

Also popular with many professionals is the ExpoDisc that provides a perfect white balance when used with digital cameras. It presents an image to the camera's optical system in near-perfect RGB (red, green, blue) balance and, because it comes in several filter sizes, will fit most cameras. For more on the ExpoDisc, go to *www.expodisc.com* or read Mikkel Aaland's *Shooting Digital*.

Color Correcting Film

Color correcting film to ensure faithful rendition in print is important. After all, you do want skin tones to look normal. The best way to avoid having to color correct film is to shoot with the type of film intended for a specific light source. Use daylight balanced film in natural light, tungsten film in artificial light. But often some correction or filtering will be needed, even if just to touch up or enhance the color in your photographs.

Each film manufacturer provides color correction information, but the best advice is to use film balanced with the light source. If you are photographing indoors with mixed lighting, a fast negative film is recommended because color correction can be done at the printing stage. A longtime favorite with sports photographers, before the advent of digital photography, was Fujicolor 800 Press film that could be pushed to ISO 1600 with excellent results in mixed lighting. Check with a professional color lab that offers push processing and ask for their opinion on which films to use. Your drugstore or consumer lab probably won't know, so ask personnel at a professional lab. (*Note*: With the popularity of digital photography, some films have been discontinued. Latest information can be obtained from the manufacturers' Web sites.)

Filters Outdoors

Filtering in outdoor settings is less problematic than color correcting film for artificial light. Among the most common use of filters outdoors is to warm up a scene. When photographing in snow or at high altitude in strong sunlight, on overcast days or in the shade, your pictures will invariably have a cool look. Warming filters, in the 81 range, can improve the look of these pictures, increasing color saturation and giving a more pleasing result.

Polarizers can enhance your outdoor images by increasing contrast and color saturation, penetrating haze, eliminating distracting reflections, and

dramatically darkening pale blue skies. Those shots of magnificent white clouds contrasting against a deep blue sky are invariably made with a polarizer on the lens. The disadvantage of polarizers is that you will lose light—1.5 to 2 f-stops—and they do make images look cooler.

(*Note*: Comprehensive information on color photography in mixed lighting, conversion filters, and the color temperatures of numerous lighting sources is available on the Internet from companies such as Eastman Kodak Company. See the Resources Section.)

Imaging Software

There's no arguing that the top-of-the-line imaging software with which all others are compared is Adobe Photoshop in its latest version—whichever that happens to be as you read this. This is the program used by professionals and serious amateurs. Powerful, complex, and with a vast array of features, Photoshop is probably more than most amateurs need but once mastered it will almost certainly solve any situation you have with digital imaging. Its entry-level version, Photoshop Elements, is also powerful and more user-friendly, a fraction of the price, but with enough features to support images from high-end digital cameras.

Also aimed at the average photographer is Ulead PhotoImpact, a cost-effective image editor well worth considering. A bit more expensive—at writing—and not really for beginners is Corel Paint Shop Pro X. This would be a good option for the photographer who has outgrown an entry-level program and needs something more powerful but doesn't want to buy Photoshop.

Microsoft offers Digital Image Suite, and Apple has also developed Aperture, a versatile and feature-laden image-editing program for Macintosh users. At about $500 at this writing, it is definitely worth serious consideration.

The software that comes with your digital camera might very well meet your needs, but check out other programs that might make organizing your digital photography more efficient including shareware and freeware programs like GIMP for Windows and numerous others. (See the Resources Section.)

Useful Peripherals

Digital photography peripherals abound—just check any computer magazine. Here are some that I have found very useful. A fast card reader to transfer images from the memory card to your computer is a wonderful gadget. Obviously, you can transfer images direct from your camera to computer, but a card reader simplifies the procedure. Another useful tool—and to many photographers who spend time in the field, it is indispensable—is a multi-media storage viewer. Numerous models exist but from personal experience, the Epson P-2000—and by reputation its successor the P-4000—is excellent. Storage viewers facilitate downloading images direct from a flash card—you simply insert the card—so the card can be reformatted once the transfer is complete. Being able to scrutinize the images on a high-quality LCD screen means you don't have to take a computer with you on a field trip. Storage capacity varies but most are in the 40GB to 80GB range. Reliable and less expensive portable storage devices—external hard drives—without viewing capability, such as from LaCie and iMageTank are available but being able to see your images either as thumbnails or as full-screen size could be worth the difference in cost. (*Note*: Numerous other manufacturers supply field storage devices. The aforementioned are only examples. See the Resources Section.)

Another useful tool is a fast CD/DVD burner. Most computers include burners but an external unit will soon pay for itself in convenience and speed.

Battery Longevity

Digital cameras consume battery power, and the more features you activate—such as constantly composing through the LCD screen or chimping—

the quicker you deplete the battery. Carry a fully charged spare battery if you're going to shoot more than a few pictures. How well you look after those batteries affects their longevity. Follow the maker's instructions on initially charging the battery and adhere to the manufacturer's recommendations on maximizing the battery's life. You'll be glad you did!

Extreme temperatures can adversely affect all batteries but to what extent seems to vary with the battery. Keeping batteries protected from extreme temperatures, such as carrying them inside your jacket in cold conditions, will almost assuredly improve their efficiency and longevity.

Points to Ponder

- Analyze your needs before investing in camera systems, either digital or film.

- Digital photography offers huge advantages, but there are also downsides to consider.

- Film equipment, although being rapidly overhauled by digital products, does have its benefits and you might be able to acquire or upgrade economically.

- If "going digital," be prepared to invest time and money into the acquisition and learning process, especially if you use powerful and complex software such as Photoshop.

- The choice for imaging software is vast, with price ranges to match. Consider the shareware and freeware programs that are available.

- Don't simply erase images from your memory card. Reformat the card once you've transferred the pictures for permanent storage. Doing this will increase the card's longevity. Not doing it will damage the card permanently, eventually making it useless.

- Be aware that the film grain equivalent for digital photography is noise. The higher the ISO selected, the more noise or grain is likely to appear in your images.

- It's tempting to get too many gadgets. Be selective in choosing peripherals, and acquire only those you will use often.

- Be aware that film and digital camera sensors don't always "see" the color of subjects as faithfully as the human eye.

- Understand white balance and/or film color correction.

- When shooting with digital equipment, capture at a higher quality—a larger file—to be able to downsize for e-mailing and Web use, rather than capturing a small file and be limited in uses.

- If shooting indoors, use a fast, color negative film that can be color corrected when printed.

- Experiment with the white balance settings in your digital camera to see the different effects.

- Digital cameras consume a lot of battery power, so learn how to maintain those batteries to get maximum efficiency. Protect batteries from temperature extremes.

EXPOSURE AND LIGHTING

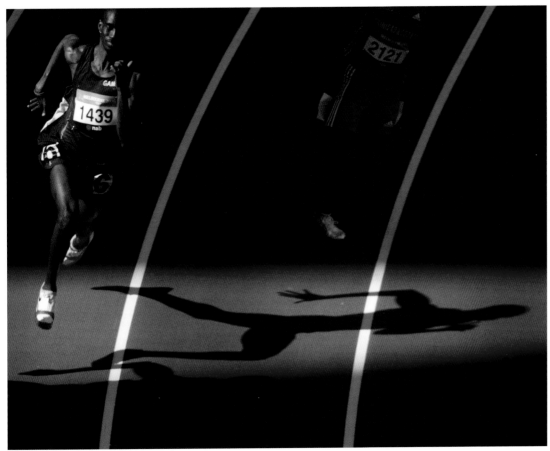

Planning, precision, and the vision of an artist in harnessing the interplay of light, shadow, and speed contribute to this exciting image of an athlete powering through a shaft of light with a fellow competitor just behind, still in shadow. Canon 1D, ISO 200, 800mm f5.6 lens, manual exposure, 1/1000 at f5.6. © Duane Hart

Regardless of what sport you intend to photograph, fundamentals such as correct exposure and making the most of existing lighting conditions are important. And you must ensure that the color in your pictures is accurate, especially when photographing in artificial light. Without understanding these basic elements and applying them, you will not consistently produce good photographs.

If you're using digital equipment, master the image quality and other settings that meet most of your needs and stick with them. (See Selecting Image Quality in chapter 2.) If you're shooting film, get to know the characteristics of a certain film, or films, under your most common lighting situations. Once competent in the basics, you will have the technical foundation to expand beyond them and be able to consistently produce the images that you conjure up in your mind's eye.

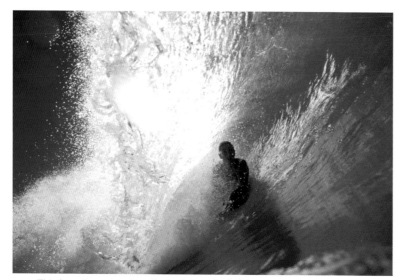

This from-the-water shot of a body boarder inside a translucent wave was taken on Australia's Gold Coast. Seconds after the shot was made, the surfer went over the photographer. Nikon N90S, water housing, 16mm lens, ISO 100 film, 1/500 at f5.6. © Mark A. Johnson

Exposure—Get it Right at the Start

Correct exposure makes life as a photographer so much easier. Digital images or scanned film photographs can be adjusted to some extent in a computer to compensate for less-than-perfect exposure, but that does not match correct exposure. Some photographers will argue that there is no such thing as a correct exposure and that it's subjective. That's fair comment, but for most purposes a well-exposed image with a range of tones all the way from black to white is the ideal foundation for whatever you intend doing with the photograph.

Nailing a correct exposure every time should be your goal. Even though the keys to great sports photography are anticipation, timing, and quick reflexes,

don't underestimate how good lighting can really bring out the drama or enhance the mood of the moment. Many great sports photographers are artists in every sense of the word, and it shows in the way they use light to great effect.

Measuring Light Intensity

Light meters, either handheld or built into the camera, are your best ally in determining correct exposure. Modern in-camera metering systems are sophisticated and sensitive, and can be relied on most of the time but not always.

Regardless of how accurate they are, in-camera light meters can be fooled for one reason. They are calibrated to measure light as if it is being reflected from scenes with an average reflectance known as 18 percent or middle gray or middle tones, about halfway between black and white—and so are films. When measured in monotones, most scenes can be valued as 18 percent gray. When a meter reads something bright, such as snow, it will be fooled by the intensity of light reflecting off the

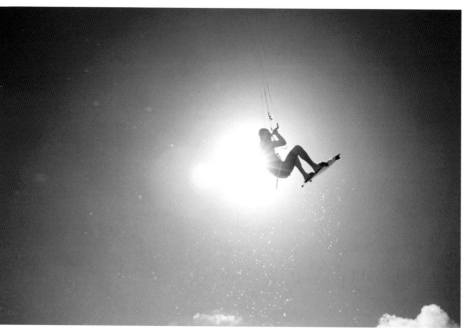

Matrix metering came to the rescue in tricky lighting conditions for this intriguing picture of a kite surfer silhouetted against the sun in Moorea, French Polynesia. Nikon N90S, aperture priority, water housing, 35–135mm lens, ISO 100 film, 1/800 at f5.6. © Mark A. Johnson

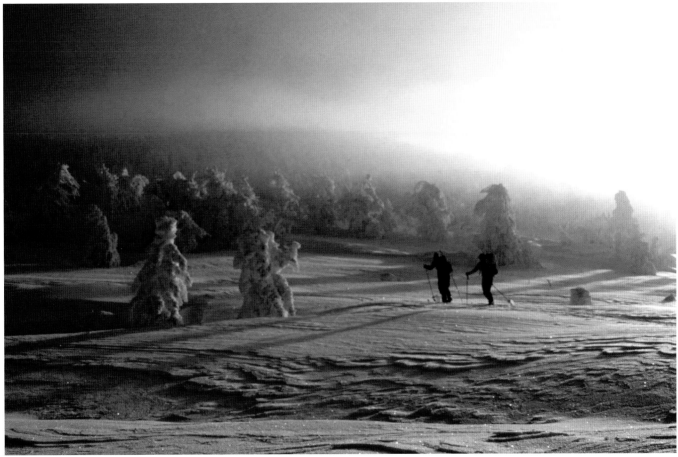

Early morning just before dawn is a favorite time to shoot, says Bob Woodward of this dreamy, misty picture that shows skiers in their environment. Canon EOS 1N, 35–350mm f4/5.6 lens, Fujichrome Provia 100, 1/125 at f5.6. © Bob Woodward

snow. Consequently, the photograph will be underexposed if you shoot it as indicated by the meter. In other words, the meter will indicate that you should be shooting at f22 when in fact the correct f-stop might be f11.

As a test, photograph a white wall using the exposure determined by the in-camera meter. Then make another exposure after opening up one or two f-stops. The first photograph will probably look muddy or gray. The other should depict the wall as white. As long as you are aware of this characteristic of in-camera meters and have an idea of what the correct reading should be, you can override or compensate for what the meter is telling you.

You should test your camera's metering system for accuracy by photographing at various ISO speeds and bracket your exposures an f-stop or

more either side of the meter reading and then check the results to see which are closest to the original scene. Do this before you photograph an important event—not during it!

In-Camera Metering Systems

Many modern cameras calculate exposure by taking in not only the brightness but also color and contrast values and subject distance. Your camera manual will provide details on the systems and how to make full use of them. You might see these systems referred to as matrix, multi-zone evaluative, partial, center-weighted, or spot. Most cameras will allow you to select things such as aperture priority (you nominate the aperture, the camera selects the shutter speed); shutter priority (you

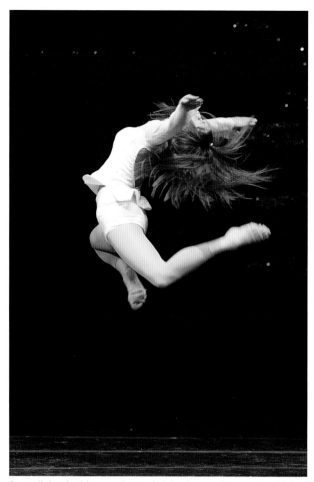

A spotlighted athlete against a dark background presents a tricky lighting situation, but Ben Chen overcame the problem by setting his meter on partial, or center-weighted, mode. Jennifer Andersen executes a graceful ring jump at a performing arts event. Canon 1D, 70–200mm f2.8 lens, ISO 640, 1/250 at f2.8. © Ben Chen

designate the shutter speed, the camera selects the aperture); program (the camera selects both aperture and shutter speed), or manual (you determine both shutter speed and aperture). The following are examples of three metering modes:

Matrix metering: This uses a multi-segment matrix sensor (about 7 to 10 segments or zones, sometimes more) that detects scene brightness and contrast in the whole scene to determine exposure. When lenses that are compatible with the camera's auto focus and metering system are used (in Nikon, these are D or G lenses; other manufacturers have their equivalent lenses), subject distance is also factored in to give an even more accurate

exposure. This is known as 3D matrix metering. As a general rule, matrix metering or its equivalent is very accurate and can be relied upon.

Center-weighted metering: As the name implies, this places emphasis on brightness within the center of the viewfinder. The camera will measure light over the entire scene but gives greater weight to a circle about 12mm in diameter in the center. You can compose your picture by placing the center circle on a specific area to determine exposure for that area. About 70–75 percent of the meter's sensitivity is concentrated on that 12mm circle.

Spot metering: Nearly all the meter's sensitivity will be concentrated on a small circle (in the 3–5mm range), either in the center of the

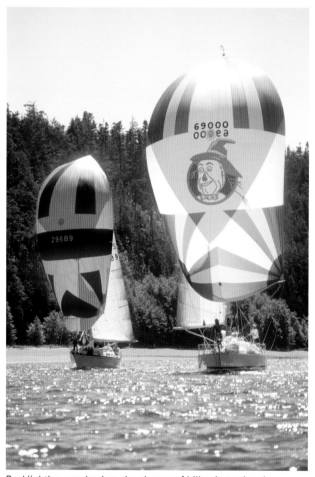

Backlighting emphasizes the shapes of billowing spinnakers during the annual Oak Harbor race week in Washington State. Nikon FE2, Fujichrome 100, 300mm f2.8 lens, 1/500 at f8. © Peter Skinner

viewfinder or in some cameras in other selected areas of the scene. Spot metering is very handy when measuring light reflecting from a small, important part of the picture. It is useful in backlit situations when you want to determine exposure on a specific part of the main subject. Once mastered, spot metering is a powerful and creative tool.

Understanding Basic Daylight Exposure—The Sunny f16 Rule

With experience, photographers learn to get a feel for the intensity of light. They know what their meters should be telling them and base their exposure accordingly. There are ways of getting it right without having to rely on your meter. A traditional and useful rule of thumb for determining exposure is the sunny f16 rule, or basic daylight exposure (BDE), and it's relatively simple. Under bright sunny conditions, set your aperture on f16 and use the reciprocal of your ISO as the shutter speed. So, if your ISO setting is 200, the BDE will be f16 at 1/200 sec., or any other aperture/shutter speed combination that gives you the equivalent— such as f11 at 1/400 sec., f8 at 1/800 sec., and so on. BDE is an excellent reference point if you're faced with tricky lighting conditions or are photographing scenes with highly reflective surfaces such as beach or snow.

If you're going to be photographing under the same conditions for a long time at a stretch, you can dial in exposure compensation if your camera facilitates this. So, if you were photographing in the aforementioned beach or snow conditions, dial in a one-and-a-half or two-stop overexposure. That would result in your meter reading at about f16 at 1/200 sec. rather than the f32 or thereabouts that it would do otherwise. Conversely, if you were photographing in conditions with a lot of dark surroundings, the meter would want to give you a larger aperture, say f11 or f8, and your images would be overexposed and washed out. Going the other way from compensating for bright scenes,

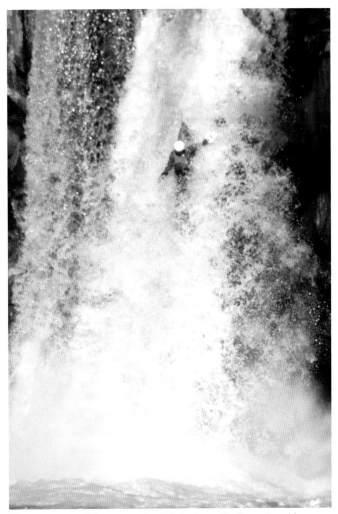

The raw power of these massive falls is dramatically captured in this heart-stopping shot. Canon EOS 1N, 70–200mm f2.8 lens, Fujichrome Provia 100, 1/500 at f16. © Bob Woodward

you could dial in compensation to underexpose by an f-stop or two and get a more accurate exposure. If you are familiar with BDE, alarm bells should go off in your head when your meter gives a reading that seems out of line. Just remember to reset the exposure compensation dial to zero once you've finished shooting that scene. Also, keep in mind that under cloudy or other conditions, you will have to adjust exposure. Under cloudy conditions with even lighting, your meter will probably be very accurate but do check its reading.

Exposure Based on BDE

Once you've grasped the fundamentals of BDE, you can determine exposure based on the variation of lighting conditions from basic daylight. The following guidelines were established many years ago by the faculty of the prestigious Brooks Institute of Photography in Santa Barbara, California, where I worked for about nine years; I still refer to this information.

Approximating Middle Gray

You can also determine exposure by taking a meter reading of a subject with neutral tones. An 18 percent gray card, available from photographic stores, is ideal. Or you can simply focus on something like a brick wall, a green shrub, or some other foliage with middle tones—not too bright or dark—and use the meter's reading. A piece of clothing or the back of your hand (depending on how tanned you are!) can also approximate 18 percent gray and help determine exposure. Just make sure the light falling on your subject is the same as that illuminating your test object.

A method I often use to get a reference point when photographing outdoors is to take a reading from an evenly lit patch of blue sky. This is especially useful when photographing water sports—surfing or sailing and other water sports where a lot of light is being reflected, which could confuse the meter.

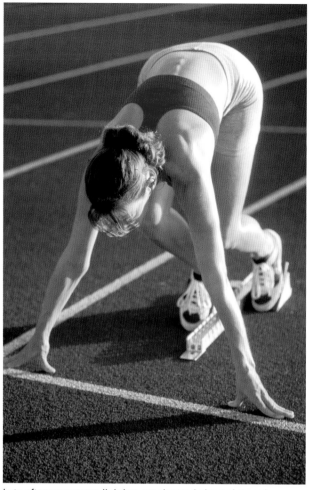

Late afternoon warm lighting, an elevated viewpoint, and incorporating the lines of the track make this shot of the start of a sprint. Nikon F100, 70–200mm f2.8 lens, ISO 100 film, 1/500 at f4.
© Mark A. Johnson

SITUATION	EXPOSURE WITH ISO 200
Sunlight—normal subject in sunlight	Use BDE f16 at 1/200
Sunlight—for silhouette effect, shooting into sun	Use 2 f-stops less—f32 at 1/200
Sunlight—bright snow, sand	Use 1 to 1.5 f-stop less—f22/f16.5 at 1/200
Sunlight—backlit subject, exposing for shadow area	Use 2 f-stops more—f8 at 1/200
Overcast—weak, hazy, very soft shadow	Use 1 f-stop more—f11 at 1/200
Overcast—normal, cloudy, bright	Use 2 f-stops more—f8 at 1/200
Overcast—heavy or open shade	Use 3 f-stops more—f8 at 1/200
Night football, baseball, races, track meets, boxing, basketball, hockey and so on	Use 6 f-stops more—f2.8 at 1/100 or 7 f-stops more—f2.8 at 1/50

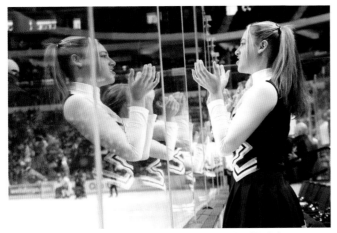

Light bouncing off the ice and reflections in the Plexiglas contributed to a tricky lighting situation. Bruce Kluckhohn used strobes to photograph this Hibbing High School cheerleader but later added another two-thirds of a stop in Photoshop to get it just right. Canon 1D, ISO 200, 35–350mm f3.5/5.6 lens at 63mm, 1/500 at f5.6, strobes. © Bruce Kluckhohn

Quality and Direction of Light

Equally as important as the quantity of light, and more so for the aesthetic value of an image, are its quality and direction. Quality can be described as soft or harsh, diffuse or direct, warm or cold, and so on. Environmental portrait and nature photographers say the best times of day to photograph are early morning and late afternoon when the light is warmer and softer—they're right. You will not always be lucky enough to have optimum light quality while shooting sports—unless you are working with athletes in outdoor settings such as snow skiing or surfers at sunset—but you can take advantage of the quality of light by being aware of it.

Direction of light is also important and while covering sports often means taking the light as you find it, position yourself to make the light work for you. Try to avoid photographing when light is directly overhead, as this will cast unflattering shadows on people's faces.

Most stadiums or indoor sports facilities, especially the better ones that cater to television coverage, will have lights placed around the field, giving reasonably even illumination. High school gymnasiums and other facilities might not be well lit but in general, today's indoor sports facilities are illuminated sufficiently to allow photography.

(*Note*: The color temperature of light, especially in indoor facilities, also becomes a factor, as discussed in chapter 2.)

In the outdoors, daylight, or natural light, is the source and here are some directions of natural light to consider.

Front light: As the term implies, the light will illuminate the athletes from the front and the light source will be behind you. This is the safest form of lighting, giving full illumination with few side shadows. Because it is a safe light, it also means correct

Made for the cover of a running magazine to portray the essence of winter running, this image is enhanced by side lighting. Center-weighted metering determined exposure in the tricky lighting. Canon EOS 1N, 100mm f2.8 lens, Fujichrome Provia 100, 1/500 at f8. © Bob Woodward

Streams of water are ripped from the surface as a triathlete surges out of the swim leg of his event. Note the backlighting. Nikon D1X, ISO 200, 80–200mm f2.8 lens, 1/640 at f6.3.
© Peter Skinner

Back light or rim light: This can be very effective and dramatic. Determining correct exposure for important details in shadow areas can be tricky. This is a good time to use through-the-lens, spot metering. Watch out for lens flare, caused by light coming straight into the lens; a hood is highly recommended. Use a lens hood or shade at all times, and especially when subjects are backlit. It's easy to get a silhouette effect with backlighting but unless this is what you're looking for, be aware that you have to open the aperture to compensate if you

The mood and feeling of backlighting is illustrated as dust comes off the trail in this mountain bike image. Canon EOS 1N, 70–200mm f2.8 lens, Fujichrome Provia 100, 1/500 at f2.8.
© Bob Woodward

exposure should be easily determined, allowing you to concentrate on capturing the action. This is probably the most-used light direction in sports photography.

Side or split light: This direction of light from the side will give stronger shadows and can create dramatic images if used correctly. Just make sure the shadows are not covering all key elements of the subject, such as the athletes' faces. Exposure will require careful attention, and you will have to determine which elements are important.

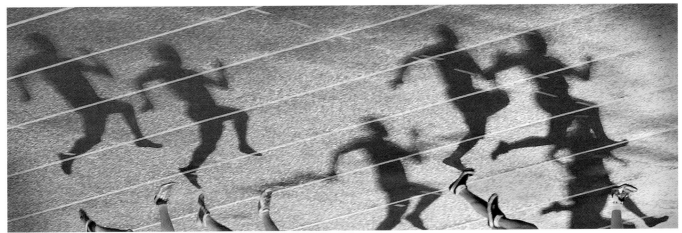

The drama of athletics is personified in a photograph in which the long shadows become the subject. Canon 1D, ISO 800, 200mm f1.8 lens, manual exposure, 1/4000 at f2.8. © Duane Hart

want detail on the front of the subject. Don't be afraid to experiment with backlighting.

USE THOSE SHADOWS

Shadows are an important element. They indicate the direction and intensity of light, and can set the mood for the entire image. You only have to study the work of master portrait painters—and photographers—to see how powerful the interplay of light and shadow can be. Similarly, when looking for different ways to portray sports, consider incorporating strong shadows into the picture. As well as strengthening visual aspects of the principal subject by drawing the viewer's attention to the lighter and brighter area of the picture—the human eye usually goes first to the lightest area of a scene before exploring the shadows— shadows can themselves be the subject. Learn to look for those shadows and make them an integral element of your composition.

Points to Ponder

- Familiarize yourself with techniques and meters to determine accurate exposure.

- Apply the sunny f16 rule.

- Experiment with and master the different exposure modes in your camera's metering system.

- Learn how to "see" light: its intensity, quality, mood, and direction.

- Strengthen your composition by incorporating shadows.

CAPTURING THE ACTION

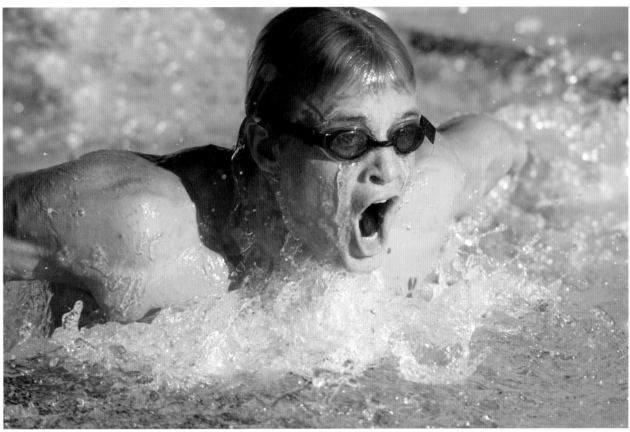

Australian butterfly swimmer Pierce Hardy of Caloundra, Queensland, powers to the end of the pool. Swimmers are best photographed as they burst above the water. Nikon D1X, ISO 200, 300mm f4 lens, 1/1000 at f5.6. © Peter Skinner

Virtually every day, we see great sports action photographs in newspapers and magazines. As the term implies, the photographers who made these images have truly "captured the action." Because we see them so often, it can be easy to overlook the skill and talent involved in producing these attention-grabbing photographs. While luck might be involved in making great sports shots, invariably, luck favors the photographer who knows what to expect, and is well prepared to capitalize on that fleeting, never-to-be-repeated moment when something extraordinary happens.

The dramatic image of a skier leaning into a turn after coming over a crest at break-neck speed was made because the photographer knew the exact spot where the move would be executed and was prepared for that definitive shot of a climactic moment. Just before it happened, the photographer reacted as skillfully and professionally as any well-trained athlete who rises to the occasion at a critical

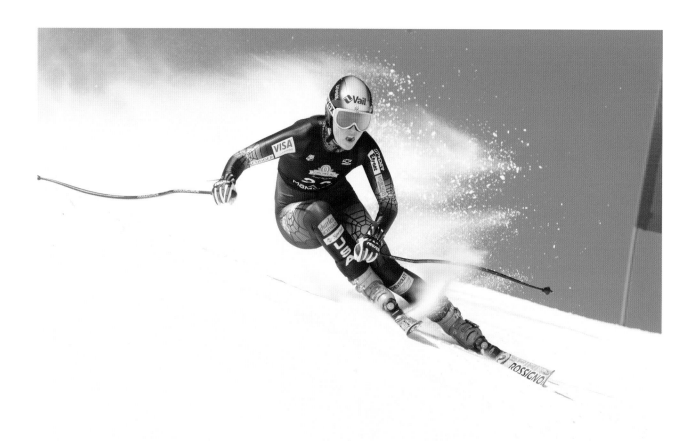

Pre-focusing on a spot and anticipating the peak of action is part of a successful formula for Brian Robb. Here, downhill skier Lindsey Kildow, USA, competes in the 2005 U.S. alpine championships at Mammoth Mountain, California. Canon ID Mark 11, ISO 160, 300mm f2.8 lens with 1.4X extender, 1/1300 at f7.1. © Brian Robb

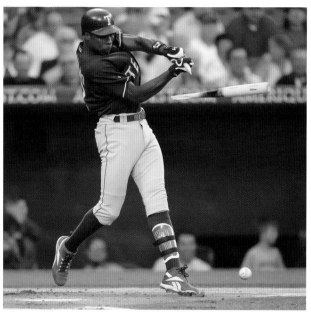

When Texas Rangers second baseman Alfonso Soriano broke his bat, Ben Chen was quick to freeze the action. Canon 1D MKII, 400mm f2.8 lens, ISO 1600, 1/3200 at f2.8. © Ben Chen

time. In about the time it takes to blink, the moment was over, but it was captured in a photograph.

In many ways, sports shooters are not too different from the sportsmen and -women they photograph. Athletes are competitive, and so are top sports photographers. Being prepared, whether you're an athlete or a photographer, is paramount. Nothing out of the ordinary might happen, but when it does you might miss it if you are not ready.

Location, Position, and Planning

There is no right or wrong way to shoot sports. It's an individual choice based on your own vision, creativity, what you're trying to portray, and to a large extent the access you can get to the action. Most sports are better photographed from specific

Nobody knew this young Australian hurdler's shoe would fly off his leading foot but Duane Hart timed it perfectly. Being prepared is vital in making shots like this. Canon D30, ISO 100, 200mm f1.8 lens, pattern metering, 1/1250 at f3.5. © Duane Hart

spots or angles of view, and knowing a sport will help you choose the ideal locations. If you're covering a sport such as football, baseball, tennis, or any other game where the boundaries are defined, positioning yourself is dictated to a large extent by the way the game is played and the area most likely to produce the shots you're after.

Presuming you are familiar with the sport and know the best angles to shoot from—or conversely, viewpoints to avoid—you still need to plan ahead. Some things might seem basic and logical, but it's surprising how overlooking details can sabotage your efforts. Covering outdoor events that are spread over a long course such as a cycling road race, marathon, triathlon, cross-country ski race, or white-water kayaking requires special planning. Scouting ahead of time is vital. And have a shot list for specific pictures. This can save you trying to cover everything. Other images apart from the ones you plan will present themselves—they are a bonus for sound preparation.

Know the course and the best vantage points. Keep in mind the time of day, the angle of the sun, and how long that spot is likely to be well lit. Ask officials about the course layout. These people want coverage of their events and will probably do what they can to help you but don't leave the

approach to the last minute! Also, ask whether and when access to any part of a course might be closed. Rushing to a great location only to find it is off limits would be frustrating, to say the least.

Once you've selected the best vantage spots, get the approximate times that athletes will get there after the start and how many circuits will be made. An elevated vantage point can be

Getting the ball on the racket is a key to great tennis shots like this one of Maria Sharapova powering into a backhand stroke. A long lens isolated her from the background. Canon 1D MKII, 300mm f2.8 lens, ISO 800, 1/2700 at f2.8. © Ben Chen

handy and you can even take your own, such as a small, lightweight stepladder, an aid that Bob Woodward uses often.

The finish of an event is usually the most crowded part of the course—with spectators and other photographers. So, if you're hoping for a shot of the winner crossing the line, be prepared to get there early and wait. If you want a varied diet of images, you are better off out on the course.

The Peak of Action

Sports provide a multitude of great subject matter but perhaps most typical are the peak-of-action shots made at just that right instant—the decisive moment—when all the elements of a phase or play come together. Often this happens when the subject or a ball is between the rise and fall of a movement and can be caught with a slower shutter speed. For example, a basketball player momentarily suspended before slam-dunking the ball may be moving slowly enough to be photographed at 1/125 sec. A shot

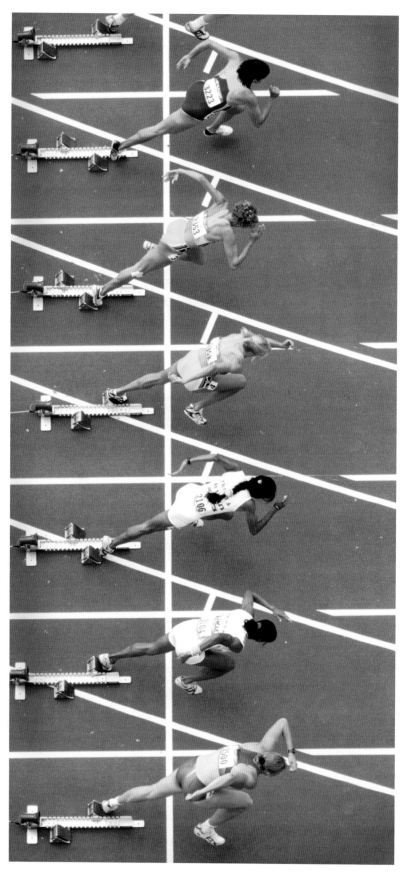

taken just before that, as the player rises to the net, might need a shutter speed twice as fast.

The difference between that peak of action and a split second before or after it can be the difference between a good shot and a great one. Peak-of-action shots usually are the result of several factors, not the least being the photographer's intimate knowledge of the sport, accurate focusing, his or her sense of timing and anticipation, and having the presence of mind to press the shutter just before the action. Taking the shot as it happens will almost definitely result in an "after the event" picture—a good one, perhaps, but not a great one.

Essentials to Capture the Action

Be in the right position and use a focal length sufficient to isolate the principal subject matter. The shutter speed should be fast enough to freeze the action but some blurring on the outer part of the shot—feet or hands or a ball—can enhance the shot. Usually a shutter speed of 1/500 sec. or faster is needed, especially if a telephoto lens is used. Use the widest aperture possible. This has two advantages: 1) the shallower depth of field of a wide aperture will help throw a potentially distracting background out of focus and 2) you will be able to use a faster shutter speed, reducing the chances of camera movement.

Depending on the ISO setting—either the film speed or the ISO setting

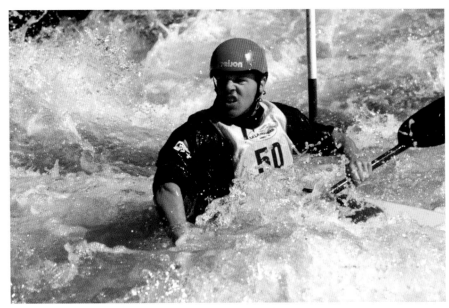

The intensity of kayak slalom racing is captured as the racer passes upstream through the gate and starts to look downstream to his next gate. Canon EOS 1N, 70–200mm f2.8 lens, Fujichrome Provia 100, 1/250 at f16. © Bob Woodward

either succeeding with a typical play, or shooting the peak of action as the opposing team thwarts the play. Knowing the players' style and habits gives them an edge. All athletes, Little Leaguers, high school players, Olympians, and even older sportsmen and -women in the growing ranks of senior

A wireless remote camera mounted behind the backboard was used by Ben Chen to catch this brilliant shot at the hoop as California Baptist University player Pete Rajniak of Luxembourg gets the two-pointer. Rajniak, a college standout, went on to play professionally in Spain. A wide-angle lens ensured sufficient depth of field to maintain sharpness throughout. Canon 1D, 16mm f2.8 lens, ISO 1000, 1/400 at f2.8. © Ben Chen

on a digital camera—you should aim for an exposure in the range of 1/500 sec. to 1/1000 sec. at f4. Of course, if you have an f2.8 lens, use that aperture and the corresponding shutter speed.

Timing, Anticipation, and Knowing the Athletes

These come with knowledge of the sport and being aware of what's likely to happen. Diane Kulpinski points out that knowing the flow of the action, not necessarily all the rules, is critical to capturing good images. "That way you have a good idea of where peak action is likely to occur and what it will look like," she said.

And it pays to know not only the sport but its participants. Most athletes have habits or a style that make it easier to anticipate their next move. Team coaches and managers study films of their opponents ahead of matches to plan how to counter specific moves or players. Leading professional sports photographers do much the same thing, even if for different reasons. They want to capture the action of that athlete

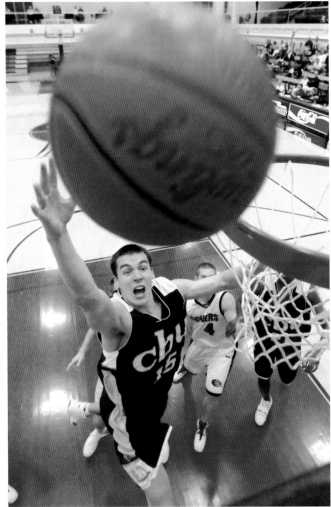

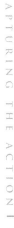

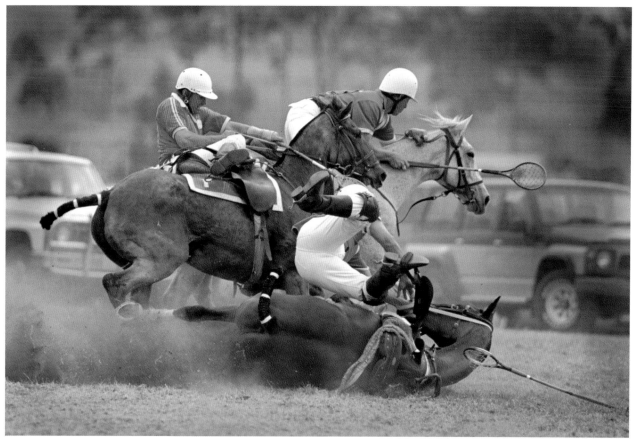

Being ready for any eventuality was key to getting the shot of tumbling ponies and polocrosse players hitting the turf. Nikon 801, 300mm f2.8 Tamron lens, manual focus, Fuji 800 film, 1/1000 at f2.8 © Duane Hart

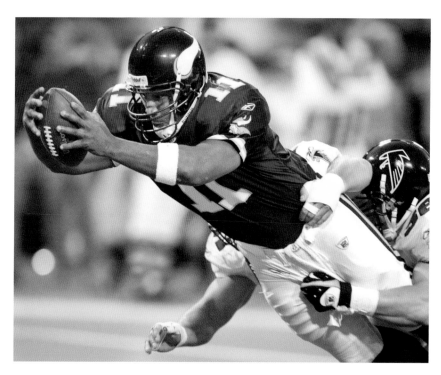

Daunte Culpepper of the Minnesota Vikings valiantly dives for the end zone. Bruce Kluckhohn anticipated and captured the action. Canon 1D, ISO 800, 400mm f2.8 lens, 1/500 at f2.8, available light. © Bruce Kluckhohn

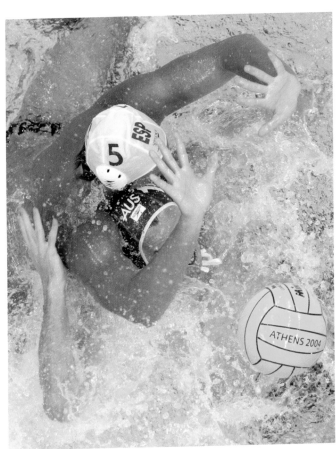

A great example of an overhead view adding another dimension to sports photography. Arms and hands flail and water boils as Spanish and Australian water polo players contest possession at the 2004 Athens Olympic Games. Canon 10D, ISO 800, 200mm f1.8 lens, pattern metering, 1/1000 at f2.8. © Duane Hart

lens has a medium telephoto focal length when fully extended. With any compact camera—and this can be applied to auto focus SLRs too—as you prepare to take a shot, depress the shutter button to lock focus where you think the action will happen and then just prior to that anticipated peak action, press it all the way. And as pointed out in chapter 1, shooting in the *continuous* mode to get a sequence of images when the shutter-release is pressed, can compensate to some extent for shutter lag. Coping with the point-and-shoot camera's technical shortcomings will be a challenge, but not an insurmountable one. Mastering your camera's manual mode—if it has that capability—will also improve your chances of success, as the camera's response will be faster.

Shooting in Artificial Light

If you're using film in artificial light, the simplest approach is to load up with fast negative film, something on the order of ISO 800 that can be push-processed. If you're using a digital camera, Bob Woodward offers this advice: 1) Set the appropriate

competitions have their individual style.

Bill Hurter, editor of *Rangefinder* magazine and a former sports photographer, advises that a good rule of thumb, in addition to knowing a sport, is to never take your eye off the ball or puck or action, especially when shooting sports such as baseball, basketball, football, ice hockey, or tennis at the pro level. There's always the chance you or your camera will get hit, as has happened to him.

Point-and-Shoot Cameras

Serious sports photography is the domain of SLR cameras with interchangeable lenses, but compact point-and-shoot cameras can be effective in making sports photographs, especially if your camera's zoom

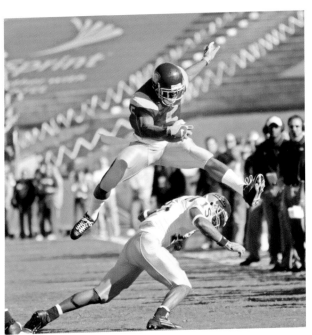

USC Trojans tailback Reggie Bush hurdles a University of California, Los Angeles (UCLA) defender on his way to a touchdown. Background color strengthened the image. Canon 1D, 280mm lens, ISO 200, 1/2000 at f4. © Ben Chen

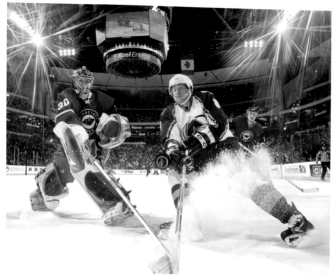

This powerful shot of Dwayne Roloson of the Minnesota Wild and Teemu Selanne of the Colorado Avalanche going for the puck, in a St. Paul, Minnesota, game was taken from a remote position in the dasher board, slightly above ice level and through lexan. The camera was triggered by a radio unit. Canon 1Ds, ISO 200, 17–35mm f2.8 lens at 17mm, 1/500 at f5.6. © Bruce Kluckhohn

ISO speed for the light, or lack thereof. 2) Using that speed, make test images with all the pre-set white balance settings and see which produces the best color. Experimentation is possible with digital, so test before a shoot.

And if you're having trouble getting the correct white balance from mixed artificial lights and your test pictures have strange-looking colors, consider setting your digital camera to black and white. (*Note*: An excellent tool for determining white balance is the ExpoDisc, *www.expodisc.com*.)

Bruce Kluckhohn, team photographer for the NHL's Minnesota Wild, and also the Minnesota Twins, cautions that stadium lights reflecting off the ice can fool camera meters, so be careful not to take a reading off the ice and thus underexpose your photographs. Take a meter reading off a gray card or some object with middle tones to select exposure.

Focusing Skills

First and foremost, pay attention and stay focused—both mentally and through the lens. Keep your lens focused on your subject or the area in which you anticipate peak action. Your focusing skills should be finely tuned, using either

manual or auto focus. Auto focus in modern cameras is fast and accurate, but you will have to decide what AF sensor position you use. Some auto focus cameras sensors are in the center of the viewfinder, but many cameras have multi-sector auto focusing, allowing the photographer to choose what area of the image is in focus. The skill is in being able to compose your shot with that sensor on the subject.

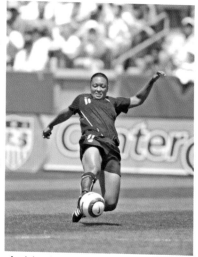

Anticipation and tight framing contributed to the success of this shot of U.S. national soccer team player Angela Hucles advancing the ball. Canon 1D, 400mm f2.8 lens, ISO 100, 1/3200 at f2.8. © Ben Chen

Many pros still prefer manual focus, especially if they are concentrating on a particular area of a field—such as the goalmouth in a soccer match or a base in a baseball match. Auto focus is very handy if players are running towards you, although pros adept with manual follow focus often use that method for this situation too.

Most cameras have automatic film advance, with more sophisticated models offering rapid

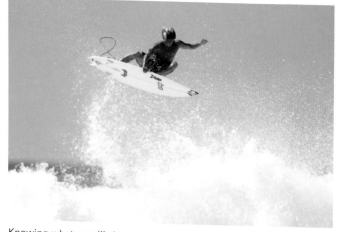

Knowing what was likely to happen was key in getting the shot of a high-flying surfer performing a rail-grab maneuver. Canon 1D, 800mm f5.6 lens, ISO 200, 1/2000 at f5.6. © Ben Chen

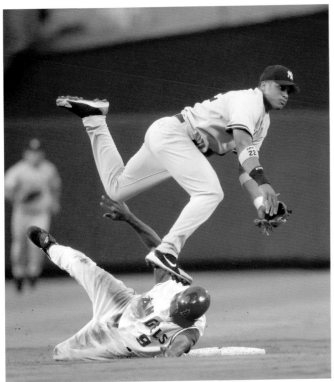

High-flying action in an Angels and Dodgers game was captured for posterity. Canon 1D MKII, 400mm f2.8 lens, ISO 1600, 1/2000 at f2.8. © Ben Chen

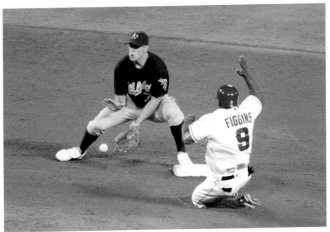

Los Angeles Angels third baseman Chone Figgins steals second base against the Oakland Athletics. Anticipating play resulted in getting the shot. Canon 1D MKII, 400mm f2.8 lens, ISO 1600, 1/2000 at f2.8. © Ben Chen

advance and several frames per second. This allows the photographer to concentrate on shooting, rather than having to cock the shutter and advance film. It also facilitates sequences of athletes in action. However, experienced pros often don't rely on firing a burst of images to capture peak action. Nor should you rely on a sequence of shots to get that climactic image. Anticipate the moment, and be selective.

Developing and improving focusing skills requires practice—lots of it. Whether you are going to use manual focus or auto focus, you need to know your skills and the camera's capabilities. A good way to practice—even if you are likely to get a few strange looks—is to photograph moving cars. Stand beside a busy street and focus on cars coming at you, as they go by, and going away. Simply getting the feel of composing and focusing on moving subjects is good practice—with or without taking a picture. With a digital camera, you can see the results immediately.

Slow Shutter Speeds and Panning the Action

An excellent way to accentuate speed and motion is to use slow shutter speeds that result in some blurring of the subject. Another way to give the feeling of speed is to pan the camera as the athlete goes by. The background will be blurred, making the subject stand out and emphasizing the feeling of speed while adding impact to the photograph. Also, the blurring of detail in many panning shots makes them timeless—that is unless you can spot a detail such as a piece of equipment, perhaps a snow ski, that dates an image—and thus always

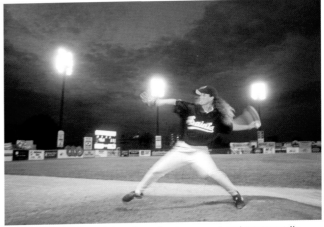

The blur of the pitcher's hand emphasizes speed and power as Ila Borders warms up for the St. Paul Saints. Canon, ISO 100 Fujichrome film rated at ISO 200, 17–35mm f2.8 lens, 1/160 at f2.8. © Bruce Kluckhohn

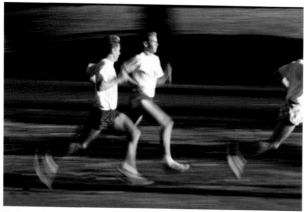

A slow shutter speed and panning with the athletes emphasizes the feeling of speed in this shot of high school cross-country runners. Canon EOS 1N, 70–200mm f2.8 lens, Fujichrome Provia 100, 1/60 at f22. © Bob Woodward

with the principal subject(s) in the viewfinder and follow them. Take the photograph just before the subject reaches the focus area—anticipate the action. And keep panning the camera after you've made the shot. In sporting terminology—follow through. Rotate your body with the movement of the subject, press the shutter, and keep panning. If you simply press the shutter and stop panning, the chances are the subject will be blurred or will have moved out of the frame.

When panning, use a relatively slow shutter speed, even as slow as 1/15 sec., and therefore a smaller aperture, which will increase the depth of field. A slower shutter speed will also result in fast-moving extremities being blurred, thus emphasizing speed and motion. Experiment with a combination of shutter speeds and apertures. Try panning and blurring different elements of the subject, such as athletes' legs.

have that contemporary or "now" look about them.

Some tips on panning the action are: Pre-focus on a spot you know the athletes—or whatever the subject is—will go by. As they approach, compose

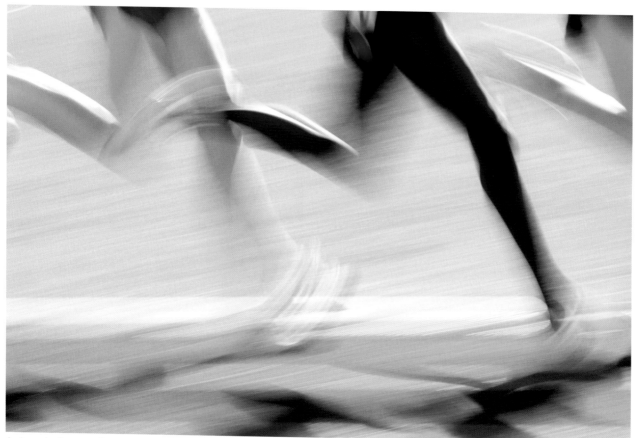

A slow shutter speed, panning with the runners, and using a long lens for a tighter composition helped create this "running legs" shot. Nikon FE 2, Ektachrome 100, 300mm f2.8 lens, 1/30 at f22. © Peter Skinner

A slow shutter speed accentuated the speed of the spinning skater, and a long lens isolated her from the background. Nikon FE2, Fujicolor 800 rated at ISO 1600, 300mm f2.8 lens, 1/60 at f8. © Peter Skinner

Different Lenses for Different Looks

What lenses you use will be determined by how close you can get to the action and what kind of pictures you hope to shoot. The range of lenses available is huge, from fish-eye lenses that take in 180 degrees of view, or in some cases even more, to super-telephoto lenses that require very sturdy tripods to use efficiently. These extreme focal lengths are necessary tools for specific kinds of images but in general are not necessary to meet most photographers' needs. The following guidelines

show how to take advantage of the most commonly used lenses.

Wide angle: These are ideal for getting in very close and creating images with greater depth of field—that is, in focus from the front of the image to the back. This forced perspective can add interest and impact to the photograph. Also, an image made from down low with a wide-angle lens—a ground-level viewpoint—creates a more dynamic, unusual perspective and can turn an otherwise ordinary or mundane picture into an eye-grabber. Don't overlook the potential of wide-angle lenses for portraiture either. Position the subject so he or she is surrounded by the paraphernalia of the sport or has a background that identifies the sport.

A slow shutter speed and panning with the fast-moving board contributed to the impact of this shot made in a lagoon in Moorea, French Polynesia. Nikon N90S in a housing, 35–135mm lens, ISO 100 film, 1/30 at f22. © Mark A. Johnson

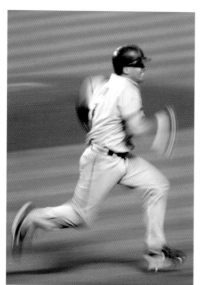

A slow shutter speed accentuated motion as Houston Astros second baseman Craig Biggio raced for first base. Ben Chen got the shot; Biggio was out! Being able to change the ISO (film speed) for individual shots is a great advantage of digital photography. Canon 1D MKII, 400mm f2.8 lens, ISO 50, 1/25 at f2.8. © Ben Chen

Zoom lenses: Lenses in the 70–200mm range are probably the most used by sports photographers. In addition to providing the advantage of a range of focal lengths, zoom lenses can be used for zooming while taking a longer exposure, creating an interesting effect. A fast zoom lens with a constant aperture throughout the zoom range is best but will be more expensive than one with a variable aperture.

Telephoto lenses: Longer lenses, 300mm and up, get you closer to the action. They are most effective when used at full aperture to isolate the subject and throw distracting backgrounds out of focus. They narrow the angle of view, also helping to isolate the principal subject and fill the frame. Because of their shallow depth of field, long lenses demand accurate focusing.

The Direction and Speed of the Action

If you follow the suggestion to practice photographing moving cars or any other subject in motion, keep in mind that the shutter speed needed to stop the action will depend on the direction the subject is going relative to the frame of the photograph. A subject going by you will move much more quickly across the viewfinder than one either coming straight at you, or at an angle either away from, or towards, you. Another factor is the

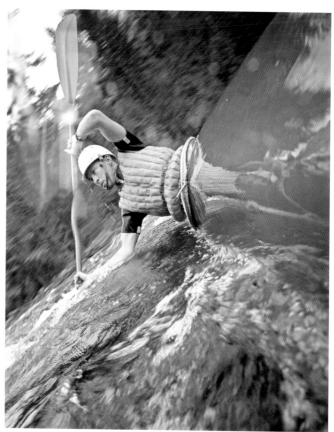

A white-water kayaker nears the tipping point on the Upper Hudson River Gorge, the moment captured with a remote-controlled camera (customized by the well-known Marty Forscher) mounted on the kayak. The image was featured in a *Life* essay on kayaking. Motorized Nikon F (in waterproof housing) 20mm lens, Ektachrome film, 1/250 at f5.6. © Bob Gomel

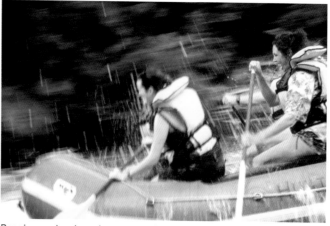

Panning and a slow shutter speed accentuate the thrill and fun of white-water rafting. Canon EOS 1N, 100mm f2.8 lens, Fujichrome Provia 100, 1/60 at f8. © Bob Woodward

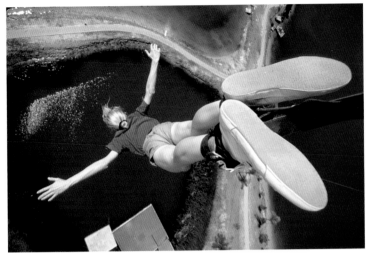

Because of safety reasons, the bungee jumper at a Gold Coast facility in Australia couldn't actually leap with a camera attached to a rope to fall with her. The camera with a 16mm fish-eye lens was mounted on the platform and triggered remotely as the "jumper" swung into mid-air. Nikon F100, ISO 100 film, 1/250 at f8. © Mark A. Johnson

of 1/1000 sec. or thereabouts. (*Note*: When any subject is going by at speed, panning the camera with the movement is suggested. When panning, a slower shutter speed is possible, but some blurring of extremities will probably be evident.)

Shoot Economically to Save Film or Card Storage

distance the subject is from the camera—the further away, the slower the shutter speed you can use to stop the action.

As an example, an athlete running straight at the camera could be "stopped" with a shutter speed of 1/250 sec. The same athlete running at a three-quarter angle by you could be stopped at 1/500 sec.; and running straight by you, would need a shutter speed

Built-in rapid film advance and auto focus operation make it possible to shoot hundreds of pictures in quick fashion. That's an advantage at times; in fact,

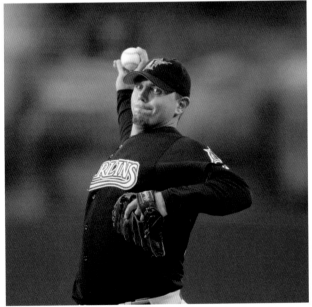

Looking down the barrel as Florida Marlins pitcher Brian Moehler unleashes. A fast shutter speed and shooting wide open isolated Moehler from the background. Canon 1D MKII, 400mm f2.8 lens, ISO 1600, 1/3200 at f2.8. © Ben Chen

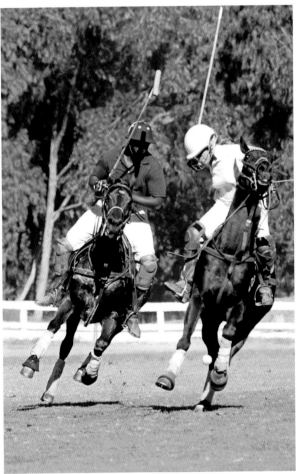

Polo players thundering head-on towards the camera were "compressed" with a long lens. Canon 1D, 300mm f2.8 lens, ISO 400, 1/500 at f8. © Ben Chen

professionals often shoot hundreds of images at an event, but their needs are different from the average amateur's. Keep in mind that a large quantity of pictures creates a lot of extra and perhaps unnecessary work after the event. How much time do you want to spend going through prints or slides or editing images on a computer? Being more selective, choosing your targets carefully, and shooting only when the chances are better that you will get what you want, may be a better tactic. If players become too small in the viewfinder, don't shoot. If you're using digital equipment, you can also edit in the field and delete images that don't look good.

Panning the motion created this stunning shot from the water of a jet ski rider leaning into a tight turn at Goleta Beach, near Santa Barbara, California. Nikon FM2, 50mm f2 lens, ISO 100 film, 1/60 at f/16. © Mark A. Johnson

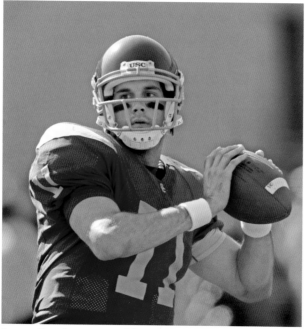

An excellent "sports portrait" was made as USC Trojans quarterback Matt Leinart warmed up. A long lens isolated Leinart from the background. Canon 1D MKII, 400mm f2.8 lens with 1.4X extender, ISO 200, 1/1300 at f4. © Ben Chen

Faces Are Important

Athletes' faces and their emotions are the stuff of good sports photography. Facial expressions rate near the top of criteria for winning shots, and if you can consistently combine the action with great expressions, you're doing just fine. Generally,

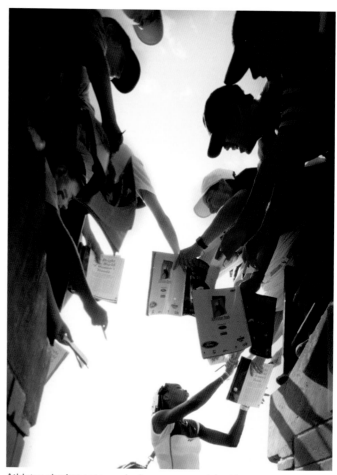

Athletes signing autographs is a common sight. Not so common is a dynamic and compelling image like this of Venus Williams keeping faith with fans. The moral: look for different angles of view. Canon 1N, 17–35mm f2.8 lens, Fuji Sensia slide film, exposure not recorded. © Duane Hart

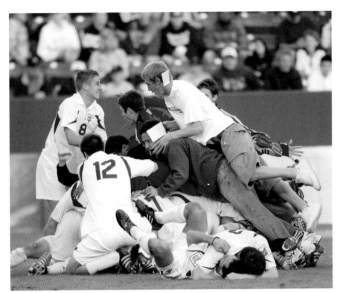

Jubilation abounds as the Indiana University Hoosiers soccer team celebrates after winning the 2004 NCAA College Cup. Canon 1D, 400mm f2.8 lens, ISO 640, 1/1600 at f2.8. © Ben Chen

photographs of athletes moving away from you will not have the desired impact, so don't waste time photographing them. Better to have the subject coming towards you or presenting a three-quarter view.

Game's Over—Keep Shooting

The final whistle or match winning point might mean the contest is over for the athletes—but not for photographers. When the game ends, the jubilation and dejection images—players or fans celebrating a win or looking downcast after a loss—are likely to appear. Look for those great reactionary shots from players, coaches, benches, or fans, and if you can get in close, use a wide-angle lens to capture the post-game excitement.

It takes a cool head to maintain focus when mayhem erupts all around you after a game has ended—especially a close result in a major contest—but being able to do that is key to getting those great shots. So, regardless of the event, get prepared before the game ends.

Shooting Different Sports

Let's take a look at photographing different sports. Obviously, there are far too many to include every

game ever played. Just keep in mind that the technique and equipment used to photograph a particular sport can be applied to others and at all levels—professional sports or Little Leagues. The best advice in all of this is go and shoot—learn by actually doing it.

Baseball: The first base side is a favored angle for shooting baseball as the third baseman, shortstop, and second baseman all face you

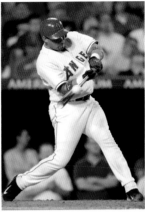

Los Angeles Angels catcher Bengie Molina swings and hits, and Ben Chen got the shot. Canon 1D MKII, 400mm f2.8 lens, ISO 1600, 1/2000 at f2.8. © Ben Chen

to make a play at first. Also, the stolen base—first to second—happens right in front of you. Even at amateur or Little League baseball games, this location is still the best. Long lenses, 300mm and up are often needed—many pros shoot with 600mm lenses—especially if you are trying for head-on shots of the pitcher. Diane Kulpinski, who shoots a lot of youth baseball, tends to favor a 300mm lens, at times with a 1.4X tele-extender. And she always uses the auto focus feature.

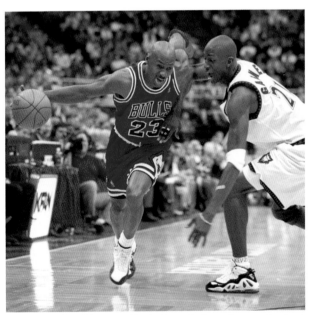

Michael Jordan drives past Kevin Garnett, the action emphasized by the front-on view and low angle, shot with a 70–200mm f2.8 lens. Fuji ISO 800 speed negative film pushed one stop, 1/500 at f2.8. © Bruce Kluckhohn

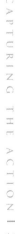

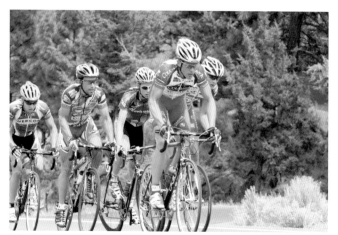

Bob Woodward stood on a small stepladder for a better angle as cyclists reached the top of a rise. Canon 20D, 70–200mm f2.8 lens, ISO 100, 1/250 at f8. © Bob Woodward

Basketball: The best vantage point is behind the basket on the floor. With a long lens, you can shoot the action at the opposite end of the court. When the players are at your end, you can switch to a shorter lens and get great action. Overhead shots, taken with cameras mounted above the net, give a dynamic look. Favorite lenses are in the 20–35mm f2.8, 24–70mm f2.8, and 70–200mm f2.8 range. Also often used are medium telephoto lenses, such as an 85mm f1.8. Youth basketball, which is less intense than the NBA and major college games, abounds in photo ops.

Cycling, road and track: Know the layout of the race route, the length of the race, and how many laps are involved. Scout the course ahead of time so you can pick the best vantage points. Bob Woodward likes shooting cyclists—and roadrunners—on an uphill section to better freeze the action and show the entire body. A small lightweight ladder can make the difference between a good shot and a great shot—it provides a different perspective. Look for road lines curving into the background—they can accentuate motion. If using digital equipment, edit on location during the event once the lead riders have passed. Bicycle racing on stadium tracks is exciting, fast moving, and provides repetitive photo opportunities because the track is oval and the competitors will go by numerous times during a race. A favored position is at a slightly elevated spot looking into a bend—use a long lens of around 200mm or

300mm. The inside of the track is also a good place to shoot from. Track cycling is ideal for panning and blurring techniques. Try the wide, medium, and long lens approach too, so you can capture the feel and aesthetics of the stadium before zeroing in on the action.

Field sports—football, hockey, rugby, soccer. Sports such as football, field hockey, rugby, and soccer are photographed with similar techniques and while each game is different, the following principles, in general, can be applied.

If you are not restricted to a box or seat and want to roam the sidelines, keep ahead of the action, so it will always be coming toward you. But you'll have to stay alert and make sure you don't

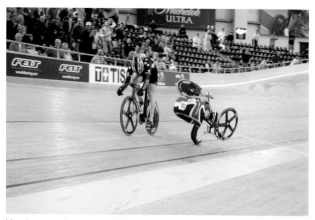

You have to be prepared for spills like this, as track cycling world champion Jamie Staff of Great Britain takes a tumble during the third round of the 2005 World Cup of Track Cycling in Los Angeles. Nikon D2H, ISO 400, 17–55mm f2.8 lens at 40mm, indoor ambient light, 1/200 at f3.8. © Steve Trerotola

get hit by the ball or players. Action moving away from you is usually a bad angle as all you will get are backs and uniform numbers. Kneepads might be needed—you might have to crouch in one position—as will a long lens and monopod. Pros usually carry two more camera bodies and a range of lenses from 20mm to 400mm. A lens in the 80–200mm range is always handy. Initially, see what you can get with just one lens rather than be overloaded with equipment. Rugby is free flowing without as many set plays as football, so keeping up with the game—or staying in one location near the try line (end zone)—is an individual choice.

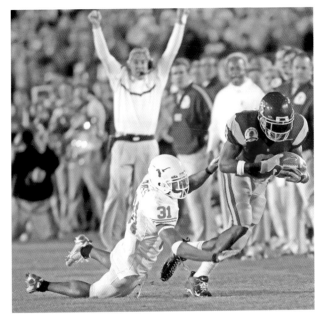

USC coach Pete Carroll reacts to Trojans receiver Dwayne Jarrett fighting to cross the end zone. Both the excitement of the action and the coach's emotional response were skillfully captured. Canon 1D MKIIN, 400mm f2.8 lens, ISO 1250, 1/800 at f2.8. © Ben Chen

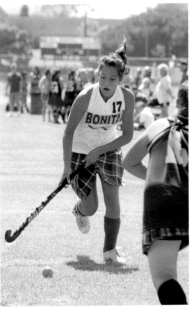

Shooting field hockey players head-on is one of the best ways to isolate the action. Nikon D2H, ISO 200, 70–200mm f2.8 VR lens, 1/320 at f8. © Steve Trerotola

Behind the try line is a good location, as players heading for the line will be coming straight at you. Predictable action is most likely to happen at lineouts when the ball is thrown back into play, and at scrums where opposing forwards contest the ball.

Soccer (internationally known as football) is a fast-flowing, end-to-end game where the players are constantly changing direction, so trying to run and keep up with the ball will probably be futile. A favorite spot is near a corner from where you can shoot action in and around the goal. Behind and to one side of the goal net is also an excellent vantage point. At times, you'll be frustrated because great action will be happening at the far end of the field. Be patient and prepared. The play will eventually come your way. In some cases, a 200mm lens will be adequate but a lens such as a 300mm, 400mm, or even longer is probably the better choice, especially if you want to isolate specific players or aspects of the game. As with all ball games, don't waste film or memory card space if the action is far away. Shooting field hockey is very similar to photographing soccer.

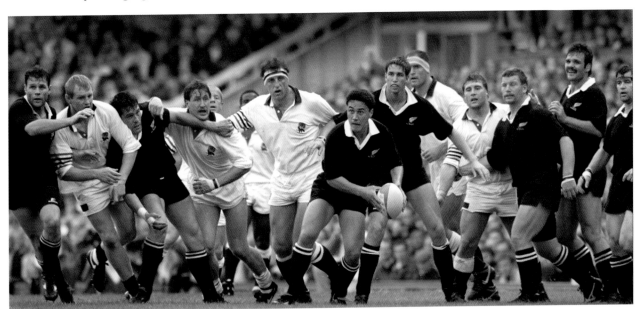

Rugby action often centers on the halfback, the key ball distributor, and shooting from a low angle emphasizes the play. Canon 1N, 400mm f2.8 lens, Fuji 800 film, 1/1000 at f2.8 © Duane Hart

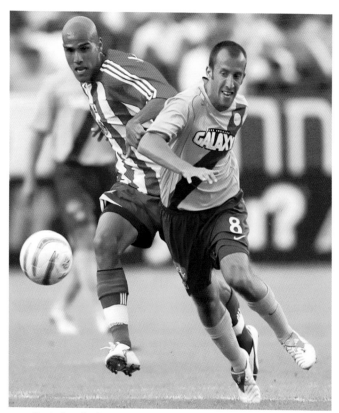

Capturing the intense struggle for possession during soccer matches is possible if you know the likely flow of play. Always try to include the ball in the shot. Canon 1D, 400mm f2.8 lens, ISO 800, 1/800 at f2.8. © Ben Chen

cope with artificial lighting. A zoom lens in the 70–200mm range would probably cover most events. An f2.8 aperture is recommended so you can use shutter speeds of 1/250sec. or faster.

Hockey: The NHL puts cutout circles in the Plexiglas for long lenses to stick through. And a wide-angle lens should be at hand, as sometimes the checks happen right on your pane of Plexiglas. Anywhere on the glass is a good angle in hockey. You can shoot through the Plexiglas, but auto focus can be problematic. Watch for that puck. You can see the checks coming, but the puck is usually traveling at very high speed. Leading hockey photographer Bruce Kluckhohn points out that amateurs photographing in high school rinks often face difficult lighting conditions if rink-side because they have to shoot through glass with inferior optical quality. The best vantage point, he advises, is from above the glass level so that the view is unobstructed and the entire background is ice. And use a long lens. At his home rink of the Minnesota Wild, Kluckhohn has hard-wired eight large Speedotron electronic flash units in strategic locations to provide consistent overall lighting. These are triggered remotely when he shoots from any location. He prefers to photograph the action coming straight at him, and his favorite lens is a 35–350mm f3.5/f5.6 Canon lens.

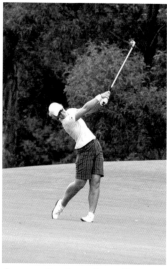

A competitor in an Australian LPGA event follows through after her approach shot from the fairway. A long lens and waiting until the shot is made avoids distracting golfers. Nikon D1X, ISO 200, 300mm f4 lens, 1/640 at f5.6. © Peter Skinner

Golf: Before venturing out to photograph golf, ask someone about correct etiquette. Avoid getting in the player's line of vision; use a long lens to reduce the possibility of camera noise distracting the player; wait until the shot has been hit to take the photograph. Good viewpoints are beside a fairway near where drives will land and second shots will be made; looking back at the tee box from the side; greenside; and near bunkers—sand erupting just after the shot can make for great images. Zoom lenses such as the 80–200mm are commonly used, as are lenses in the 300mm and 400mm range.

Gymnastics: Because of the numerous disciplines involved—such as vaults, balance beams, parallel bars, rings, and more—gymnastics provides a wide variety of photographic opportunities of repeatable activities. Events are held in a defined area so you can position yourself at one location knowing that you won't have to run the length of a field. Gymnastics are held indoors, so be prepared to

Ice skating: Follow the advice on shooting hockey. If shooting from the stands, a lens in the 200mm to 300mm range will probably be needed and a 300mm f2.8 lens on a monopod works well. Skaters will be more predictable in their movements than hockey players, so focusing will

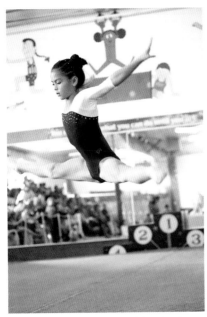

Split second timing and anticipation froze this young gymnast in action. Spot metering ensured accurate exposure. Canon 1D, 70–200mm f2.8 lens, ISO 1600, 1/320 at f2.8. © Ben Chen

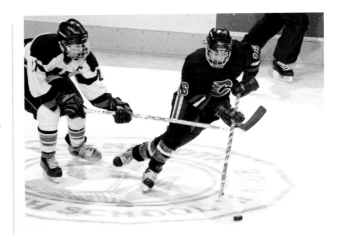

Action on the ice during a high school hockey tournament in St. Paul, Minnesota. Canon 1D, ISO 200, 35–350mm f3.5/5.6 lens, 1/500 at f6.3, lit with strobes. © Bruce Kluckhohn

be easier—and you don't have to dodge pucks.

Kayaking and canoeing: Generally the courses for flat-water kayaking and canoeing are set a considerable distance from the shore. That means you'll need a lens in the 400mm to 600mm range to capture the action that is best shot from a 45-degree head-on angle or from the side. A raised vantage point can also help. White-water kayaking offers virtually unlimited shooting possibilities. Great shots can be taken from the water level, from the riverbank, or high above the river and either head-on, from the side, or as kayakers descend rapids. You can also paddle and shoot from the water. If you do, use a wide-angle zoom lens and a portrait lens—and get a good waterproof camera container.

Motor sports: Regardless of the motor sport, the major consideration is safety—yours and the driver's. Never turn your back on the track because the vehicles that use it are very, very fast, and accidents can happen. Because track-racing means that the competitors will go by numerous times, you can plan the type of photographs you want and set up accordingly. A great spot is looking down onto a curve in the road to shoot vehicles as they go through the turn. With a long lens, you can really compress the picture. Above a straight-away, panning competitors as they go by, is another good vantage point and compact cameras can be used from here. Zoom lenses in the 70–200mm range and telephotos lenses up to 500mm are popular with the pros. Events such as motocross and other bike events where competitors go over

jumps and through tight bends provide great photo ops. Pick your spot, get ready, and stay out of the line of the race. Ask race officials about access to better and safer spots. At any motor racing event there's going to be dust, dirt, oil, and other potentially damaging matter floating around, so protect your equipment as much as possible.

Mountain biking: This sport lends itself to a range of lenses and allows shots from a variety of angles. It's also a sport where experimenting with pans and slow shutter speeds can produce some startling results. When going wide, consider doing a wide scenic shot with a small rider in the midst of it, or lying down beside the trail and shooting up on a rider to capture a canopy of trees and sky overhead.

Rock climbing: The best climbing shots are taken from a fixed rope hanging next to the route being climbed. The photographer works his or her way up and down the fixed rope with ascenders. A good wide-angle zoom lens is all you'll need if you shoot this way. Dramatic environmental shots can be taken from a distance with a 300–600mm lens to capture a climber or climbers clinging to huge rock walls.

Snowboarding: To shoot snowboarding in the half-pipe, go wide and get as close to the lip of the pipe as possible to catch the action as competitors launch upward. Advises Diane Kulpinski: "Get inside the fencing and in front of the crowd. Stay

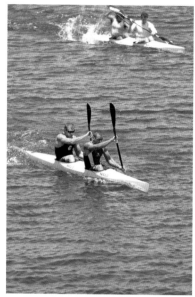

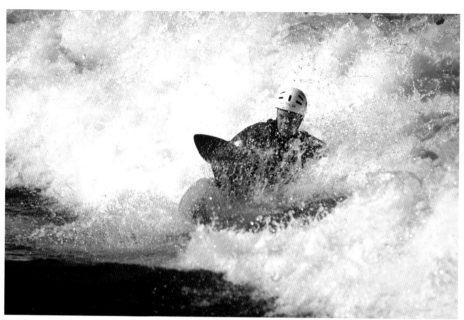

Shooting flat-water kayaking from an elevated position provides a good perspective and helps show the separation between competitors. Nikon D1X, ISO 200, 300mm f4 lens, 1/2000 at f5. © Peter Skinner

Surfing a kayak on a large river offers a wonderful contrast in elements as the kayaker heads for glassy water ahead. Canon EOS 1-N, 35–350mm f3.5/5.6 lens, Fujichrome Provia 100, 1/500 at f11. © Bob Woodward

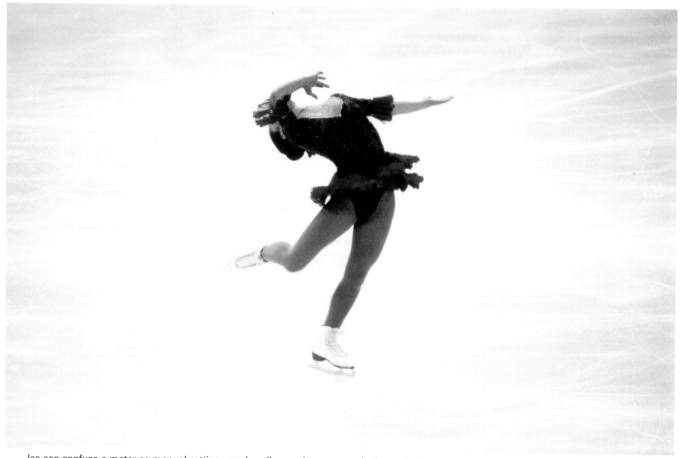

Ice can confuse a meter so manual settings work well once the exposure is determined. Nikon FE2, Fujicolor 800 rated at ISO 1600, 300mm f2.8 lens, 1/500 at f2.8. © Peter Skinner

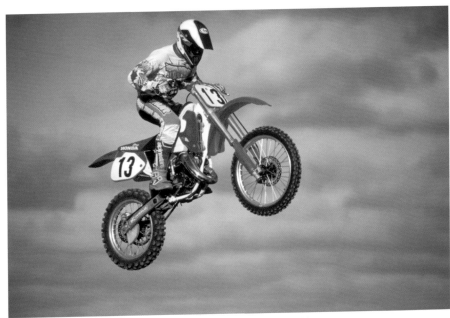

Any form of motor sports is potentially dangerous. A 70–200mm zoom lens and auto focus enabled photographer Mark Johnson to stay safe and make the shot on Kauai, Hawaii. Nikon F100 camera, ISO 100 film, 1/1000 at f4. © Mark A. Johnson

a terrain park calls for a combination of lenses from wide to long and knowing when the rider will go on the rail or for jumps.

Snow skiing: A normal 50mm lens—35mm film equivalent—is very useful for shooting recreational alpine ski action while including some of the environment. Compact cameras that fit easily inside a jacket are ideal. Fill flash can help illuminate shadowed faces.

Competitive alpine skiing requires a fast long lens and the 300mm f2.8 lens (often used low, so as not to obstruct spectators' views, so kneepads or something insulated to sit on and stay warm are advised. From about half or two-thirds of the way down the course, you can take advantage of using a long lens while the action is up higher on the course. Switch to a wide-angle as they approach your position. Depending upon lighting of the course, you may want to use a fill flash on the wide-angle shots." Shooting snowboarding in

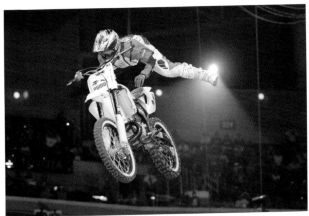

There's no second-guessing your technique for this kind of action. Motocross champion Chuck Carothers performs in the Moto X Best Tricks finals in Los Angeles. Canon 1D, 70–200mm f2.8 lens, ISO 500, 1/500 at f2.8. © Ben Chen

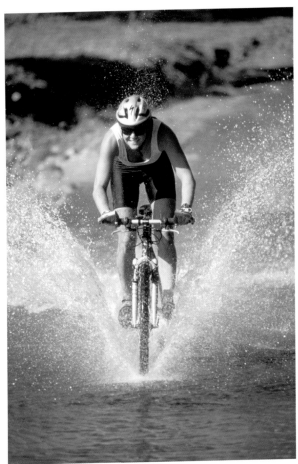

Auto focus is very handy when the action is coming straight at the camera. Nikon F100 on tripod, continuous servo, 300mm f2.8 lens, ISO 100 film, 1/800 at f5.6. © Mark A. Johnson

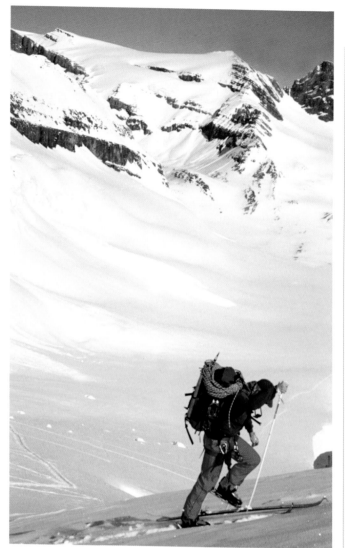

With so much white snow, exposure needed careful attention in capturing the essence of a ski mountaineering adventure on Canada's Wapta Icefield. Canon EOS 10S, 35mm f2.8 lens, Fujichrome Provia 100, 1/250 at f11. © Bob Woodward

It is easier to get closer to the action in cross-country skiing. When shooting ski touring, include the environment. That means a wide-angle and portrait lens is all you'll need. With cross-country ski competition, a lens such as a 70–200mm f2.8 zoom will isolate the competitors. (*Note:* With all snow sports, be careful of exposure. Bright sun on snow will throw your meter off by two or more f-stops and you should meter off a gray card or a neutral tone. Or take a reading off the snow and open up two or more f-stops.)

Street and backyard games: Some consider these the "pure essence" of all sports. Pick-up games played in parks, on streets, in driveways, and in backyards are truly international. The beauty of photographing street games is that your equipment can be minimal—one camera, one lens, and your own enthusiasm—and access is virtually assured, so opportunities are unlimited. If you see a group playing a game, politely ask if you can photograph them and take it from there. Don't simply concentrate on the action either. Include the environment and also bystanders in your pictures. The atmosphere of street games is as photogenic as the competition. Look no further for inspiration than Walter Iooss' photograph of Cuban kids playing baseball.

Surfing, wind surfing, and kite surfing: These sports are similar in that they happen in and on the water where salt spray, sand, and at times immense waves have to be contended with. Specialists regularly shoot from the water, and this requires extreme fitness, surf knowledge, and water skills. These experts use cameras—either digital or film—and lenses mounted in waterproof housings or other waterproof equipment such as the venerable Nikonos camera system. Great shots can be made from the shore with long lenses—300mm and longer—with elevated vantage points offering the best opportunities. Piers, rock jetties, or headlands are ideal spots. For best results, shoot only when surf and lighting conditions are good and excellent surfers are in action. Kite and wind surfers on calm waters can be photographed from down low and can result in spectacular images of high-flying athletes. Be aware that light

with a 1.4X teleconverter) is a favorite with professionals. Most alpine race shooters station themselves downhill from a slalom gate or a spot on the downhill course and shoot up at the skier. Fast shutter speeds are essential. Brian Robb said that with high-speed alpine events such as Downhill and Super G, he usually uses manual focus to pre-focus on a point, often a gate uphill, and shoots for the peak action such as the highest point of air, right on the gate, or a transition between gates. For giant slalom and slalom he often uses servo auto focus that tracks the subject.

reflected from water, white foam, or sand can result in underexposure. (Refer to Understanding Basic Daylight Exposure in chapter 3.)

Swimming: There are four swimming strokes—freestyle, backstroke, breaststroke, and butterfly. Time your shots so the swimmer's face, or head and shoulders are breaking from the water. The best photographs of freestylers are usually made when they turn their head to breathe; shoot backstrokers when their arms are elevated in mid-stroke; and breaststroke and butterfly swimmers look best when they are surging above the water. A photograph taken just as a swimmer's head emerges from the water can also be interesting, especially if smooth, unbroken water is cascading down the swimmer's head. Swimmers photographed from underwater, either with waterproof equipment or through viewing windows, also make for intriguing images. The lenses used will depend on your distance from the swimmers and your vantage point. Long lenses from 200mm and up work best for photographing individuals.

Tennis: Between the net and the baseline at ground level is an excellent vantage point. Many photographers shoot from directly behind the action into the opposite end of the court, but that requires a long lens and you might have to shoot through the net. With the side view, you can

Half-pipe action doesn't get much closer than this. Fill flash enhanced the ambient lighting. Canon EOS 3, Fujichrome ISO 100, 24–35mm f2.8 lens, exposure not recorded. © Diane Kulpinski

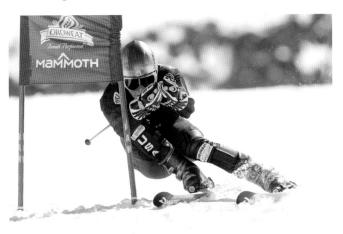

Giant slalom skier Tim Jitloff, USA, powers into a turn during the 2005 U.S. alpine championships at Mammoth Mountain, California. By pre-focusing on the gate and shooting just before the skier reached it, Brian Robb captured the moment. Canon ID Mark 11, ISO 100, 300mm f2.8 lens with 1.4X extender, 1/1300 at f5. © Brian Robb

photograph each player, after they change ends, from the same location. It's good for action coming at you and depending on which side their backhand side is, they will be facing you. If you can get a good overhead position, shoot down on players for a different perspective. Try to include the ball on or near the racket. And if you can't get courtside, tennis can be shot from the stands with a long lens.

Track and Field: Track meets are usually a hive of activity with running, jumping, and throwing events happening simultaneously, so you have a choice of subject matter. Concentrate on one or two competition areas. Starts and finishes of track races are two of the most popular subjects. Sprints

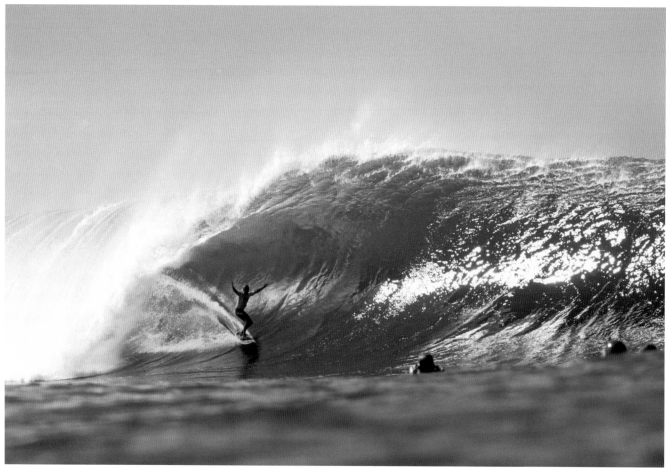

Hawaii's Pipeline was huge on the day Mark Johnson made this photograph from the water. Photographing in surf this size is for experts only. N90S, water housing, aperture priority, 35–135mm lens, ISO 100 film, 1/400 at f8. © Mark A. Johnson

and hurdles are explosive and over quickly, so you have to be set up in advance and react accordingly. In hurdles, the field will be tightly bunched at the first hurdle. Distance races provide the opportunity to photograph athletes as they circle the track. Field events, such as the shotput, high jump, long jump, pole vault, and javelin are contested in specific areas, so you can be set up in advance. Generally, longer lenses will be more useful for field events while shorter focal lengths can be used for some track events, especially if you can get close.

Look and Learn from the Pros

An excellent way to improve your sports photography is to study the work of the pros. Rather than just glancing at photographs in the sports pages of a newspaper or a magazine, take time and study the pictures. Analyze them to ascertain the technical, aesthetic, and emotional aspects of the photograph. What were the equipment and lighting? Did the image tell the story? Is it action-packed, emotional, definitive of the event? Obviously, not all photographs will meet these criteria, but many will. That's why they were published.

Points to Ponder

- Plan and prepare for the event you are going to photograph.

- Good spots to shoot from are vital, so scout locations well ahead of time.

- Contact event organizers to obtain all relevant information.

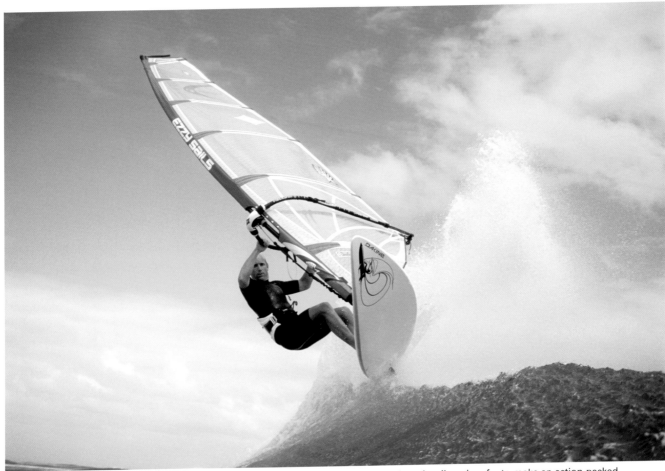

As the wind surfer banked off the top of a Kauai wave, Mark Johnson framed the board, sail, and surfer to make an action-packed image. Nikon N90S in a housing, 35–135mm lens, ISO 100 film, 1/500 at f5.6. © Mark A. Johnson

- Know the sport; know the athletes and their likely reaction or plays.

- Hone your skills, especially quick focusing and composing.

- Try different techniques such as panning and blurring to show speed and movement.

- Look for images that define key moments of the action and emotion.

- Don't waste film or card storage—pick your subjects and shoot selectively.

- Don't be a slave to one lens. Master different focal lengths and maximize the potential of each.

- Add impact by filling the frame—tight cropping and isolating the action are effective ways of strengthening images.

- Show athletes' faces in your photographs—they help tell the story.

- Don't stop photographing when the event ends; look for the jubilation or dejection shots.

- Never take your eye off the ball at sports such as baseball, ice hockey, basketball, or tennis. There is always the possibility of getting hit by a ball, puck, or a player.

- Serious sports photography is best done with SLR equipment, but compact cameras have their place if you can get close to the action and pre-focus on the area where you anticipate the action will take place.

- When photographing indoors or under lights with digital equipment, check the white balance by doing some test shots and use an

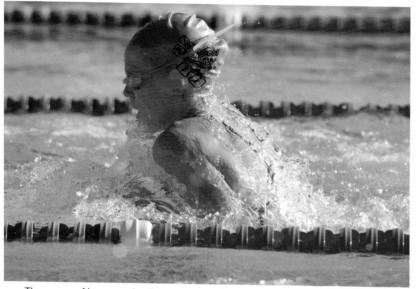

The power of breaststroker Tessa Wallace of Caloundra, Australia, is captured as she surges at the top of the stroke. Nikon D1X, ISO 400, 300mm f4 lens, 1/2500 at f5.6. © Peter Skinner

- When shooting at any sporting event, be respectful of the officials, athletes, and spectators, and know when it's not okay to photograph—such as when a golfer is about to tee off or putt.

- The techniques used for photographing many sports are applicable to others. Know the game and flow of play, and you'll do just fine.

- Study and analyze sports images in magazines and newspapers to see how the pros do it.

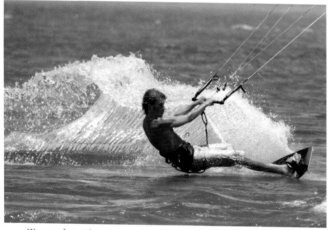

Kite surfers often come close to the shoreline, providing the opportunity for tight action shots. The wall of spray emphasizes the speed of the surfer. Nikon D1X, ISO 125, 300mm f4 lens, 1/1600 at f5. © Peter Skinner

ISO of 800 or higher. If shooting with film, use a fast negative film of about ISO 800 that can be push-processed.

- Stadium lights reflecting off ice can fool your meter. Take a reading off a gray card or some other object with neutral tones to determine exposure. Manual exposure should be considered when photographing under artificial lights. Similarly, your meter can be fooled by light reflecting off sand or snow, so be careful not to underexpose. You might have to open two or more f-stops to get the right aperture.

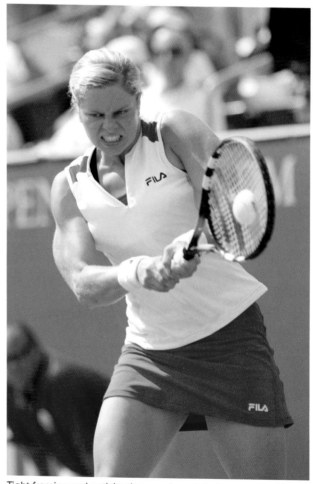

Tight framing and anticipation—and great timing—come with experience and knowing the sport to get powerful shots. Kim Clijsters belts a backhand. Canon 1D MKII, 70–200mm f2.8 lens, ISO 400, 1/6400 at f2.8. © Ben Chen

PHOTOGRAPH GALLERY

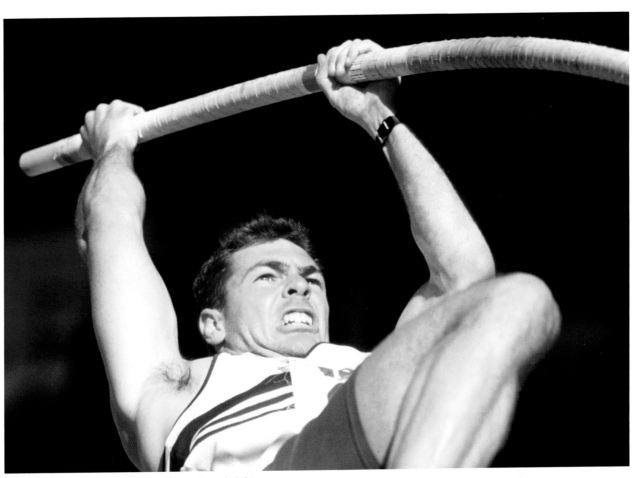

There are several ways to shoot pole vaulting. A tight, well-composed image that depicts the intense concentration and strength of the athlete, and the bend of the pole as it loads up to launch the vaulter is certainly a good one. Nikon 801, Tamron 300mm f2.8, Fuji Sensia Slide Film, manual focus, 1/1000 f8. © Duane Hart

A Collection of Action Images

The adage that a picture is worth a thousand words is certainly appropriate for the images that are featured in this section. We have, however, included technical and other information wherever possible in the hope that the combination of words and pictures will help you in your own photographic endeavors. Good shooting!

Athletes racing towards the camera can be photographed at a slower shutter speed than if they were going by the photographer but using a fast shutter speed always helps stop the action. Nikon FE2, Ektachrome 100, 80–200mm f2.8 lens, 1/1000 at f5.6. © Peter Skinner

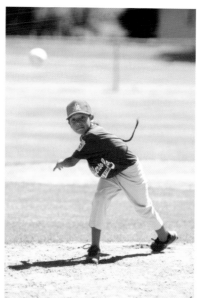

Los Angeles Angels second baseman Adam Kennedy completes a double play against sliding New York Yankees shortstop Derek Jeter. Canon 1D MKII, 400mm f2.8 lens with 1.4X extender, ISO 1250, 1/800 at f4. © Ben Chen

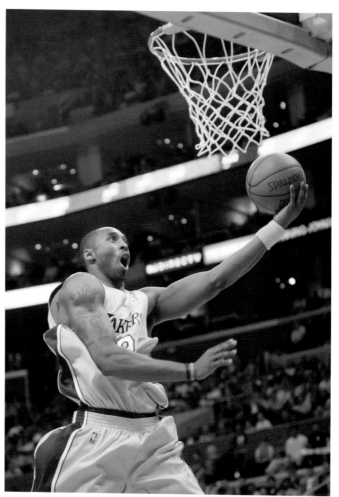

A young basketballer drives for the line at full speed. Action like this is the stuff of youth sports. Canon 1D, Mark II, 70–200mm f2.8 lens, electronic flash, 1/200 at f2.8. © Diane Kulpinski

Los Angeles Lakers all-star guard Kobe Bryant takes it to the hoop. Shooting from below the action emphasized the intensity of an explosive moment. Canon 1D MKII, 70mm lens, ISO 1600, 1/640 at f2.8. © Ben Chen

SPORTS PHOTOGRAPHY

Carefully planned composition and warm lighting are key to this "flowing" shot of 2000 elite men's U.S. road cycling champion Carl Decker. Canon 20D, 70–200mm f2.8 lens, ISO 100, 1/250 at f5.6. © Bob Woodward

Professional sports photographers often shoot for corporate clients, in this case for a cycling jersey manufacturer. Canon 10D, 70–200mm f2.8 lens, ISO100, 1/250 at f11. © Bob Woodward

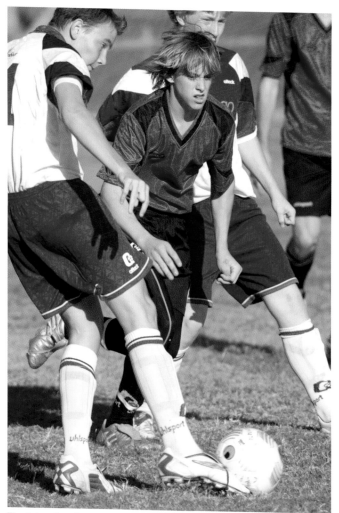

The intensity of soccer action is highlighted as a player moves in to intercept a pass from his opponent in a soccer game on the Sunshine Coast, Australia. The image was made with a long lens and from behind the goal line to capture oncoming play. Nikon D1X, 300mm f4 lens, ISO 250, 1/1600 at f5.3. © Peter Skinner

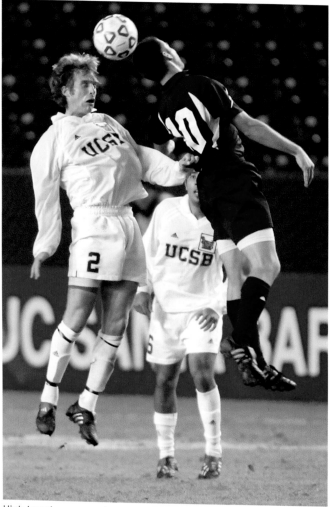

High-jumping soccer players heading the ball in the air are frozen in action. Canon 1D, 400mm f2.8 lens, ISO 1000, 1/640 at f2.8. © Ben Chen

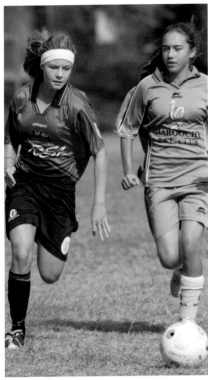

The race for the ball is on during a soccer match on the Sunshine Coast, Australia. Keeping the ball in the picture enhances soccer action shots. Nikon D1X, 300mm f4 lens, ISO 250, 1/1600 at f5.3. © Peter Skinner

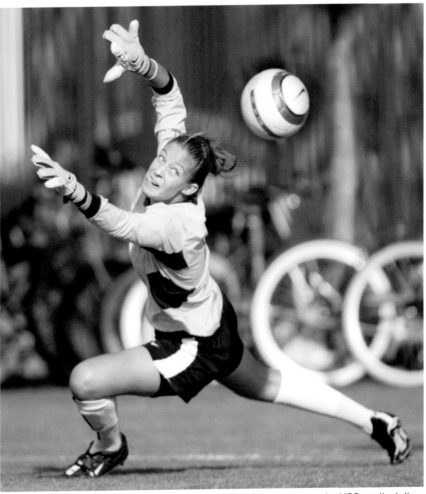

The goal area is ideal for peak action soccer shots like this diving save by USC goalie Julie Peterson. Canon 1D, 400mm f2.8 lens, ISO 200, 1/5300 at f2.8. © Ben Chen

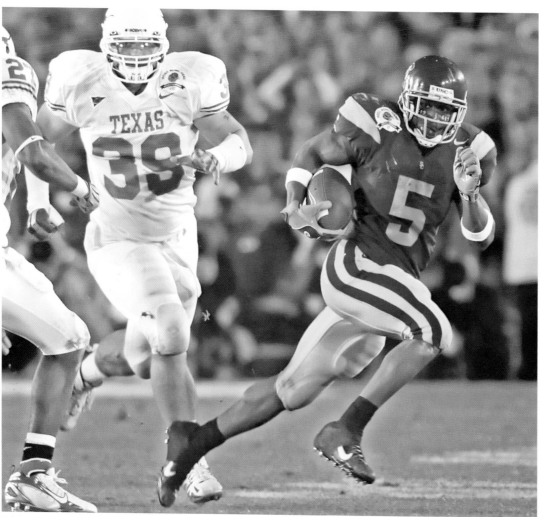

USC Trojans tailback Reggie Bush turns the corner while being pursued by the Texas Longhorns defense. Ben Chen anticipated the play. Canon 1D MKIIN, 400mm f2.8 lens, ISO 1250, 1/800 at f3.2. © Ben Chen

Arizona Wildcats cornerback Wilrey Fontenot anticipated the pass and intercepted the ball. Ben Chen knew the play was coming and captured the moment. Canon 1D MKII, 560mm f4 lens, ISO 400, 1/2000 at f4. © Ben Chen

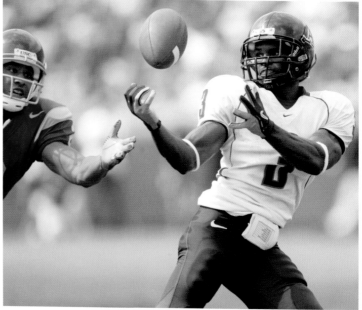

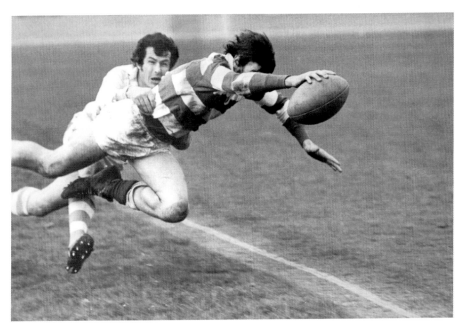

The last ditch tackle by the fullback could not stop the try (touchdown) being scored in this New Zealand inter-provincial rugby match. Knowing where the action would happen and quick manual focusing helped capture a key moment. Nikon F, Ilford FP4, ISO 125, 135mm f2.8 lens, 1/500 at f4. © Peter Skinner

Filling the frame with fast-moving action is not easy, but practice makes perfect. Ben Chen got it just right as Arizona State University Sun Devils wide receiver Derek Hagan has the ball stripped from his hands. Canon 1D MKII, 400mm f2.8 lens, ISO 400, 1/640 at f3.2. © Ben Chen

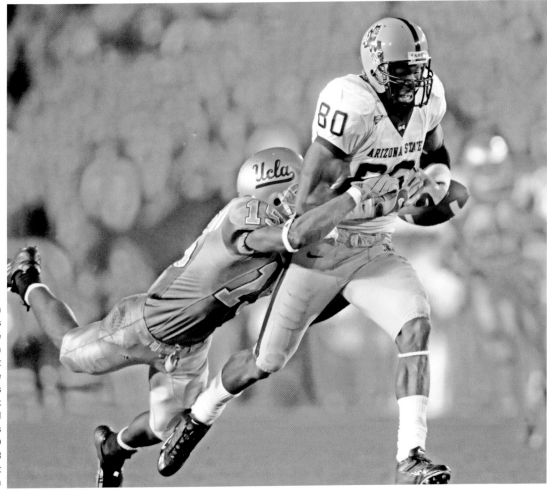

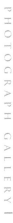

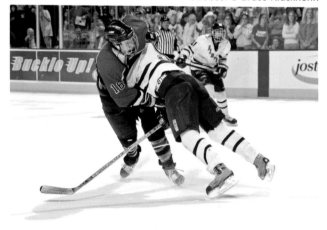

Players contest possession of the puck during the Minnesota high-school hockey tournament. Canon 1D, ISO 200, 35–350mm f3.5/5.6 lens at 95 mm, 1/500 at f5.6, electronic strobes. © Bruce Kluckhohn

Intense concentration is written all over this little girl's face as she eyes the lofty heights of a rope-climbing event. Spotlighted shots like this require careful exposure. Canon D30, ISO 1600, 200mm f1.8 lens, pattern metering, 1/350 at f1.8. © Duane Hart

A tight shot of a puck face-off at Minnesota Wild game. Canon 1D, ISO 200, 35–350mm f3.5/5.6 lens, 1/500 at f5.6, lit with strobes. © Bruce Kluckhohn

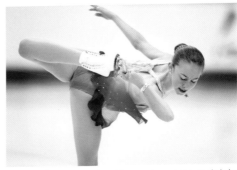

An excellent example of how a long lens and tight composition can enhance an image. Kimmie Meissner performs during the International Figure Skating Classic in St. Paul, Minnesota. Canon 1D, ISO 640, 400mm f2.8 lens, 1/500 at f2.8, available light. © Bruce Kluckhohn

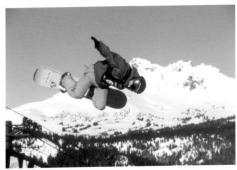

A high-flying snowboarder competing in a half-pipe competition at Mt. Bachelor, Oregon, is caught mid-air with a snow-capped mountain as an ideal backdrop. Canon EOS 3, Fujichrome ISO 100, 70–200mm f2.8 lens, exposure not recorded. © Diane Kulpinski

This 1968 shot of the U.S. Olympic bobsled team training at Mount Van Hoevenberg, Lake Placid, New York, illustrates just how fast the sport is. *Life* photographer Bob Gomel, seated in front of the brakeman, squeezed a pneumatic release to fire a Nikon camera mounted on the cowling. Three runs were made, bouncing over jagged ice at 105 mph, for exposures of 1/125, 1/60, and 1/30 second. © Bob Gomel

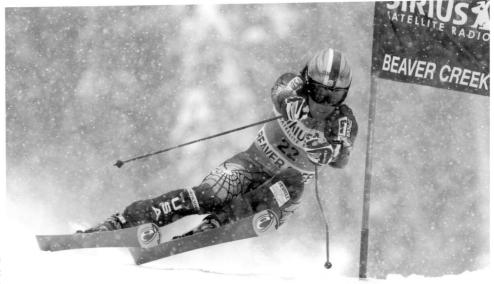

Dane Spencer, USA, goes airborne during a world cup giant slalom race at Beaver Creek, Colorado, and perfect timing—and knowing what to expect—captured the action. Canon ID Mark 11, ISO 640, 300mm f2.8 lens with 1.4X extender, 1/1000 at f5.6. © Brian Robb

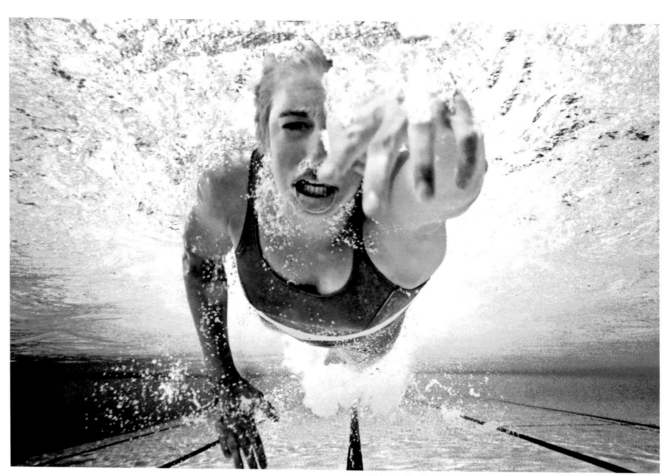

This perfectly timed underwater shot of a U.S. Olympic freestyle swimmer training in Los Angeles was made using a motorized Nikon camera in a housing customized to accommodate a 250-frame film magazine. © Bob Gomel

Water cascades from breaststroker Michala O'Brien of Caloundra, Australia, as she reaches the top of the stroke. Anticipation and shooting just before the swimmer's head bursts from the water helps capture peak action like this. Nikon D1X, ISO 200, RAW, 6300 K, 300mm f4 lens, 1/1250 at f5.6. © Peter Skinner

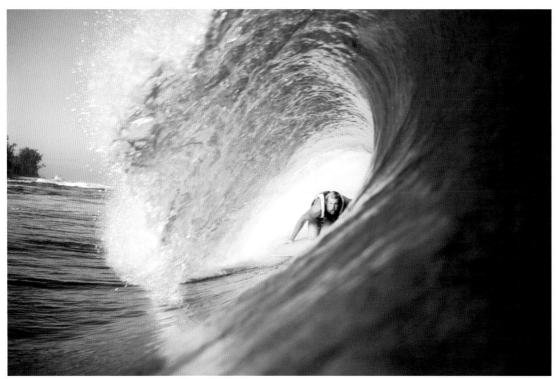

Water skills, fitness, and timing are prerequisites to make tube shots like this one from Oahu, Hawaii. Olympus, 50mm lens in housing. Ektachrome 100 film; 1/500 at f5.6 © Mark A. Johnson

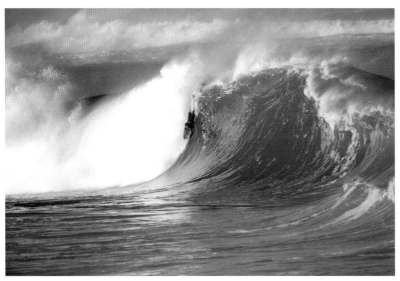

Body boarders thrive on testing their skill and nerve in the massive Waimea shore break, Hawaii, one of the few places where it's possible to get eye level with huge waves from the shore. Nikon F100, 300mm f2.8 lens, ISO 100 film, 1/800 at f4. © Mark A. Johnson

This kite-surfing action image says it all—tropics, fun, and athleticism. And it was shot from the beach in Kauai, Hawaii. Nikon F100, 35–135mm lens, ISO 100 film, 1/500 at f5.6. © Mark A. Johnson

A long lens, an extremely fast shutter speed, and wide aperture were used to capture the peak action as this long jumper competed in a Senior Olympics event in Houston. Note how the blurred background makes the athlete stand out. Nikon F5, Agfa Scala film rated at ISO 500, 300mm f2.8 lens, 1/5000 at f2.8. © Bob Gomel

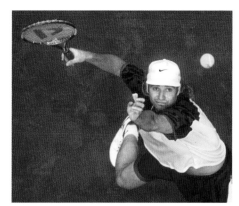

Overhead shots add excitement and a fresh look to action images. Andre Agassi winds up to serve during a Davis Cup match. 300mm f2.8 lens, Fuji Provia 400 film rated at ISO 800 and push processed, 1/500 at f2.8. © Bruce Kluckhohn

Perfect timing captures the moment at the 2002 Minnesota Tennis Challenge as Anna Kournikova returns a shot. A wide-open aperture ensured the subject is isolated from the background. Canon 1D, ISO 800, 70–200mm f2.8 lens at 195mm, 1/500 at f2.8, available light. © Bruce Kluckhohn

Age does not dim the competitive spirit. Muscles straining, this athlete gives it his all at the Houston Senior Olympics. Nikon F5, Agfa Scala rated at ISO 500, 300mm f2.8 lens, 1/5000 at f2.8. © Bob Gomel

SPORTS PHOTOGRAPHY

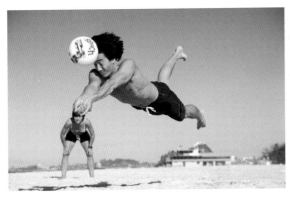

Anticipation and perfect timing were essential in pulling off beach volleyball action shot from a low angle. Nikon N90S, 20–35mm f2.8 lens, ISO 100 film, 1/1000 at f4. © Mark A. Johnson

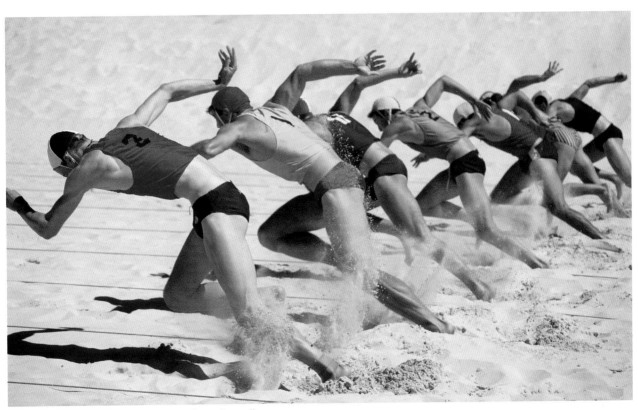

They're away! Sand flies as contestants in an Australian surf-lifesaving beach sprint accelerate from the start. Tight composition and timing the shot so the sprinters' arms are in unison strengthen the image. Nikon 801, Tamron 300mm f2.8 manual focus, Fujichrome Velvia, 1/1000 at f4. © Duane Hart

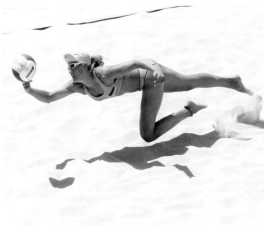

An overhead view and split-second timing as the player stretches mid-air, portray beach volleyball action and fingertip control. Note the juxtaposition of the shadow, and the eruption of sand. Canon 10D, ISO 100, 200mm f1.8 lens, pattern metering, 1/1000 at f4.5. © Duane Hart

THE EMOTION OF SPORT

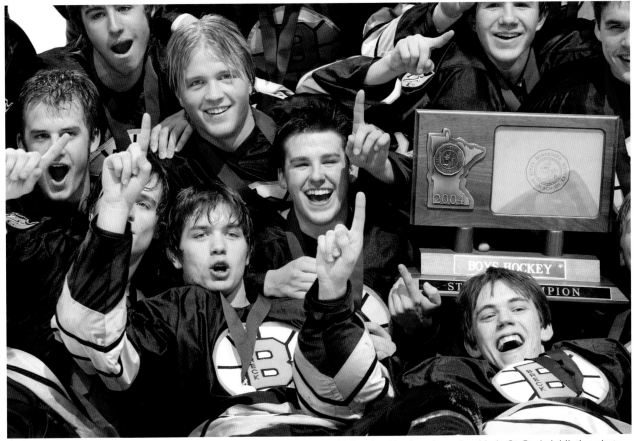

Guess who won? Breck students celebrate winning the 2004 Minnesota high-school hockey championship in St. Paul. Jubilation shots tell the story. Canon 1D, ISO 250, 35–350mm f3.5/5.6 lens at 135mm, 1/500 at f5.6, electronic flash. © Bruce Kluckhohn

Few endeavors bring out the range of emotions more than sport. Whether it's a group of biased, one-eyed, and very vocal supporters urging their side on, heckling an umpire, cheering in victory, or mourning a loss; or a nail-biting parent watching his or her Little Leaguer at bat with the score tied in the final game of the season, the opportunities to photograph raw emotion are there. They present golden opportunities for memorable images.

Most pictures portraying emotion result from the photographer having a keen eye, looking beyond the expected, and being prepared. Numerous opportunities for these kinds of pictures will present themselves during an event, but you need to determine your priorities. Will you concentrate on action shots during the game and then go for jubilation or dejection shots at the end; or try to cover both action and emotion while the game is underway and then shoot flat out when the game ends?

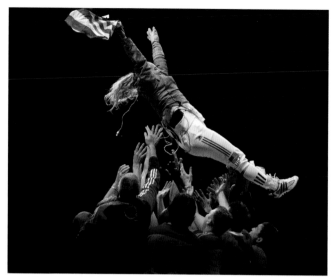

There's no doubting the joy in this image as a U.S. fencer is tossed into the air after winning the 2004 Olympic gold medal. Canon 10D, ISO 800, 70–200mm f2.8 lens, pattern metering, 1/1000 at f2.8. © Duane Hart

Celebration, Excitement, and Jubilation

Excited fans cheering their team, going wild at a key play or the moment of victory are great material for celebration shots. The photographer who can move in close, compose quickly, and fire off a series of images that truly capture the unbounded joy of the moment will come up with winning jubilation shots. A great advantage is that celebrating fans will usually be very happy, and cooperative subjects are, in most cases, willing to mug it for the camera. Fist pumping, the universal "we're number one" finger-raising, and other traditional gestures made by fans celebrating are good subject matter. Similarly, players on the bench and team officials getting excited also provide excellent photo ops. A shot of celebrating baseball players streaming from the dugout at game's end says it all—we won! There is probably no better moment for the ultimate in jubilation images than the instant of victory—as that vital goal is being scored or the blast of the final whistle signals a win. Focus on the right people at that time and you'll have great shots.

Overall shots of large crowds of flag- and banner-waving fans epitomize the excitement that sweeps a stadium. Tens of thousands of people cheering, chanting, or doing a wave create an exciting spectacle, and images of this colorful mass of humanity can be just as exciting. Include a scoreboard or banner that symbolizes the venue or event to add interest. Hold the camera high above your head and take the shot—that little extra elevation can make a difference.

An informal team shot of the players and coaches holding a trophy aloft or the team sitting and sprawled around the trophy also shouts "victory and jubilation."

Tension and Strain

You can see tension and strain on the faces of players and fans alike, before and during an event. Often, this is when people like to be left alone—they probably won't be as receptive to a camera as when they're celebrating—but if you take the photograph diplomatically—that is, don't simply thrust the lens into the subject's face—you could come away with a revealing portrait.

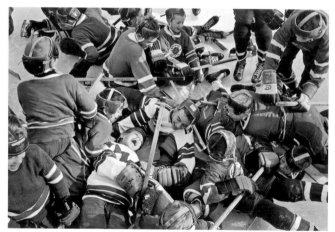

Life photographer Bob Gomel was assigned to do a story on the exploding popularity of Little League ice hockey. He followed a New Jersey team, compiling a comprehensive selection of action images, but wanted a powerful shot to open the story. This was it! To get it, he used imagination and resourcefulness. "I put a ten-dollar bill under a puck on the rink and the kids poured onto the ice to find it," he said. © Bob Gomel

Heroics and Heroism

Sport is all about heroes and their achievements. Look for photographs of sporting heroes whether in action or in quieter, more reflective moments. And while heroes for the sporting public at large might be NFL quarterbacks or major league baseball stars, your sporting hero could be your own son or daughter competing in Little League. Getting good shots of your sporting hero is simplified to some extent because you can concentrate solely on them and their efforts rather than on the entire event. Access to professional sportsmen will not be as easy, but you can still shoot from the stands and occasionally there will be photo opportunities at spring training or similar events. On the other hand, photographing your Little Leaguer or high school athlete will be less complicated. You've still got to produce the images, but you'll have a better chance of getting close to the subject.

Camaraderie, teamwork, relief, elation, and consolation at the 1996 Olympic Games in Atlanta. The emotion-packed image of Canada's gold medal–winning 4 by 100 meter relay team embracing says many things. Being ready is paramount for such evocative shots. Canon 1N, 400mm, f2.8, Fuji 800 film, 1/1000 at f2.8. © Duane Hart

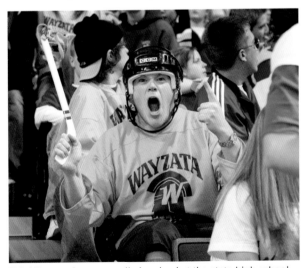

This Wayzata fan was really involved at the state high school hockey tournament in St. Paul. Shots like this help tell the story of an event. Canon 1D, ISO 400, 35–350mm f3.5/5.6 lens at 90mm, 1/500, f4.5, strobes. © Bruce Kluckhohn

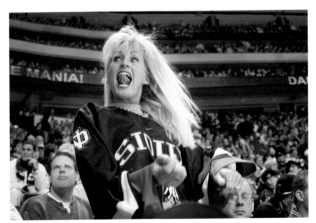

A fan gets really excited at a Western Collegiate Hockey Association, final-five tournament, and Bruce Kluckhohn has brilliantly captured that excitement. Canon 1D, ISO 200, 35–350mm f3.5/5.6 lens at 35mm, 1/500 at f4.5, strobes. © Bruce Kluckhohn

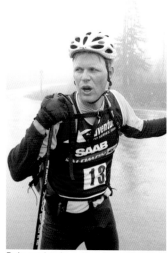

Pain and exhaustion from the extreme conditions during the North American RAID adventure sport championships are revealed in this tight portrait. Canon 20D, 17mm lens, ISO 200, 1/160 at f4. © Bob Woodward

Dejection and Disappointment

In any game, someone's going to lose. Images of dejected players, team officials, or fans are all part of the story. They can say as much about a game as the jubilation photographs. Look for the downcast player on the bench, head in hands or covered by a towel, disappointed fans shaking their heads in disbelief, an exhausted player slumped over, dejection written all over his or her face. Pictures of these situations have a common message—we did our best, but lost! A photograph of dejected players in the foreground with the all-revealing final scoreboard in the background has a poignancy about it that any viewer with an ounce of sporting empathy will appreciate. Similarly, an image of jubilant victors in the foreground with the vanquished in the background— or vice versa—is very telling.

Although not a pleasant subject, injury is a fact of sporting life. Don't set out to portray the pain of the injury—although a grimacing face does tell the story—but instead aim to depict the disappointment that a game, a season, or even a career has ended prematurely. Photographing an injured player is a personal choice and depends on your role at the game. The injury could have a major influence on the outcome, which makes it newsworthy. So, if you're photographing for a publication, take the shot and let the editor decide whether it runs or not.

Confrontation

Many sports are about confrontation and in-your-face aggression. Shots of competitors involved in face-offs can make great visuals. Similarly, athletes or coaches vehemently disputing an umpire's decision are good photographic material. These images might depict the less noble aspects of sports, including things such as bad sportsmanship and temper tantrums, but some confrontation shots can be humorous. Who could suppress a grin at a photograph of an irate Little Leaguer glaring up at the umpire with a "How can you call that out?" expression on his or her face?

Emotions can run high at MLB games. Los Angeles Dodgers pitcher Brad Penny wasn't too happy at being tossed out of a game. Canon 1D MKII, 400mm f2.8 lens with 1.4X extender, ISO 1600, 1/800 at f4. © Ben Chen

Encouragement and Support

Look for the shots that epitomize camaraderie and encouragement. The coach with an arm around the athlete's shoulder, giving words of advice or encouragement; players in a huddle, listening to their captain's final instructions prior to a game; a Little League coach having a heart-to-heart with a youngster about to go to bat. Sports abound in images like these.

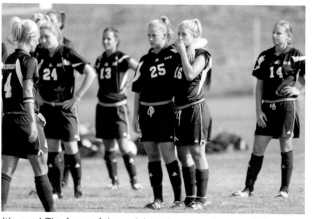

It's over! The faces of these dejected soccer players tell the story of a disappointing loss. Emotional moments like this are integral to sports. Canon 1D, 400mm f2.8 lens with 1.4X extender, ISO 200, /1600 at f4. © Ben Chen

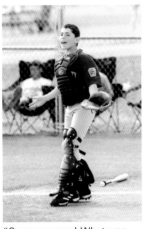

"Come on ump! What was that?" Questioning decisions is universal to sport, and photographs portray the emotion. Canon EOS 3, ISO 400 Fujicolor, 100–400mm f4.5/5.6 lens, maximum aperture. © Diane Kulpinski

A coach's pep talk becomes the focal point of the moment. Look for images like this when covering youth sports. Canon 1D, Mark II, 70–200mm f2.8 lens, electronic flash, 1/200 at f2.8. © Diane Kulpinski

Planning to Capture Those Emotional Moments

You need to plan on capturing these moments of high drama and emotion. Professionals have a game plan to get what they need to fulfill their publication's needs. They work out ahead of time where they are going to be when emotions are likely to run highest—the end of the game is an obvious time, but there might be others such as when a legendary player is making a final appearance. Regardless of what event you're photographing, plan ahead and put yourself in the right location to document the emotion. If you do it right, you'll have a collection of images that will complement the more typical action photographs that you make.

What Equipment to Use

Depending on your principal subjects, this type of photography could be ideal for compact point-and-shoot cameras because much of the time you will be able to use wide-angle lenses. And if you intend to isolate an individual, say on the bench, and can get reasonably close, a short-to-medium telephoto lens, equivalent to a 105mm lens on a 35mm camera, will be ideal. Watch professional photographers working at the end of a game. Invariably they will be shooting repeatedly at close range, using wide-angle lenses and fill-in flash. You should do the same—use a wide-angle lens and augment the ambient light with

flash. This is one of those times in sports photography where probably you will be close enough to use flash. And if the winning team spontaneously gathers for an informal team shot with a trophy, have that wide-angle lens and flash ready. (*Note*: When you start using flash, if it's allowed, make sure you have changed the shutter speed to the correct synchronization speed. In the excitement of the moment, a basic thing like this can easily be overlooked.)

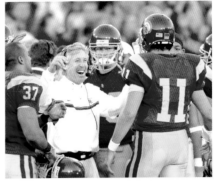

A great moment in sport is captured for posterity. USC head coach Pete Carroll congratulates senior quarterback Matt Leinart for his last appearance at the Los Angeles Memorial Coliseum where Leinart had never lost during his four years as a starter for the Trojans. Ben Chen knew the significance of the moment. Canon 1D MKII, 400mm f2.8 lens, ISO 1250, 1/1000 at f2.8. © Ben Chen

Points to Ponder

- Think about possible images that bespeak emotion prior to the event, so you're prepared.

- Determine who your principal subjects will be for these shots—players, the bench, fans?

- Look for overall crowd shots with banners and flags waving. They make great excitement shots.

- Subjects such as jubilation, disappointment, tension, and heroics epitomize emotion.

- Use a wide-angle lens to get in close on shots of cheering fans or players.

- Use fill flash for close-up people shots, if flash is permitted.

Barbara Petzold anchored her East German team for an unexpected win in the four by five–kilometer cross country–ski relay at the 1980 Lake Placid Olympics, and the team erupted in an equally unexpected display of exuberance at the thrill of victory. Canon F-1, 100mm f2.8 lens, Ilford 100 ISO black and white film, 1/125 at f5.6. © Bob Woodward

THE AESTHETICS AND MOODS OF SPORT

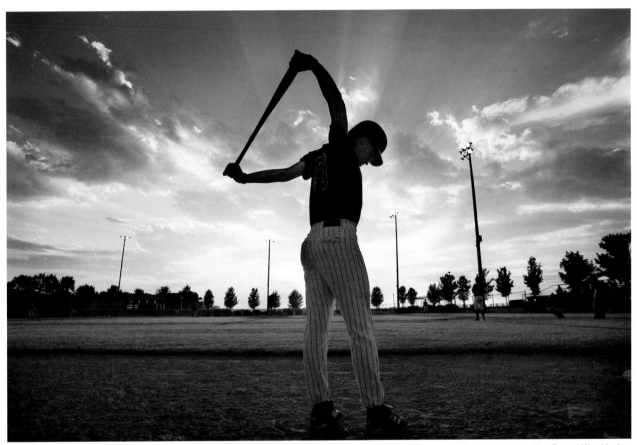

This image really says baseball, illustrating just how powerful photographs that portray the setting for a game can be. Bruce Kluckhohn got in close and used a wide-angle lens to create an evocative shot of Jason Kuerschner preparing to bat in a rural Minnesota game. Canon 1Ds, ISO 200, 20mm lens, 1/640 at f5.6, available light, color adjusted from RAW file. © Bruce Kluckhohn

Photographers who have the vision to look beyond the parameters of competition can extract iconic and representative images that speak eloquently of the essence and character of the game—it's just a matter of training the eye to look for those "identifying abstracts" of sport.

Sports photographers, with empathy for their subject, know how to make images that personify the environment in which sport is played. Let's consider the fields of sport, both manmade and natural, and how your photographs can portray them.

Capturing the Atmosphere Within a Stadium

A stadium is certainly an ideal venue to photograph a variety of subjects without even having to move from your seat. The great thing about a packed stadium is the excitement it creates with crowds, color, noise, and a general air of expectation and anticipation. Your goal should be to capture not only that excitement but also some of the less

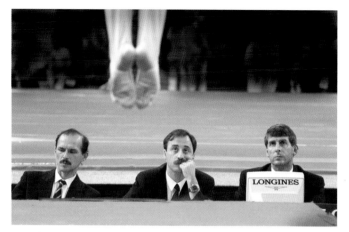

The gymnast's feet are barely showing (no pun intended) and yet we know what's happening. The judges' expressions suggest it's been a long day. Train your eye to see these vignettes when shooting sports. Nikon 801, 300mm, f2.8 Tamron lens, manual focus, Fuji 800 film, 1/500 at f2.8. © Duane Hart

have fast enough film (color negative is recommended) or can bump the ISO on your digital camera into the 800 or higher range.

Also, depending on the sport, try to get a seat that puts you near areas or zones where key action is likely to occur, such as the goal mouth of a soccer or field hockey game, because even though we're talking about the aesthetics and moods of sport, you'll want to include some action shots in your coverage.

obvious nuances of the event and its participants.

With just a few lenses, you should be able to get most of what you need from your seat. Before you arrive at the stadium, try to get a seat with the sun behind you—assuming you're attending a daytime event. If it's a night event, this won't be too much of an issue, as long as you

Overall shots of stadiums help set the stage for coverage of an event. This overview of the Xcel Energy Center in St. Paul, Minnesota, was photographed with a combination of ambient light and electronic flash. Canon 1Ds, ISO 200, 20mm f2.8 lens, 1/125 at f6.3. © Bruce Kluckhohn

The background mural and the swinging arms of people heading for the Los Angeles Coliseum at the 1984 Olympics combine to make an interesting shot that says "sport." Nikon FE2, Kodachrome 64, 35–105mm f4 lens, 1/250 at f8. © Peter Skinner

WIDE, MEDIUM, AND LONG

What you shoot in a stadium is your call—you will have plenty to choose from—but the wide, medium, and long approach favored by many professionals is worth following. Once you've settled in, use a wide-angle lens to capture the overall scene—or as much as the lens will allow—and also take a series of overlapping pictures that can be combined into a panorama. This is an area where digital cameras are very useful. Presuming your camera has the capability, the manual will explain how a series of images

Stadium shots capture the essence of the venue, but lighting can be tricky. Correct exposure for scenes like this one at the Los Angeles Coliseum is about six f-stops more than basic daylight. Nikon FE2, Ektachrome 100, 24mm f2.8 lens, 1/30 at f4.
© Peter Skinner

can be stitched together to create panoramas. The wide-angle lens is great for massed crowd shots and works really well with a prominent point of interest in the close foreground. Think of wide-angle shots as setting the stage. Flags being waved, an unusual hat, or even a close-up of a cheering fan can look good in the immediate foreground with the crowd in the background. Use a smaller aperture, say in the f11 to f22 range, and you'll have great depth of field, thus getting near and far subjects in focus. At that aperture, you will have to hold the camera steady enough to compensate for a slower shutter speed.

In Edmonton Canada colorful flags of many nations portray the international flavor of a world skating competition. Exposure was based on an average reading of the flags which approximated 18 percent gray. Nikon FE2, Fujicolor 800 rated at ISO 1600, 80–200mm f2.8 lens, 1/250 at f4. © Peter Skinner

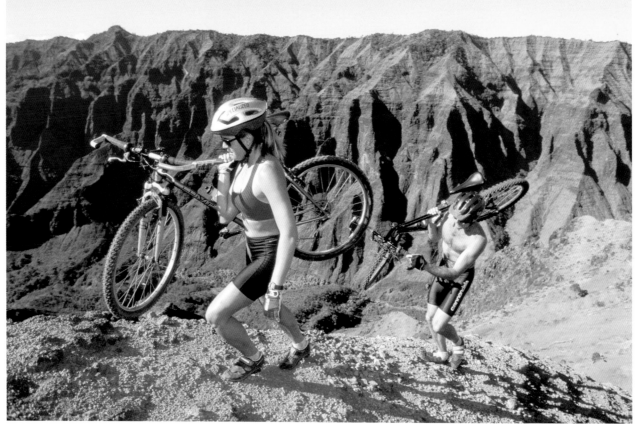

Mountain bikers carrying their bikes set the scene against the dramatic backdrop of Waimea Canyon in Hawaii. Nikon F100, 100 ISO film, 20–35mm f2.8 lens, 1/250 at f11. © Mark A. Johnson

A medium-length, focal-length lens, say in the 50–200mm (35mm film equivalent) range, is ideal for photographing sections of the crowd, the scoreboard, the bands, or isolating some of the action on the field. A zoom lens, in the 70–200mm range, is always handy for this type of coverage.

And then go long—with a lens of 300mm or more—to isolate specific subjects and moments on the field. Depending on where you're sitting in the stands, even a long lens might not isolate individuals but you will be able to compose and shoot elements that would be out of reach of shorter lenses. When using a long lens from the stand, a monopod is a great asset whereas a tripod probably would get in the way.

The Great Outdoors

Anyone who has ever looked down from the highest chair on a ski slope will appreciate the grandeur of that setting. Similarly, early morning mist rising

off a golf course, or perfect waves peeling around a point are scenes that will gladden the hearts of aficionados of those sports. Such sporting environments combine the attractions of nature and sports photography, and thus provide great subject matter. As with any outdoor scene, lighting is key so if you are going to photograph subjects like these, look for the softer light of morning or late afternoon. And while these outdoor environments often look their best when pristine and devoid of humans, keep in mind that people in the great outdoors add scale to the setting, so try to photograph them both ways—with and without people—and then make up your own mind about what works best as a sports-related image.

The equipment you use will vary according to the location and its accessibility. If you have to backpack into the mountains for an alpine skiing shoot, chances are you'll limit your equipment to one or two lenses, and a lightweight tripod. (See chapter 1.) Conversely, if you can drive to a golf

A kayaker running these 50-foot falls was shot in winter to accentuate the ominous canyon rocks and portray the relationship of diminutive kayakers in a magnificent setting. Canon EOS 1N, 100mm f2.8 lens, Fujichrome Provia 100, 1/125 at f5.6. © Bob Woodward

Portraying the aesthetics and moods of sport is ideal for incorporating shadows into your pictures. Whether in a stadium or an outdoor setting, it's highly likely you will be able to find a position from where shadows become part of the scene. They might not be obvious at first, but make a point of looking for them and if possible, harness their visual impact.

It's All in the Details

Close, tight shots of almost any subject—even to the point of being an abstract—can have impact and arouse greater interest than an overall photograph of the same subject. As mentioned above, sports are replete with such images. Great photographers such as the late Ernst Haas were masters of photography in the abstract because they could extract from a scene the essential details that both characterized the subject and yet demanded closer scrutiny to identify it. Their images were both revealing and mysterious. What a wonderful combination! If you let loose your imagination, you can find a plethora of opportunities in the paraphernalia of sports. The only limit is your imagination and vision. Just to get you started, here are some ideas.

course and know the layout ahead of time, you'll have the luxury of being able to take more equipment to choose from. The wide, medium, and long philosophy of shooting in stadiums also applies to photographing outdoor settings. Photographs of sporting environments should be planned to determine the best time of day, angles of view, accessibility, and how people can be incorporated.

SHADOWS ARE POWERFUL

In chapter 3, we mentioned the importance of shadows as powerful elements of composition.

Hawaii's infamous and feared Pipeline on Oahu is a magnet for the world's best surfers and surf photographers. In the foreground, photographers congregate in the impact zone. Nikon F100, ISO 100 film, 600mm f4 lens, 1/500 at f5.6. © Mark A. Johnson

A wonderful profile portrait taken with a long lens of Minnesota Wild goaltender Dwayne Roloson portrays his intense concentration as he watches the opposition warm up. Canon 1D, ISO 200, 35–350mm f3.5/5.6 lens at 350mm, 1/400 at f5.6, strobes. © Bruce Kluckhohn

- A battered baseball glove

- A footballer's helmet

- A tight shot of an athlete's grip on a bat, golf club, or hockey stick

- A boxer's bandaged hands

- Close-up of an athlete's eyes, hands, or feet

- A swimmer's goggles

- A rock climber's taped hands jammed in a crack on a rock wall

- An ice axe's tip—or a climber's crampons—penetrating the ice

A still-life photograph of baseball bats in Miesville, Minnesota, speaks of a slice of history in the game. Originally photographed in color, the image was converted to black and white in Photoshop. Canon 1D, ISO 100, 400mm f2.8 lens, 1/200 at f2.8. © Bruce Kluckhohn

SPORTS PHOTOGRAPHY

Shots like this have to be planned and executed well. Bruce Kluckhohn set up Dyna-Lite strobes to capture the instant the puck slammed into the back of the net. Canon 1D, ISO 100, 70–200mm f2.8 lens at 70mm, 1/400 at f18, auto white balance. © Bruce Kluckhohn

- A tight shot of a skier's goggles reflecting the environment, such as mountains

- A gloved hand in a ski pole grip when the ski racer is in the start house

- A hand making contact with a volleyball during service

- Tight shot of feet or hands on the starting line at a track event

- An athlete concentrating, or relaxing (perhaps listening to music through headphones)

- A hockey puck hitting the back of the net

Points to Ponder

- Try to portray the character or atmosphere of the environment, stadium, or setting.

- Take the wide, medium, and long lens approach used by many professionals and start with a wide-angle view initially and then work in for the tighter shots with longer lenses.

- A wide-angle lens works really well with a prominent subject in the foreground to capture the viewer's initial interest. Many landscape photographers favor this technique, and it also works well for sports subjects.

- Look for details, even abstracts, which can make intriguing subject matter.

The hand outstretched to snare the catch and the stumps in the background say "cricket!" Detail images like this tell the story well. Canon 1N, 200mm f1.8, Fuji Sensia slide film, 1/1000 at f2.8 © Duane Hart

GETTING ACCESS AND WORKING WITH SPORTS GROUPS

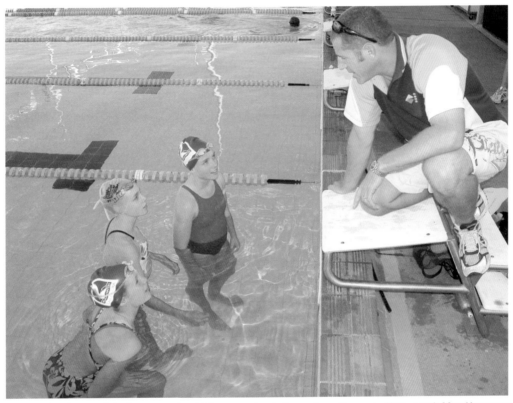

Cooperating with coaches is one of the best ways to obtain access to photograph youth sports. Here, coach Matt Howes works with a group of young Australian swimmers—Kelli Fullager, Tessa Wallace, and Rebekah Patterson—at the Caloundra Aquatic Centre in Queensland. Nikon Coolpix 5000, ISO 200, 9mm (approx. 35mm in 35mm film equivalent), aperture priority, auto white balance, fill flash, 1/500 at f5.3. © Peter Skinner

Generally, the key to getting the best sports shots is getting close to the action. The bigger the event or league the harder it is to get credentials that allow you to get close, especially these days when security and restrictions are so much tighter. To obtain that access, you need to get in touch with the people who run the show—association officials, club secretaries, team coaches, and such.

A good way to gain access is to have a portfolio of images to show that 1) you're a competent photographer and serious about what you want to do and 2) that you want to do the right thing by the people you work with. If you're just starting out, demonstrate that you want to produce a portfolio of sports photography and that you'd like to work with the team, club, or association.

Most sports groups are happy to cooperate with photographers. After all, your pictures might be useful in promoting their activities. Be enthusiastic because enthusiasm is contagious. Even the most

Youth sports wouldn't happen without these important people. Shots like this help round out coverage of events. Canon EOS 3, ISO 400 Fujicolor, 100–400mm f4.5/5.6 lens, maximum aperture. © Diane Kulpinski

The single team. Being a team photographer is an excellent way of being involved. Get in touch with the team coach and inquire about the possibility of being the team photographer. Depending on the age of the players, parental permission might be needed but if the coach agrees, you have made a good start. The advantage of working with a single team is that you will get to know everyone, and in essence you will become a key team member.

Little Leagues. A good initial contact is the local parks and recreation department who are usually closely involved with all the different sports involved. Find out to whom you should direct your inquiries and go from there.

Clubs and associations. Many clubs field numerous teams of different ages, boys and girls, men and women, so being involved with a club can give you access to a wide variety of teams and players. Initially, the club secretary is probably the most appropriate person to contact. Associations are the governing body for the clubs that fall under their jurisdiction, and working with them will probably be more complicated. Conversely, once accredited or authorized by the association, your access to all the games and events will be far more extensive.

High schools and colleges. The size of the school will determine your initial contact. In some cases, the principal's office will be appropriate, but in larger schools sports photography accreditation comes from the athletics department, the sports information director, or equivalent. Photographing major college sports usually requires affiliation with an accredited publication or agency; so don't be surprised if you get turned down if you don't have that. On the other hand, you might very well find that less popular sports will welcome a photographer who might be

"Okay, guys. Go get 'em." Encouraged by coaches, young baseball players head for the field. Including coaches in images emphasizes the team aspect of sports. Canon EOS 3, ISO 400 Fujicolor, 100–400mm f4.5/5.6 lens, maximum aperture. © Diane Kulpinski

hard-nosed coach will respect an enthusiastic photographer who simply wants a chance to make great sports pictures.

Let the sports officials or clubs know what the photographs are for. Don't say they're just for yourself and then later turn around and try to sell them. Images you make initially just to get experience might eventually be of value to someone—especially if they're good—so don't limit yourself. There's every chance someone will want to buy your photographs or a local newspaper or other publication might want to use them. (*Note*: Always retain the copyright in your images.)

Diane Kulpinski, of Bend, Oregon, an experienced former newspaper photographer who now has her own business photographing Little League and school sports, urges photographers to talk to officials before photographing an event. In her experience, once you get the support of coaches, others will gladly cooperate. Her advice is: Never simply turn up at an event and start taking photographs without talking to officials. Better yet, make contact well before the event. "If you want credibility, talk to the people in charge. Often they will give you more help than you ask for or expected," she said.

Contacting the Right People

The following are possible starting points to get access to sports teams or clubs.

Winners are grinners! And being able to work closely with these happy basketball players paid off. Canon 1D, Mark II, 70–200mm f2.8 lens, electronic flash, 1/200 at f2.8. © Diane Kulpinski

able to promote their events and help with publicity.

Professional sports. The public relations department is the appropriate contact, but as with major college sports, media affiliation will probably be a prerequisite. If you're just starting out, this is not the most likely point of entry.

Training camps. Spring training is an ideal opportunity to get up close and personal with athletes, and this can also be an excellent time to photograph your favorite athletes in a more relaxed setting.

Get It in Writing

Once you've got the authorization to photograph your chosen sport, or sports, on a regular basis get that authorization in writing from the right person. Many organizations provide a laminated media or photographer accreditation to display, so inquire whether something like that is available. And if you're the team photographer, have a card made up and signed by the appropriate team official and wear it in a prominent place when you're shooting an event.

Legally Speaking

You've got permission from the right people to photograph the events and participants, but what are you allowed to do with the photographs? Can they be published in a club or association newsletter, a newspaper, magazine, or on a Web site? When are model releases needed, and do you have to get a release from everyone you photograph? To get some insight on this topic, we sought advice from a respected authority on the subject, Victor S. Perlman, general counsel for the American Society of Media Photographers, ASMP, a leading trade association for photographers who photograph primarily for publication in advertising, commercial,

and editorial markets. (A wealth of information on many topics is available to the public at *www.asmp.org*, although sections of the site are accessible only by members.)

Q: In broad terms, when does a photographer not need a release from people who appear in photographs made at a public event, such as a football game or track and field meet at which organizers permit photography by spectators?

A: First, you have to remember that the laws affecting these questions are primarily the rights of privacy and publicity, and those are state—not federal—laws. For that reason, the answers to the same question can vary considerably, depending on which state(s) are involved. Second, answers to all legal questions depend primarily on the facts of each case, and specific details that may appear minor can often prove to be extremely significant. Finally, when in doubt, get a release—an ounce of prevention is worth far more than a pound of cure.

Having said that, the prevailing rule in the U.S. is that you need a person's permission before you can use a likeness of him or her for "purposes of trade or advertising." Conversely, that means that editorial uses typically do not require releases. One exception to that *may* be photos used on covers, which could arguably be considered a form of advertising.

Q: I will be photographing the Hot Comets playing the Bobby Dazzlers in the final of the regional soccer championship for boys under thirteen years old. The photographs might be used in the local newspaper, the soccer association's printed newsletter, and on their Web site. Do I need to obtain a release from the players' parents or guardians?

A: For minors (people under eighteen years of age), releases are most effective if they come from legal guardians who are appointed by a court. The rights of parents are "natural" rights, as opposed

Getting access to the team paved the way for a delightful shot of smiling soccer players at a high school play off. Canon 10D, 300mm f2.8 lens, exposure not recorded. © Diane Kulpinski

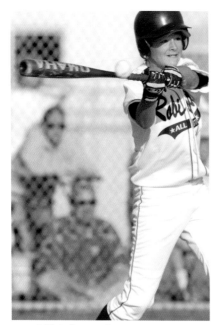

A Little League batter swings, and Steve Trerotola was on hand to shoot it. Making contact with officials opens doors to photograph these young athletes. Nikon D2H, ISO 200, 70–200mm f2.8 VR lens with 1.4X extender at 280mm, 1/2500 at f4. © Steve Trerotola

Access to the Little Leagues opens the opportunity for images such as this of a catcher awaiting the pitch. Nikon D2H, ISO 400, 70–200mm f2.8 VR lens with 1.4X extender at 240mm, 1/1250 at f4. © Steve Trerotola

to rights created by law. Because of that, parents' rights are a lot less defined and clear than rights that are spelled out by statutes and/or courts. If a minor had both a parent and a legal guardian, and if there were a conflict between the two on the exercise of a right that both had, the legal guardian's decision would most likely trump the parent's. That is why a release from a legal guardian is better than a release from a parent—there is no question as to the guardian's authority to issue the release or the enforceability of the release. If there are no legally appointed guardians (and in most cases there aren't), releases from parents are almost as good. Releases from minors by themselves are worthless, but a signature by a teenager on a release signed by his or her parents can provide some additional protection.

With regard to the specific uses being planned here, publication in the local newspaper should not require a release. The association's newsletter is in a much grayer area of the law, and the answer will probably come down to whether a particular

judge thinks that specific usage looks more like an editorial use or more like a commercial use. Despite that, my guess is that, as a practical matter, most associations and other non-profits do not typically get releases for that type of usage. The answer for the Web site is similar, and it will depend heavily on whether the Web site appears to be more commercial or more informational.

Q: A book publisher would like to use some of the photographs to illustrate youth sports. Is a release needed?

A: Typically no, again with the possible exception of photos used on the book jacket. Also keep in mind that publishers frequently want to use images from their books, and especially their book covers, in advertisements for the book. That kind of use would definitely require a release.

Q: Are there potential restrictions on using images in a book?

A: I'm assuming that the book is a traditional, editorial publication (whether in print or in e-book form), not an advertisement or catalog disguised as a book. In that case, the only requirements are that the images be published in a context that is truthful, without substantial manipulation, and that does not falsely make the subject come off poorly so as to damage his or her image or reputation.

Q: A manufacturer of sports apparel or soccer shoes wants to use some of the images in brochures and other advertising. Do I need to get a release for the identifiable players in those photographs?

A: Definitely, and not just from the players. If there are people in the stands whose faces can even remotely be recognized, you need releases from them (or you need to strip them out of the photos).

Q: If I decide to create a print exhibit for public display in a gallery or building foyer, do I need releases for the people in the photograph?

A: Probably not. If the building is clearly commercial—that is, the corporate headquarters of Acme Soccer Balls, Inc.—then the answer becomes much less clear. The potential problem is that the nature of the building could color a court's view as to the nature of the use. The same fine arts display that would be clearly a non-commercial use

in a museum or school could easily be seen as a form of trade or advertising in a commercial venue. For example, if the photos in the hallways of the Acme Soccer Balls building showed people playing soccer or making soccer balls, it could be both easy and reasonable to view those photos as advertising Acme's products—which is a use that definitely would require releases from any recognizable individuals.

Q: How about for an audio-visual presentation of images from the event?

A: This depends on the nature of the audio-visual presentation. If it is for educational or entertainment or some other non-commercial purpose, releases are typically not required. However, if it is part of a sales presentation, you would need releases.

Q: Am I allowed to put any of those images on my own Web site?

A: Again, that depends on the nature of your Web site. If it looks more like an electronic sales brochure, you would need releases; if it looks more like a virtual art gallery, you probably wouldn't.

Q: What resources would you suggest photographers read or access to get a better understanding of the subject of releases?

A: Trade associations like ASMP have both Internet and print information that is very helpful. In addition, there are lots of books that deal either exclusively or substantially with this subject. The Web is a great research tool, and there is an immense amount of material available through a simple word search. However, you should be very, very careful in relying solely on Web information. There is virtually (no pun intended) no accountability, and there is a ton of bad information on the Web. If you read something on the Web, my recommendation would be to rely on information either provided by people who have published the same information in print form or that is confirmed in multiple sources.

Q: What should photographers do if unsure about the necessity of a release?

A: First choice: Get a release. Carry stacks of the forms in your camera bag. Don't expect to be able to get a release after the event is over—it is likely to be difficult to impossible to identify, let alone contact, all of the people involved. Also, once

people are removed from the event, they are often more reluctant to sign releases.

Second choice: Carry lots of liability insurance that specifically covers this kind of claim. And, no, I am not being sarcastic here. If you are going to work as a professional, you need to do business as a professional. Do you know any doctors or lawyers who don't carry malpractice insurance?

Third choice: Make a risk-reward analysis. Photographs do not usually generate enough of a licensing fee for any single use to cover the costs of defending a lawsuit.

Points to Ponder

- Demonstrate to sports clubs or association officials that you are serious about what you want to do. This will help you get access to their events.

- A sample portfolio of what you have in mind will help open doors for you. Keep the portfolio to about five or six images.

- Point out that your photographs could very well help the club or organization promote their activities.

- Be enthusiastic when you approach an official or coach. It's hard to say no to someone who is genuine and enthusiastic but needs help to succeed.

- Coaches can be a great help in getting access.

- Once you've got access to photograph events at a club or association level, get a letter or some other credential. It could save having to explain yourself to people not aware of your association with the organization.

- The photographs you are making could be of interest to your local newspaper or some other regional publications. It's worth investigating that potential outlet for your work.

- Read the section on model releases to determine if you need them. Get releases when you can.

SELF-ASSIGNMENTS AND SPECIAL PROJECTS

8

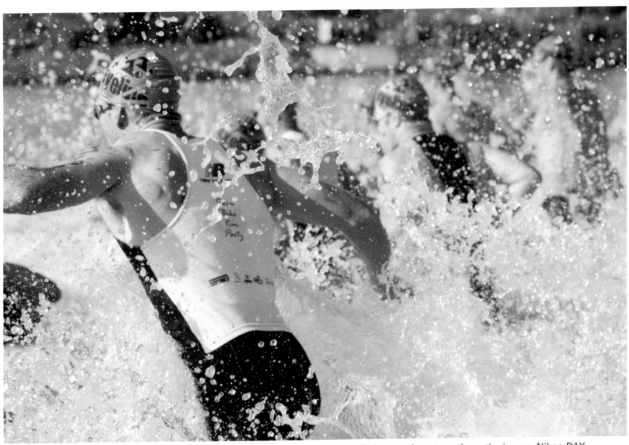

Water boils and erupts as swimmers surge forward at the start of a triathlon. Tight cropping strengthens the image. Nikon D1X, ISO 200, 80–200mm f2.8 lens, 1/1000 at f6.3. © Peter Skinner

Once you've mastered the basic techniques of sports photography, put your skills to the test. A good way to do that is with a self-assignment or a series of them that will test your skills. Most photographers get the urge to shoot self-assignments, and while they often take shape in the mind's eye, the evolutionary process can grind to a halt unless the extra step is taken—making it happen. It will be worth the effort. Many successful professional photographers jaded by the routine of studio work often take time to photograph subjects that are far removed from their typical commercial work. They do this simply to keep their creative juices flowing. Similarly, you can initiate a self-assignment centered on a sports subject that appeals to you and is easily accessible. The key is to pick a subject that will be fun and exciting, and also a challenge. And you'll probably get more satisfaction from a project that you can work on over time.

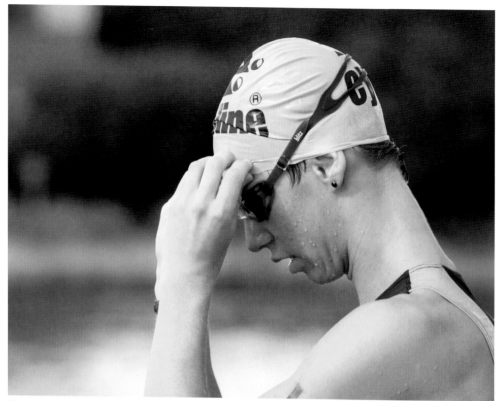

Athletes concentrating and preparing for the start of a triathlon make wonderful portrait subjects. A long lens and wide aperture isolate the subject from the background. Nikon D1X, ISO 200, 80–200mm f2.8 lens, 1/200 at f6.3. © Peter Skinner

set a pace you feel comfortable with.

Once you've determined your subject, create an outline and a shot list. Write your ideas down, and you'll find one idea will trigger others. As you develop picture ideas, think about the lens and lighting you're likely to use to make the photographs. Create the images in your mind and really think about each. That will give you visual goals rather than merely going out and making random shots. Along the way, even as you are photographing, other opportunities will present themselves. It's all part of the process.

The Photo Essay

A photo essay is a collection of photographs that tell the story of a single event or subject. It should have a powerful, eye-grabbing opening image, a series of story-telling pictures in the middle, and a strong ending photograph. The great magazine photographers of the fifties and sixties, whose work in publications such as *Life* and *Look* remain classics of the genre, pioneered the concept of the photo essay. When working on a photo essay, make sure the pictures you're planning support the overall theme. That will help keep you on track.

Getting Started

For a start, don't be too ambitious. If the project's logistics make it nearly impossible, you'll probably give up. Be realistic and set achievable goals. You do not need to complete the project in record time;

Self-Assignment Triathlon

I selected a triathlon as a self-assignment because I knew the event involved hundreds of men and women athletes of different ages, it was multi-disciplined—contestants swam, biked, and ran—and thus offered a wide variety of subject matter ranging from action to portraiture. Prior to the event, I checked the course layout and made a shot list of "must gets" which included the start of a swim, swimmers emerging from the water, a section of the bike leg, and runners on the course.

Because I was going to be moving around the course, I checked with officials to see whether there were any sections that would be closed or whether access would be limited. They told me marshals would control traffic on the course, and to simply work with them to get to where I needed to go.

To take the self-assignment exercise another step, I elected to use just one lens, one of my favorites, the Nikon 80–200mm f2.8 zoom lens

and a monopod. I used a Nikon D1X, set the white balance on 6300K because conditions ranged from sunny to overcast, and shot in RAW, so that I would capture in the highest quality and be able to adjust the white balance (color temperature) or exposure if needed before converting to JPEG or TIFF. (See Selecting Image Quality in chapter 2.)

Most of the time, I used aperture priority and center-weighted metering but occasionally used spot metering, especially in situations where the athletes were

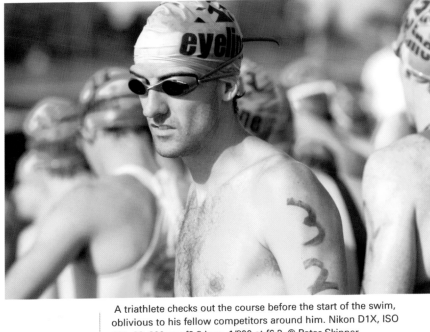

A triathlete checks out the course before the start of the swim, oblivious to his fellow competitors around him. Nikon D1X, ISO 200, 80–200mm f2.8 lens, 1/800 at f6.3. © Peter Skinner

backlit. (See In-Camera Metering Systems in chapter 3.) To a large extent, I relied on auto focus but did use manual focus for some of the bike section shots.

A triathlon is an ideal self-assignment project simply because it offers such a variety of subject matter in one event. In fact, if you adopted the team approach and worked with other photographers, you could undertake a project along the lines of *A Day in the Life of a Triathlon* documenting virtually every aspect from planning through to the end of the event. (See The Team Approach in this chapter.)

Self-Assignment Possibilities

Subject matter is limited only by your imagination and the following are the tip of the proverbial iceberg. Within each of these suggested topics, the scope of the exercise will depend to a large extent on how far you want to explore the subject. With self-assignments you can determine the subject, scope, time frame, and uses for the end result. The key is to concentrate on something you will enjoy photographing.

A school sports event. This could be a single game, a track and field meet, or swimming carnival.

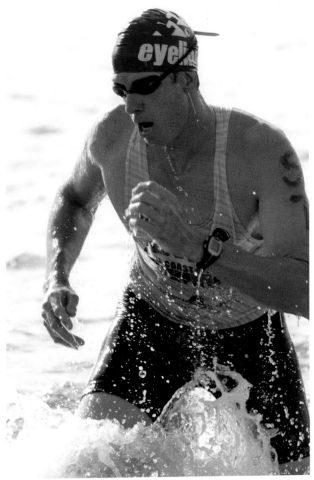

Spot metering to ensure accurate exposure, and backlighting to enhance water cascading from a triathlete as he emerges from the water, contribute to this image. Nikon D1X, ISO 200, 80–200mm f2.8 lens, 1/750 at f6.3. © Peter Skinner

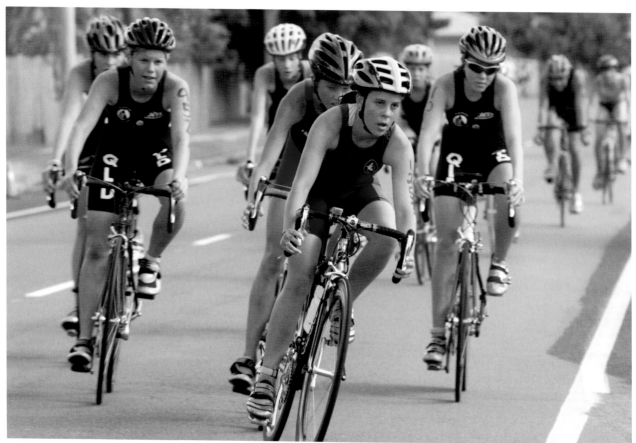

Cyclists lean into the turn near the conclusion of the biking leg of their triathlon. A long lens compresses the field. Nikon D1X, ISO 200, 80–200mm f2.8 lens, 1/180 at f8. © Peter Skinner

Make a list of potential images and then determine the equipment needed. Don't simply get to the event as it starts. Plan ahead, make contact with officials, and stick with your game plan.

A season of Little League. If your child were on a team, photographic coverage of an entire season would constitute a wonderful record of your child's interaction with other team members, opposing teams, coaches, and supporters. This would be an excellent subject if you lived in a small community, as your project would probably create considerable interest and support.

A season of any sports team. The same approach as for a season of Little League could be taken with any team with which you are associated or have an interest.

A single game. This would be a relatively straightforward assignment, but plan ahead, make a shot list, and vary your coverage by using lenses of different focal lengths and shooting from different locations.

Documenting just one player. Concentrate on a single player before, during, and at the conclusion of an event, or even several events or a season. Make a detailed shot list covering a variety of images from close-up details and intimate portraits to action shots.

A day in the sporting life of your Little Leaguer. Documenting the Little Leaguer's day (or any other sports identity you want to photograph for the day) would include photographs of him or her getting ready, with teammates, listening to the coach, practicing, in the field, hitting the home run, or kicking the winning goal. And don't overlook the after-match possibilities. Win or lose, undoubtedly there will be photo opportunities.

Editorial portraits. Sportsmen and -women usually make ideal subjects for portraits. Portraiture is much

more than simply making head-and-shoulders shots of people, and volumes have been written about the subject. Lighting is the key to great portraiture, and should you decide to embark on a self-assignment of editorial portraits of sportspeople—and don't overlook coaches and other staff involved with a team—study the work of renowned editorial photographers such as Arnold Newman, Greg Heisler, and Annie Leibovitz to see what's possible. The essence of a good editorial portrait is one that says something about the subject and identifies him or her with either the sport or some other favorite activity. It's a challenge and potentially a lot of fun. Use a range of lenses from wide-angle to telephoto and lighting from ambient to artificial to test your technical skills. Keep it simple and uncluttered.

The definitive shot. This is possibly the hardest photograph to create—the one single image that defines the event or game. It's a challenge that confronts many newspaper photographers each day. How do you make one photograph that says it all? Thorough research and being knowledgeable about the event is a good start. Perhaps a player is going to try to break a long-standing batting record; or possibly kick a field goal that will set a new team standard. Probably the best advice on this topic is to study photographs in leading publications that illustrate a major achievement and analyze them to see how they defined the moment.

The Team Approach

Working alone is one of the drawbacks of freelance photography. And you might express the same sentiment if you're working alone on a sports self-assignment. If so, consider a team approach and co-opt the aid of one or more like-minded people.

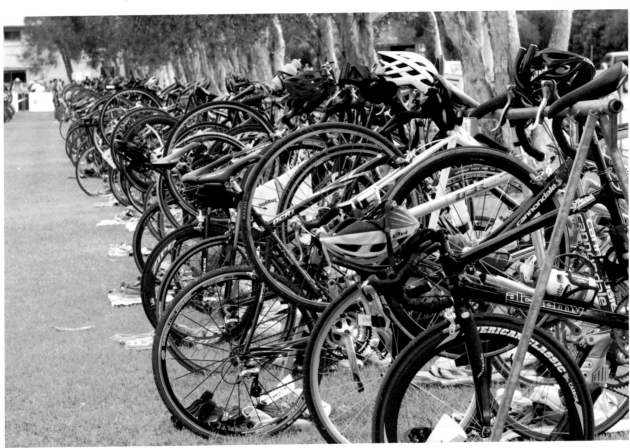

Bicycles lined up in the transition area of a major triathlon are ideal to convey the story of the event. Nikon D1X, ISO 200, 80–200mm f2.8 lens, 1/125 at f8. © Peter Skinner

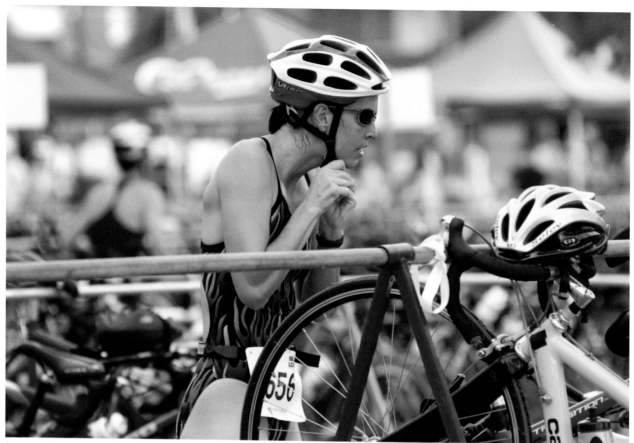

A triathlon is a wonderful subject for a self-assignment because of the variety of events and the range of equipment used. Here an athlete adjusts her helmet prior to launching into the bike leg. Nikon D1X, ISO 200, 80–200mm f2.8 lens, 1/320 at f5. © Peter Skinner

For instance, two or three parents could form a photo team to document their kids' Little League team for a whole season. It would probably be great fun and could result in a collection of memorable photographs. As with any team, you'll need a leader or coordinator to establish a game plan from the start. Determine the strengths, or favorite subject matter, of each team member and gauge where these overlap. For example, one might enjoy documenting sideline activities—such as cheering fans or the crowd—while another might be good at capturing action.

Testing Yourself with Just One Lens

An excellent way to keep things simple and also test your visual and technical proficiency is to go to an event with only one lens. Okay, you can use a zoom lens but you would probably benefit more from the exercise by using a lens with a fixed focal length lens. If you decide to try this exercise, think about picture possibilities or what you want to achieve and select the lens accordingly. It would be unrealistic to take a long lens if you want to shoot overall crowd shots. Alternatively, if you want to isolate tight action images, a wide-angle lens would not be a good choice. Be aware that you will see many pictures that will be impossible to capture, and while this might be frustrating it's part of the process.

A wide-angle lens of 20mm, 24mm, or 28mm (film camera equivalent) would be an excellent choice. Get in close and take advantage of the increased depth of field. A wide-angle lens is very versatile and also easily handheld, so you could forego a monopod or tripod. Also, don't overlook using a normal lens (the 45–55mm film-equivalent focal length). Many great photographs have been

SPORTS PHOTOGRAPHY

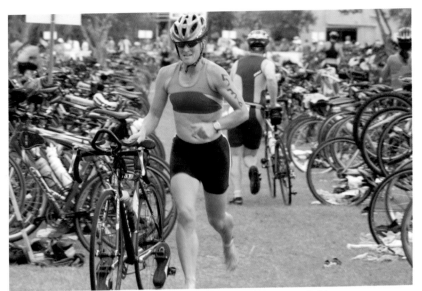

The transition area is a great place to photograph many facets of a triathlon, such as this competitor setting off on the bike section. Nikon D1X, ISO 200, 80–200mm f2.8 lens, 1/100 at f8. © Peter Skinner

Exhibiting the Work and Getting Sponsorship

The end result of a self-assignment could be a great hit with the team and its supporters. It could evolve into an exhibit, audio-visual presentation, or even a book, given that short-run printing is now a viable option. Also possible is the team's getting sponsorship from the local business community to offset expenses for both the production and public display of the work.

made with normal lenses. It's simply a matter of getting in closer for a tight shot, or backing off to get a wider angle of view. Another good choice would be a short telephoto in the 85–135mm range.

A longer telephoto lens is ideal for action images and other distant shots where you want to throw the background out of focus and isolate the principal subject, but there will be limitations with angle of view. Regardless of the lens you use, give this exercise a shot. It'll be a good test.

Points to Ponder

- With any self-assignment or project, make an outline and a list of potential shots.

- Contact club or event officials to obtain access and other support.

- Once you've selected the project, think in terms of equipment and lighting.

- Consider assembling a photo team for a more complex or longer project. A triathlon would be an ideal project for team coverage.

- If there is exhibit or other publication potential, consider seeking sponsorship.

- Use self-assignments to test yourself and your technical skills.

- Try the one-lens test—shoot an entire event with just one lens.

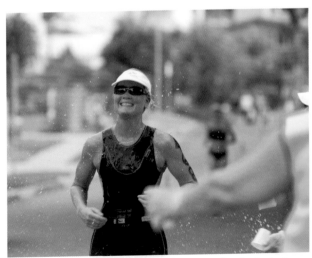

Water stations along the route provide the setting for typical triathlon images. Here an athlete welcomes a cooling shower near the end of the race. Nikon D1X, ISO 200, 80–200mm f2.8 lens, 1/400 at f4.5. © Peter Skinner

SPORTS PHOTOGRAPHY FOR LOVE OR MONEY

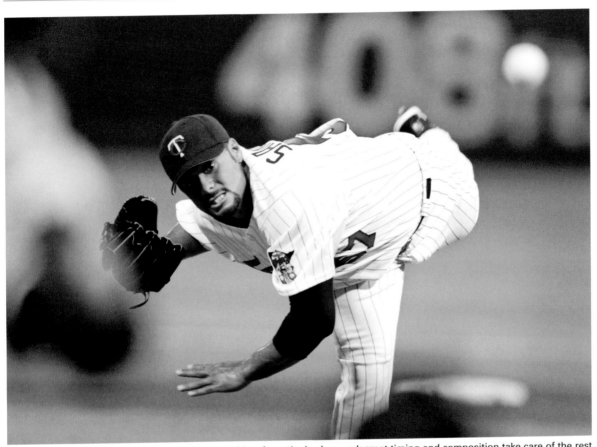

A long lens and wide-open aperture isolate the subject from the background; great timing and composition take care of the rest. This action-packed image of Johan Santana pitching at the Metrodome in Minneapolis was shot through a black net behind home plate. Canon 1D, ISO 640, 400mm f2.8 lens, 1/640 at f2.8. © Bruce Kluckhohn

Photographing sports that you really enjoy watching or are involved with can take your association with that sport to another level. And it can be a source of revenue to help cover expenses or even turn into a career.

The backgrounds of many professional sports shooters are similar. They worked on the high school paper; photographed for the school's sports department; shot a sport they played; or submitted photographs to their local small-town newspaper and then started getting regular assignments.

Many who work for major agencies or newspapers completed photojournalism degrees before interning and then getting staff jobs or contracts.

On Specializing

Concentrating on one sport is smart, especially when starting out. Advises Bob Woodward: "Pick a sport that you love and focus on it exclusively. That will allow you to become an expert in

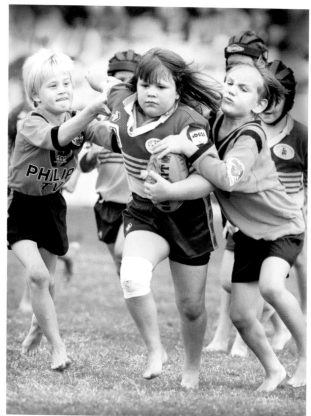

No international player could show more resolve than this young girl as she shrugs off would-be tacklers in a junior boys and girls rugby league game. Shooting action head-on pays dividends, whether it's adults or kids competing. Nikon 801, Tamron 300mm f2.8 manual focus, Fuji Reala ISO100, 1/1000 at f.8. © Duane Hart

shooting that particular sport which will in turn help you sell more images. Once you have mastered that, it's time to branch out and try other sports and see how you do with them, or photograph some non-sports subjects. By specializing to start, you get to know more about lighting, which lenses work best and when, the best shutter speeds for particular effects, the best angles to shoot from, and all the other things that contribute to good photography."

Sports Photography is Competitive

Sports photography is demanding, extremely competitive, and not the most lucrative field of photography. As competitive as it is, those who have made it their profession probably have done

so because, above all, they simply love sports and everything associated with the sporting life. They probably would not have it any other way. For many photographers, however, covering sports is a hobby. It's a way they can get more involved in sports and document that involvement, or their children's or friends' participation.

Covering Costs

The occasional hobbyist should have relatively little outlay on equipment, and the expense of film and prints will be minimal so recouping costs probably will not be an issue. On the other hand,

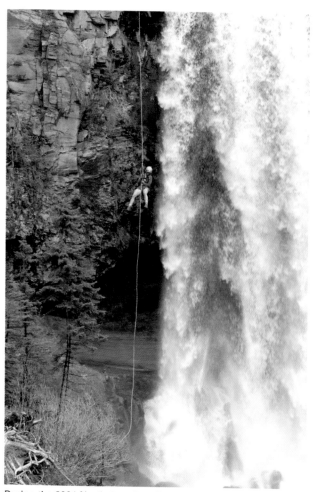

During the 2004 North American RAID adventure race championship, a long rappel down a steep cliff next to a waterfall was part of the course. Illustrated is the scope of the rappel next to the thundering waterfall. Canon 20D, 70–200mm f2.8 lens, ISO 100, 1/250 at f8. © Bob Woodward

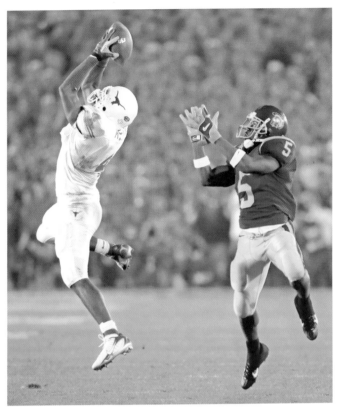

The pass was on its way and Ben Chen follow-focused on the intended receiver, USC's Reggie Bush. Texas Longhorns linebacker Drew Kelson broke up the pass attempt. Canon 1D MKIIN, 400mm f2.8 lens, ISO 1250, 1/800 at f3.2. © Ben Chen

ACTION SHOTS, TEAM PHOTOS, SPECIFIC PLAYERS

One way the serious amateur can recoup expenses—and how professionals make a living—is by providing prints for parents, players, and coaches. These can be action shots, individual portraits, or team photographs. In fact, if you are not adept at capturing the action but still enjoy being around sports, portraiture and team photography could be for you.

Many parents want good photographs of their children playing sports and will pay photographers to capture those images. This service is provided, and promoted, by many youth sports photographers—including Ben Chen and Steve Trerotola—and it's a matter of getting hired by the parents for the assignment. Youth sports photographs are featured in a variety of ways, such as trading cards, mock magazine covers, and composites.

Another photographer who has tapped into the youth sports market is Ron Pownall, a Boston photojournalist well known for his rock-and-roll photography and also accomplished in other editorial and commercial fields. As a former sports photographer, and now a baseball coach for his sons' teams, Pownall has returned to this profession. Pownall's business is Internet based and he markets his images through *www.westonsportspix.com* to capitalize on the demand for youth sports photography. If you're interested, check his site.

Two young soccer players display concentration and skill as they contest possession during a soccer game in Caloundra, Australia. Photographing the action head-on and from near the goal area is the best way to get a high proportion of good shots, regardless of the level of competition. Nikon D1X, 300mm f4 lens, ISO 250, 1/1600 at f5.6. © Peter Skinner

the photographer who has considerable investment in equipment and spends a lot of time at it probably would like to cover costs—or make a profit. There are ways to do this, but be prepared to be serious about providing a service for which you're charging. And if you are considering this as a career, you have to become a professional in every sense of the word. (See the Allworth Press books page for their other publications on photography as a career.)

Many sports associations and tournaments have contracts with professional photographers. So make sure you are not undermining or competing with someone who has done all the right business things and has contracted with officials to provide that service. Unethical photographers can seriously damage relationships between sports officials, players, parents, and other photographers. Don't be one of them.

Oomph! You can just feel the impact of the collision at home plate. Diane Kulpinski could see it coming and caught it on film. Canon EOS 3, ISO 400 Fujicolor, 100–400mm f4.5/5.6 lens, maximum aperture. © Diane Kulpinski

NEWSPAPERS AND SPORTS ORGANIZATIONS

Other possible users of your work are local newspapers and sports associations, especially in smaller markets. It's unlikely a paper such as the *New York Times* would be a potential market for you unless you were a professional freelance photographer with established credentials. On the other hand, a suburban or rural area paper could very well be interested in using your images if you meet their requirements and standards. Similarly, a professional league such as the NBA is unlikely to offer any opportunities for the beginner, whereas a lesser-known sports association or sport might welcome coverage of their events. It's also possible to combine some of the above outlets for your work. For example, you could be the photographer for a team or association and also provide photographs of their events to a local newspaper or other media. Activities like that go hand in hand.

Find a Good Lab

If you're going to sell prints, you'll need to create an efficient system for taking orders and delivering prints. So, establish a good working relationship with a processing lab. The Internet has transformed the way photographers can work with labs. Today, photographers can delegate the logistics of taking orders, collecting the money, and delivering the prints to labs and online fulfillment services. Numerous labs and other online photo services specialize in sports photography packaging. Of course, there is a charge for the service but it can streamline the operation. (See the Resources section.)

All Under One Roof

Some photographers—usually those with a large operation—prefer to do everything in-house, from taking the photograph and displaying the work online to handling orders and delivering the prints. One example is the Australian-based company Sporting Images (*www.sportingimages.com.au*) whose small team of photographers—mainly former newspaper photojournalists—covers a wide variety of sports action and also offers a team photography service. All images are shot with digital equipment and displayed online in code-protected sites from where orders can be placed. Images are then customized to the client's requirements such as size, borders, and text before being sent to a professional lab. Finished prints are then delivered by Sporting Images to the client. Sporting Images also provides magazines and other media with editorial images and has a stock photography division for editorial and advertising clients. This comprehensive and efficient service is an example of how a team of competent and talented photographers with a skilled support staff can provide a sports-related photography service to a wide range of clients.

"We can win this! Just hang tough!" Whatever this girl is saying to her teammate in a boys and girls junior rugby league match, she's certainly got his attention. Shots like this abound in youth sports. Nikon 801, Tamron 300mm f2.8 manual focus, Fuji Reala ISO100, 1/1000 at f2.8. © Duane Hart

On-Site Coverage and Service

Sporting events often hire on-site photographers to shoot teams and have prints ready by the end of the day. In the days when film reigned supreme, the photographers would make arrangements with a lab for quick turnaround. The pick-up and delivery

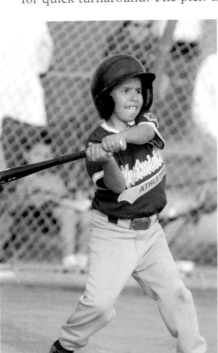

procedures were additional logistics to consider. Today, high-quality portable printers using digital technology have streamlined this process so the printing can be done on-site. (See Following your Dream—Diane Kulpinski in this chapter.)

Grit and determination are exuded by this Little League batter. Photographers shooting youth sports can profit from both portraiture and action coverage. Nikon D2H, ISO 400, 70–200mm f2.8 VR lens with 1.4X extender at 220mm, 1/1250 at f4. © Steve Trerotola

Getting Noticed

To get your foot in the door and impress a photo editor, you need an attention-grabbing portfolio. If you're just starting out, it's unlikely you will get access to the top levels of sports—not on the field or courtside—but you can still create a portfolio of sports photographs by shooting youth, college, and other competitions. Having a portfolio viewed by a photo editor requires ingenuity and perseverance. Some magazines have a standard policy on reviewing portfolios, so be prepared to make calls, write letters, or otherwise contact your targeted client to find out his or her procedure. Be prepared for rejection. It's something all photographers have to deal with at some point. The bigger the publication, the harder it will be to get noticed. A more practical starting point may be with smaller newspapers or magazines. Specialize in one or two areas, and make a comprehensive portfolio of those sports rather than try to be a generalist. Target your client with images of a subject(s) you really know and can photograph well.

There is always room for up-and-coming talented photographers, so don't give up if things don't go smoothly from the outset. Numerous outlets for good images exist, and even with the proliferation of photographers and the emergence of giant agencies, hard work and perseverance will pay off. All those well-known sports photographers whose credit lines you see in major magazines and newspapers, and in this book, had to start somewhere.

Photographing specific players has become a source of assignments for photographers such as Steve Trerotola. This Little Leaguer in the outfield is prepared for the action. Nikon D2H, ISO 400, 70–200mm f2.8 VR lens with 1.4X extender at 150mm, 1/1200 at f4. © Steve Trerotola

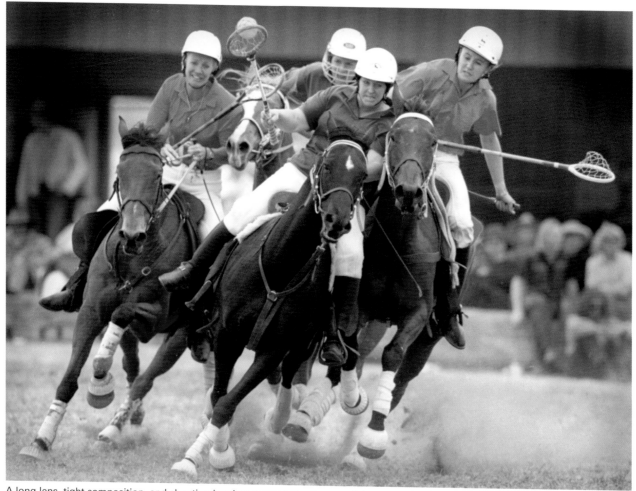

A long lens, tight composition, and shooting head-on create not only powerful images of polocrosse action but also eminently saleable ones. Nikon 801, 300mm f2.8 Tamron lens, manual focus, Fuji 800 film, 1/1000 at f2.8. © Duane Hart

(Read the biographies of our contributing photographers to get an idea of their background and vast experience.)

Stock Photography

Stock photography is existing photography that is available for use by clients for specific purposes. Many professional sports photographers make their work available as stock photography, either through agencies or from their own studios. As an example, Mark Johnson specializes in stock photography that is licensed by Corbis, his principal agency, and also several other agencies. For photographers like Johnson, one of the real benefits of shooting stock is the freedom to create images without the constraints of an assignment. But it's not a business for the faint-hearted.

Bob Woodward offers this advice: "Stock photography is a tricky business because of the dominance of two major stock agencies, Corbis and Getty, and the amount of cheap and free clip-art stock that is available today. I left a big agency and went on my own figuring that while the volume of my sales would decrease, the amount of money made on a smaller number of sales would turn out to be more. And that's how it has worked out."

Another alternative worth considering to reach buyers is the comprehensive online facility offered through Digital Railroad, whose services are best described by their company overview (*www.digitalrailroad.net*). In brief, it is an

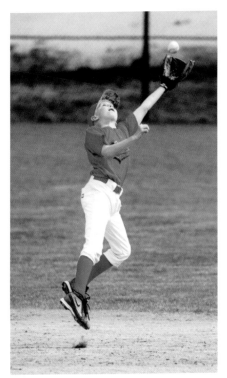

A big leap and a stretch were valiant but perhaps futile as the ball appears just out of reach. Great timing and technique isolated the peak action. Canon EOS 3, ISO 400 Fujicolor, 100–400mm f4.5/5.6 lens, maximum aperture. © Diane Kulpinski

application services company that is dedicated to solving critical technical problems facing the creators and buyers of digital imagery. Digital Railroad manages technology needs for creative professionals so they can focus on what they love: being creative.

There are numerous excellent sources of information on the business of stock photography including several publications from Allworth Press and on the Internet. Stock photography is crowded and competitive, but agencies do welcome new talent who can provide fresh and exciting images. The Picture Archive Council of America, PACA, a trade association for agencies, is a good initial source of information. (See the Resources section) (*Note*: Always retain your copyright in your work, so you can capitalize on its potential for stock photography.)

Workshops and Information Resources

There are sports photography workshops and seminars that specialize in giving hands-on instruction. Ben Chen offers a series of specialized workshops on photographing baseball, basketball, football, and soccer. Under Chen's guidance, participants photograph games using digital equipment and then later analyze and prepare the images for additional use. Each workshop concentrates on a specific sport, but the subject of general sports photography is also addressed. A bonus is that participants get to use an array of the specialized equipment that the pros shoot with, including super-fast telephoto lenses. Techniques such as setting up backboard remote-cameras to get high-perspective shots of basketball also are covered. As well as offering specific workshops, Chen conducts seminars on the business of youth sports. He can be contacted at *www.sportspixel.com* for further details.

Winter sports are popular subjects, but shooting in those conditions can be tricky. One place to

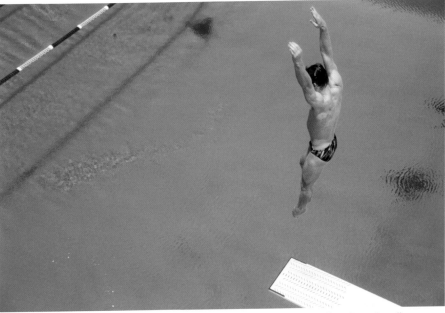

Perfect timing was the key to this well-composed photograph of Australian champion diver Robert Newbery shot from the 10-meter platform above the diver. Nikon F100, ISO 100 film, 70–200mm f2.8 lens, 1/1000 at f4. © Mark A. Johnson

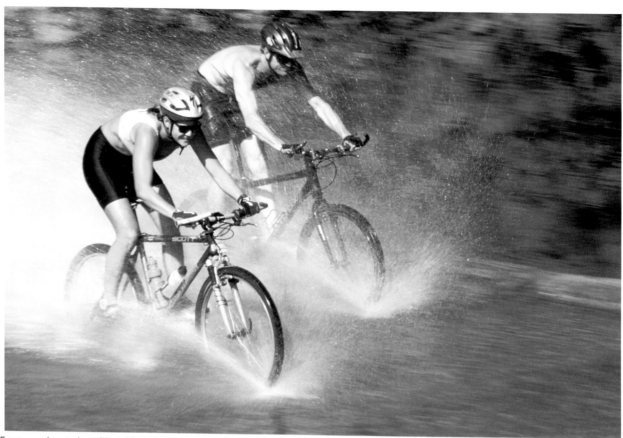

From an elevated position, Mark Johnson was able to shoot down while panning as these mountain bikers raced through shallow water. Nikon F100, 35–135mm lens, ISO 100 film, 1/30 at f22. © Mark A. Johnson

learn how to photograph snowboarding is at the High Cascade Snowboard Camp at Mt. Hood, Oregon—*www.hcscphotoworkshop.com*.

Several well-known major workshops (see the Resources section) often offer sports photography classes. Even trade associations for commercial, wedding, and portrait photographers, such as Professional Photographers of America, and Wedding and Portrait Photographers International, do have members who shoot sports, especially youth sports. They occasionally include sports photography workshops in their continuing education programs. As an example, WPPI has "All About Schools" at its annual convention, which includes a full day of programs on school photography and youth sports. Both the National Press Photographers Association, (NPPA), and the American Society of Media Photographers (ASMP), have many members who are sports photographers, and these leading trade groups provide information on the business of photography.

Points to Ponder

- When starting out, specialize in one sport until you feel confident about producing consistently good images. Then consider branching out into other sports or subjects.

- Don't give away your valuable images. Make sure you get something in

Cyclecross riders pause momentarily before taking the drop. Canon 20D, 70–200mm f 2.8 lens, ISO 100, 1/250 at f11. © Bob Woodward

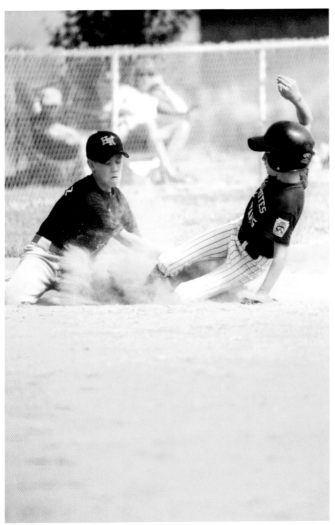

The runner slides and the dust flies. Anticipation, timing, and knowing the flow of play are essential in stopping the action. Canon EOS 3, ISO 400 Fujicolor, 100–400mm f4.5/5.6 lens, maximum aperture. © Diane Kulpinski

return so you don't undermine the work professionals do for a living.

- Don't try to sell prints at an event that is already being covered by contracted professional photographers. Unethical photographers can do great damage to everyone involved.

- Taking action shots, team photographs, and photographs of specific players are all ways of generating revenue.

- Local newspapers and sports organizations or teams could be your best starting points when looking for outlets for your photographs.

- Find a good lab and develop a working relationship with it. Knowledgeable lab personnel can be a photographer's best ally and resource.

- If you want to become a professional sports photographer, compile an outstanding portfolio of work that will interest and intrigue editors. Develop your own style that reflects what you really like to shoot.

- Your best work, especially if it's a comprehensive collection of a particular sport or fills a niche, could have great value as stock photography. Explore the possibilities of marketing your images as stock, but be aware that it's a highly competitive field and success won't happen overnight.

- Always retain the copyright in your images.

- Improve your photography by attending workshops and seminars. There are programs that specialize in sports photography that could really benefit you.

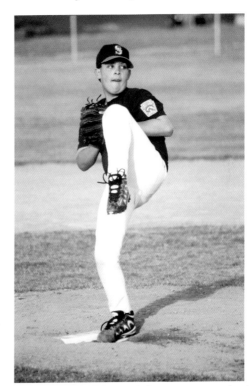

The windup, as the young pitcher prepares to unleash his fastball. Canon EOS 3, ISO 400 Fujicolor, 100–400mm f4.5/5.6 lens, maximum aperture. © Diane Kulpinski

Portraits of teams and individuals—T&I—are lucrative business for youth sports photographers. Canon 10D, 28–70mm f2.8 lens, fill flash. © Diane Kulpinski

Following Your Dream—Diane Kulpinski

Diane Kulpinski got her grounding in sports photography during her years as a newspaper photojournalist. When considering careers, the thought of a desk-bound job didn't appeal to the self-confessed "jock" and aficionado of the great outdoors so Diane opted for a degree in photojournalism, which she completed at Syracuse University, New York. Within days of graduating, she set off from her Philadelphia home on a cross-country trip to Alaska, interviewing en route by pre-arrangement with a series of mid-size newspapers, and finally accepting a job with the *Bulletin*, in Bend, Oregon. Since that time, August 1982, she has been immersed in photojournalism and while the varied assignments associated with community newspaper reportage demanded that

she photograph everything from studio food set-ups and portraits ("mug" shots) to general news and "arty stuff," Diane's real passion was for sports. As she gained seniority, became a photo editor, and got involved in middle management, Diane found herself doing more administrative work and not shooting as much as she would've liked. Adhering to the adage of "do what you love and follow your dream," she took the bold step of quitting her job to photograph children's sports with the hope that parents would buy prints of their kids in action. They did. And so Diane Kulpinski, *newspaper photojournalist*, re-invented herself as Diane Kulpinski, *freelance sports photographer and businesswoman*. She started out using the same film equipment as she had with newspapers, went digital for some subjects in 2000, and then about six years later expanded her scope of operations to go all-digital to include on-site printing at tournaments.

What Diane did, and how she did it, might inspire and encourage you to follow suit. With that in mind, we asked her a few questions about her business, which is still based in Bend, Oregon.

Q: What was the first "gig" in your freelance sports career?

A: I was told about a local baseball tournament for Little League–aged kids, so I arranged to shoot that. It was a great success. The parents, the kids, and I liked it. From then on, parents started telling me about other tournaments, and other sports that their kids were involved in. And they gave me contact names and dates. I took it from there.

Q: What sports do you cover? And do you shoot team portraits?

A: Mostly the traditional team sports—baseball, softball, football, some soccer, basketball, and wrestling. The majority of my work involves team portraits, known as T&I—Team and Individuals. Most youth sports photographers start with the T&I and get into action. For me, it was the other way around. I started in action and was asked if I could do the T&I. Of course, I said, "Yes, I can figure that out!" It is definitely volume/production type of work, but it is lucrative. You don't have much time to spend with each kid, so everything is formulated. I try to be as creative as possible and use different angles or poses to keep things fresh. If it's a smaller group, I'll let the kids decide how they want to pose, within reason.

Q: What equipment do you use?

A: I used to shoot my action tournaments on film with a Canon EOS 3 and a 300mm f2.8 lens and 1.4X extender, but now I use digital equipment and provide on-site printing at events. My principal equipment for sports action is a Canon 1D Mark II with the 300/2.8 and extender. I use other lenses, such as the 20–35mm f2.8 and 70–200mm f2.8 for action and other subjects as well.

Q: How do you display your work, and how do clients order prints?

A: I used to shoot action with film and return the following day with 4"x6" prints in plastic sleeving separated into two or three folders per game. This would require the services of a one-hour lab to turn around the prints quickly. Clients would buy

This portrait of a young football player is sure to find a place in the family album. Note the scene-setting goal posts in the background. © Diane Kulpinski

what they wanted from the folders. If they wanted enlargements, they'd fill out an order form and I'd mail them out within two weeks. With digital, I print on-site. Clients fill out an order form for the printer person to fulfill at the event and we supply 5" x 7" and 8" x 10" prints. Anything larger is sent to a lab and mailed to the client. However, while I shot action with film I have been shooting my T&I and most other work digitally since 2000.

Q: What film did you use, and why?

A: I shot Fujicolor ISO 400, 200, and some 100, but mostly the 400. I've always loved the pop and saturation of color with Fuji film, particularly when you're dealing with colorful uniforms. The advantage of film is that I didn't have to invest in

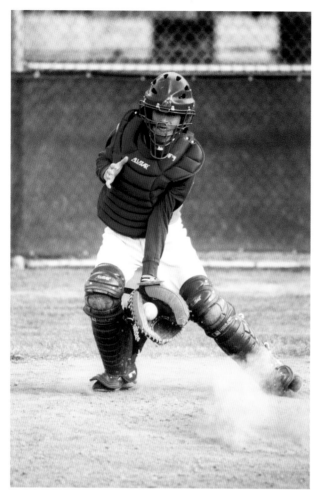

The catcher and the photographer were on the ball, as the throw to home plate ricocheted off the ground. Canon EOS 3, ISO 400 Fujicolor, 100–400mm f4.5/5.6 lens, maximum aperture.
© Diane Kulpinski

sheets out at the games and had people order at the event. I also posted online. Sales were better overall, but again, the Web sales just trickled in and often a month or two after the event. The next year I dropped the Web, because it just wasn't worth the hassle of pulling images and re-working them, getting them printed and mailing them out a month or two after the event was over. I only took orders on-site, had them fulfilled at a local lab, and mailed them out. From my experience, it seems sports action is an impulse buy. Sales are made during the excitement of the event so the on-site printing service takes full advantage of that. The problem with Web sales for action shots is that people seem to forget about buying photos

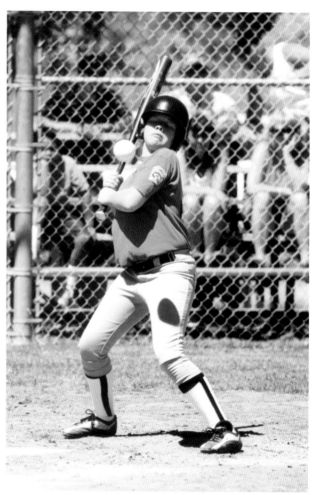

"Hey, that was close!" The batter pulls back as the pitch whistles by his chin. Diane Kulpinski's timing was right on. Canon EOS 3, ISO 400 Fujicolor, 100–400mm f4.5/5.6 lens, maximum aperture.
© Diane Kulpinski

lot of equipment such as printers, personal computers, and laptops, software that will constantly have to be updated, not to mention a vehicle to haul it all so I can do the on-site printing. I also didn't have to have a staff of four to five to work a tournament, something I could do with two or three staff when shooting film. The disadvantage of film was that I'd be up till the wee hours stuffing photo pages and putting them into the folders. It's typical to put in close to 30 hours during a two-day tournament.

Q: Do you use the Web for sales?

A: The first year, I put the images online. Sales were okay. The following year, I printed proof

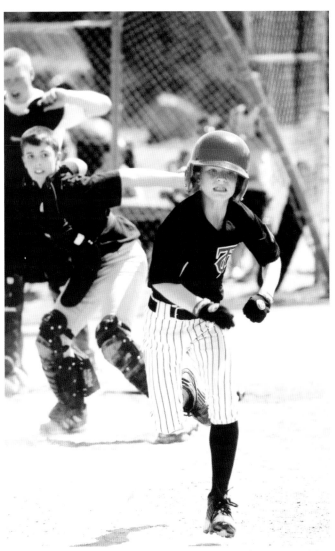

Q: And finally, what do you enjoy most about photographing youth sports?
A: Capturing the potential of kids. That's really what I hope to pass on to my clients. I want them to look at the images that I've captured and to know, now and in the future, the incredible abilities that they—and we—all possess. By looking at images that make them look good, I want them not only to have fond memories but also to remember what it feels like to be strong and graceful at the same time. I want them to feel empowered so that they create the lives they want.

A dramatic play unfolds as the batter heads for first base and the throw is on the way. Canon EOS 3, ISO 400 Fujicolor, 100–400mm f4.5/5.6 lens, maximum aperture. © Diane Kulpinski

once they have left the event. It's an extra step for them to take on their own to get that sale. The clients really have to be motivated, because it's not as easy for them. I'm hoping that by printing on-site, I'll increase the percentage of sales, as well as increase the average dollar amount per sale. I'm going to have to do that in order to pay for the investment and the staffing. I do plan to post images online for ordering once again. But they will only be available for a short period of time after the event, perhaps a week or so.

Eyes on the prize. No NBA player could focus on a shot any better than this. Canon 1D, Mark II, 70–200mm f2.8 lens, electronic flash, 1/200 at f2.8. © Diane Kulpinski

INSIGHTS—PUTTING THINGS INTO PERSPECTIVE WITH WALTER IOOSS

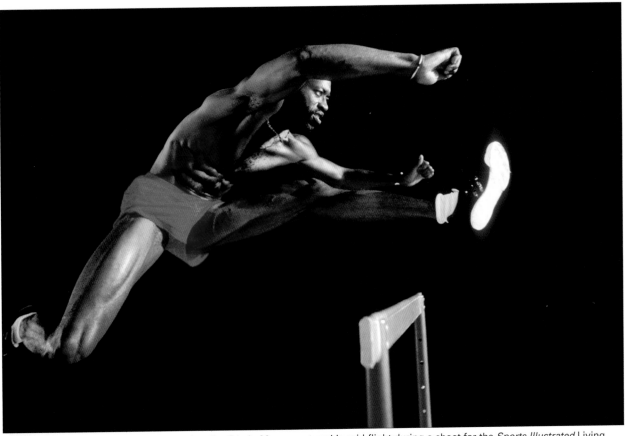

Olympic and world champion 400-meter hurdler Edwin Moses captured in mid-flight during a shoot for the *Sports Illustrated* Living Legends story. Walter Iooss used a large, black velvet backdrop, and enhanced natural light with gold fill for beautiful edge lighting. He shot with a 35mm lens from a low angle and used Fujichrome 100 film. © Walter Iooss

Most sports photographers aspire to shoot the big game, the major event, the World Series, the Olympics, world championship fights at Madison Square Garden, and in any other arena where the best pit their talents against each other. And Walter Iooss, the doyen of sports photographers, has certainly been there. Even after forty-plus years at the pinnacle of the genre, he continues to create stunning photographs of sportsmen and -women whose names and deeds are the stuff of legend.

Mention the words "sports photographer," and chances are Iooss' name will be among the first to follow. Since he first started shooting sports in

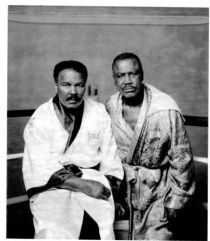

Two old warriors reunited. October 2003 was the first time in thirty years that Muhammad Ali and Joe Frazier had posed together. And Walter Iooss, who took the portrait in Frazier's gym in Philadelphia, was looking for a more joyous image than this somber outcome. However, all who saw the result—including the subjects—liked it. The shot was made with a Polaroid 20" x 24" camera. © Walter Iooss

high school—and cracked his first assignment for *Sports Illustrated* at age seventeen—Iooss' images have graced the covers of more than 300 issues of *Sports Illustrated*. He's covered five Summer Olympics, virtually every other major sports event, and photographed the greatest athletes who have run, jumped, hit balls, dived, or kicked.

He's had access to the fastest, strongest, most talented, and enduring athletes of all time—as well as the beautiful women who adorn the annual *SI* swimsuit issue—and the images he has created of these people have become as iconic as the subjects themselves.

Street Games and Stickball

But—and amateur photographers must take heart at this—as exciting and as challenging as is photographing the greatest competing at the greatest events, Walter Iooss gets as much, if not more, satisfaction from shooting sports at its most basic level: in the street, on the beach, or in dimly lit gyms where kids and unknowns are the stars. He gets charged at seeing kids living out their dreams in such down-to-earth pursuits as street stickball matches or beach volleyball and his

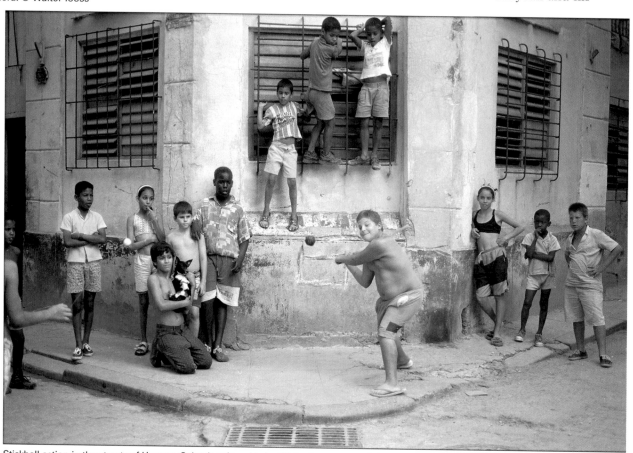

Stickball action in the streets of Havana, Cuba, is referred to by Walter Iooss as an all-time favorite shot of his. Iooss was doing a story for *Sports Illustrated* when he came across this classic scene. Shot with black and white film and a 50mm lens, the image is a wonderful example of how evocative sports photographs can be made far from the grand stadiums of international competition. © Walter Iooss

SPORTS PHOTOGRAPHY

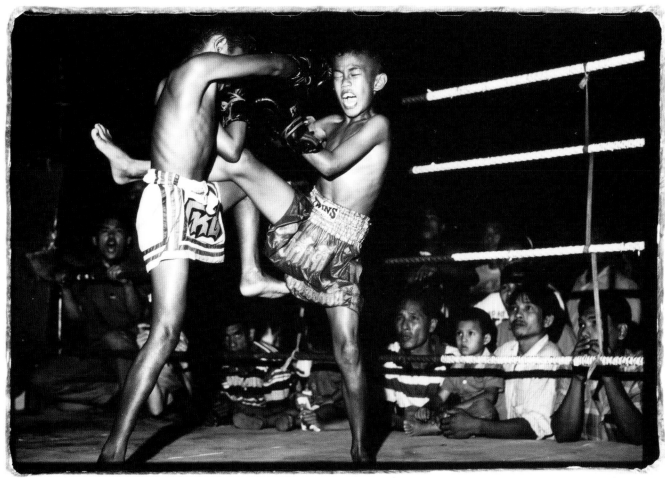

While working on a story on Thai kickboxers for *Sports Illustrated*, Walter Iooss found the reception accorded by the athletes a far cry from that usually given at major events in the USA. "They seemed happy to see me, " he said. Access to the lesser lights of the sporting world is usually easier to obtain than trying to get into major league events. © Walter Iooss

excitement is reflected in photographs that capture the very essence of these unheralded contests. Credentials are not needed to photograph sports at this level where contestants play for the sheer love of the game. But you do need the vision to be able to extract meaningful images from these environments.

While conceding that who you photograph when compiling a portfolio does help impress editors, Iooss enthusiastically maintains that he would dearly love to go back to shooting kids' athletics and Little League events. "Those subjects are beautiful to photograph," he said.

A classic case in point is the photograph of street kids playing stickball in Havana. "The shot of the kid hitting the ball captures a decisive

moment, and it was taken with nothing more than a normal 50mm lens, and a relatively unknown black and white film called Delta, not Tri-X or anything like that. I made about twenty shots and got one of my all-time favorites," he said. The image is featured as a double-page spread in Iooss' unique book *SPORTING LIFE: The Journals*, a wonderful compilation of pictures, words, newspaper headlines, and other intriguing memorabilia that chronicle part of the Walter Iooss journey through photography and life. Every sports photographer, or aspirant at any level, should have a copy of this book in his or her library. (See the Resources section.)

Considering the tens of thousands of superb photographs he has made in his four-decade

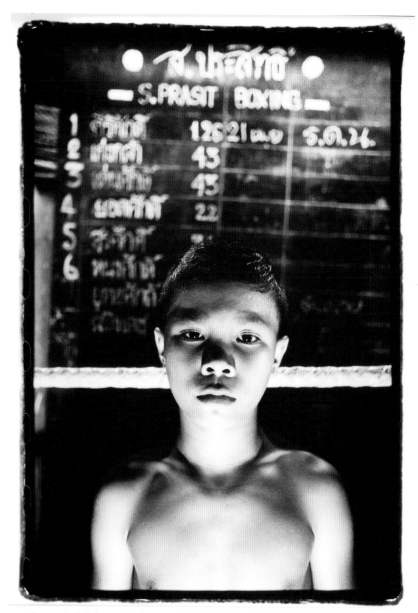

Dramatic lighting and a front-on pose combine to create an intriguing portrait of this Thai kickboxer. © Walter Iooss

The Vision Behind the Sporting Life

Iooss stresses that the camera is just a tool and great images come from the mind and vision of the shooter; if the subject matter is real and honest, the probing visual communicator will bring that out. And while technology is a powerful tool in the right hands, it's not the most important factor. "There is always room for talent, and even though technology has leveled the playing field, the best will always get noticed. When I started out, it was all manual focusing and exposure and anticipation. Those who could do it best, and consistently produced great pictures, rose to the top. Then came along auto focus and auto exposure and other technological improvements, so most people could get a sharp photograph. But the good guys still rose to the top. Technology doesn't make you a better photographer, it just makes mediocrity less mediocre," he said.

The Backyard Field of Dreams

career, that Iooss enthuses about this particular image provides insight into the make-up of a great photographer. And it also should encourage aspiring sports shooters without access to the Tiger Woods, Michael Jordans, Cal Ripkens, or Joe Montanas of the world to take heart. Virtually any photographer, anywhere, can get access to kids playing games.

No sports arena is more honest and basic, or the contest more pure, than on the street where kids compete at whatever sport you name for the sheer love of the game. This is where you find the reflections of the dreams you had as a kid, where the game itself is something of a fantasy world, the backyard field of dreams. Why does Iooss like documenting the action and making portraits of the contestants in this environment? "Because I am able to shoot them without restrictions. I am the only one there and usually welcome, unlike the major sports where the players are tired of the

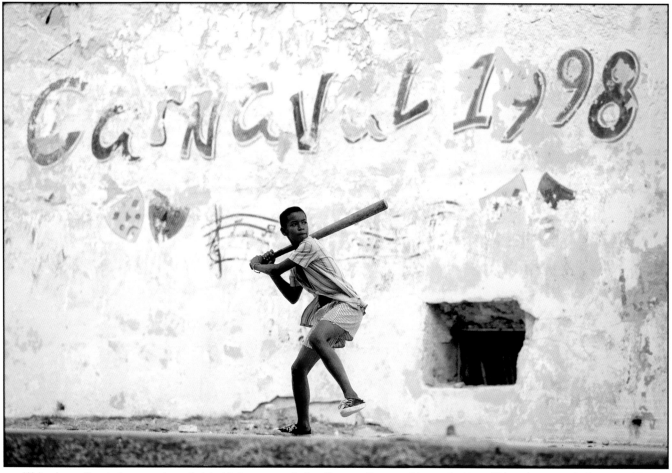

Walter Iooss likes to incorporate walls into his images, and often those walls are emblazoned with graffiti or slogans as is the case with the street stickball hitter in Havana, Cuba. © Walter Iooss

media and can resent the intrusion. When I did the series on the kickboxers in Thailand, they seemed happy to see me; a bit different from the major leagues here," he said.

In fact, Iooss says that while photographing the major leagues might sound exciting—and it can be—the events are a nightmare with packed sidelines, tight security, and intense competition. But, on the other hand, they also provide the opportunity for great photographs of the best performing at the highest levels of competition, so professional photographers are duty bound to also compete there. It's akin to a rite of passage at some stage in a sports photographer's career.

Empathy and Simpatico

A key ingredient in any successful photographic pursuit is knowledge and understanding of the subject, and competent sports shooters have it. However, much more is required to rise above the pack. Intangible qualities—such as empathy, simpatico, an understanding of the intense pressures—come into play. It is clear that Iooss has great respect for his subjects—the famous and not so famous alike—a trait that makes him welcome on the grand stages of sport and also at the down-to-earth playing fields where lesser lights strut their stuff.

Being able to get along with people from all backgrounds and being naturally gregarious have

Michael Jordan as photographed for the cover of the best-selling monograph *Rare Air*. A white textured wall made a simple, clean backdrop that imbues a studio feeling to the image. © Walter Iooss

in a nice way that burns no bridges. Great coaches can urge, cajole, beg, encourage, and motivate athletes to perform on the field. Similarly, Walter Iooss gets the most from those who perform in front of his lens.

The images that emanate from the vision of Walter Iooss are sweaty, gritty, real, honest, and technically superb. They are worth studying as much for their technical and artistic merit as for the subject matter. The sixteen-year-old kid whose entry into photography was running along the sidelines using manual focus short and long lenses to capture football action, and whose initial structured photographic education was an accelerated fundamentals course at German School of Photography in New York City, has become a master of lighting and composition. His photographs, whether of people or places, are imbued with exquisite lighting, ranging from the golden hues of dawn or dusk to carefully controlled artificial and enhanced light. Much of his lighting is also dramatic, harnessing the interplay and light and shadow to great effect. Angles, especially shooting from down low, and motion blurs play a great part in his pictures.

Walls as Backgrounds

Walter Iooss really likes incorporating walls into his work; they give the feel of a studio on location. If a wall is not available, he'll create his own for the occasion, especially if he's looking for a cleaner look to the shot. A classic case is the cover of *Rare Air*, the 1993 monograph (Harper Collins) on Michael Jordan that topped the *New York Times* bestseller list. The cover shot, with a white textured wall as a backdrop, was made on the roof of the Mayfair Hotel in Miami. "I asked the lifeguard to hold an umbrella over Michael, and I put a large white umbrella on the ground to bounce the light back into his face. The wall was perfect," said Iooss. The walls featured in Iooss' photographs are often emblazoned with color, advertisements, rough texture and bold lines—much like the photographs themselves. Iooss was once quoted as saying he'd never met a wall he didn't like.

also contributed to Iooss' success rate. An all-around athlete himself, and at one time a competitive tennis player, Iooss has those traits as well as the innate sense of the "athlete psyche." He knows what makes athletes tick; and they, in turn, know and appreciate that he knows. There's a very good reason that people like Michael Jordan, Edwin Moses, Arnold Palmer, Tiger Woods, Alex Rodriguez, Marion Jones, and virtually any other sporting icon you can name, are at ease working with him. They are professionals, and so is he. In his own way, he is as demanding—of himself and those around him—and as goal-oriented as his subjects. Getting "the shot" is paramount, and Iooss will do what it takes but invariably, it seems,

Shooting for the Gold

Photographer-aficionados of the Olympic Games will know that the 1984 Summer Olympics in Los Angeles really put Fujifilm on the map in the United States. And Walter Iooss played a major role in that achievement. His *Shooting for the Gold* assignment, a two-and-a-half year project, was itself of Olympic proportions. When Iooss got the initial call from Fuji, and attended the subsequent meeting with the company's personnel and agency, he thought he was being asked to shoot for an ad, not participate in a highly-paid dream assignment with great access and few restrictions. It meant he had to quit his staff job with *Sports Illustrated*, not an easy decision to make considering his status with *SI* and that he knew little about Fuji's product. But he went ahead, and it's now history that Fujifilm carved an indelible niche within the ranks of sports shooters and beyond.

Much has been written about *Shooting for the Gold* (the book was published by Jameson) and Iooss' trailblazing photographs, but for him the shot that stands above all others is of diver Greg Louganis—"my miracle shot"—as he dives upward against an eerie, dramatic red sky and streaks of poolside lights. It's a classic Olympic portrait that will surely stand the test of time. (See *The Definitive Image* on page 131.)

Iooss has photographed at five Olympic Games (1968, 1976, 1984, 1996, and 2000), covered virtually every major sporting championship, and had access to the swiftest, strongest, and most beautiful. If given the choice of covering an Olympic Games, a World Series, Superbowl, Pipeline Masters surfing, or an *SI* swimsuit assignment what would he choose? "It'd have to be the *SI* shoot; but not for the obvious reason. It'd be for having complete control of the shoot. When you're covering an event, you can't control what's happening. With an assignment like the *SI* swimsuit shoot, you can. Now, if offered a week shooting the Williams sisters, or Tiger Woods, I'd probably go for that," he said.

On Going Digital

For most of this career, Iooss has shot with traditional SLR equipment and film (Canon equipment and Fuji Velvia were his favored tools). He is now shooting digital—at this writing, a Canon DS II—and appreciates how it handles low light and its ease to work with, especially in situations where the ISO has to be altered to suit changing light conditions. But making the transition has not been easy. He still misses some of the traditional aspects of shooting film, such as being able to browse through a stack of Polaroids while on the flight home from a shoot. He appreciates, however, that most professional photographers have to shoot with digital equipment and *Sports Illustrated*'s photographers certainly do.

On Being Versatile

While Walter Iooss is recognized principally for his sports photography, his portfolio contains a wide diversity of other subject matter, from landscapes to travel, fashion, and beauty. The latter two categories, fashion and beauty, are best epitomized in the shoots for the *SI* swimsuit issues. Perhaps less known are his travel and landscape images, which are as rich in graphic design, color, and impact as his sports photography. His love of the ocean—that unique environment where the sea meets the land—is evident. A keen and veteran surfer (living in Montauk, New York, he's only a few minutes from the beach and about the same from the facilities for a more recent sports pursuit, golf) Iooss has that close affinity with the ocean and its environs shared by surfers around the world. "The ocean is the pulse of life, and I have always been drawn to it. And getting assignments that involve shooting at the beach is like having a paid vacation," he said. So, it's no coincidence that when the Iooss family, Walter, his wife Eva, and their sons, Christian and Bjorn (both photographers in their own right, and keen surfers) go on vacation it's to a tropical beach.

The moral of this, of course, is that the great sports photographers are visionaries who see pictures in many environments. Most are artists in every sense of the description and complement their technical mastery with exquisite design and composition, use of bold colors and strong lines, and soft hues and abstract patterns just as landscape painters or photographers do. They are also portraitists whose images of people are often classic examples of the genre. So, if you aspire to be an outstanding sports photographer, don't narrow your outlook to just action photography.

Points to Ponder

- There is always room for talent. Good photographers will rise to the top.

- The camera is only a tool. The photographer's vision is more important.

- Great photographers see great photographs in their mind's eye. And then they click the shutter.

- There are a lot of photographers, but there are also many outlets for images.

- To get a foot in the door, you need an outstanding portfolio. *SI* is not hiring rookies, so it's not a good starting point for most. Try your high school, college, or local paper to get started and create your portfolio.

- The portfolio must intrigue editors. Go beyond the traditional look and infuse your own style into the book.

- Great musicians practice, practice, and practice. So should photographers.

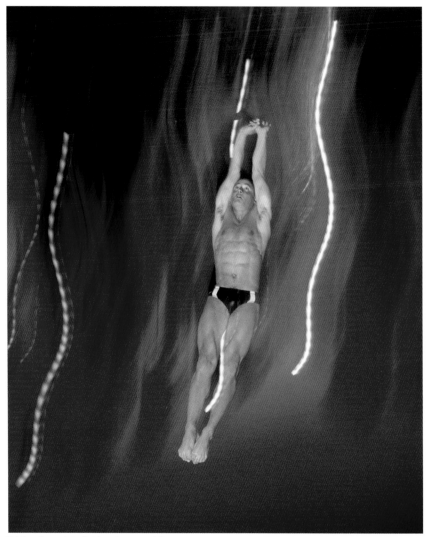

Walter Iooss' definitive image of Olympic diving champion Greg Louganis shot against a dramatic sunset. This stunning photograph was made as Louganis trained for the 1984 Olympic Games in Los Angeles. © Walter Iooss

- Memorable sports images can be made at the most basic levels of sports—Little League and other kids' athletics. Shoot street games, stickball, and other games played in local parks.

- Becoming a sports photographer is a matter of your own desire—and making it happen for yourself.

- Don't limit yourself to just action photography.

The Definitive Image

One of the most challenging tasks a photographer will face is making the definitive image—the single picture that encapsulates drama, excitement, and character, and epitomizes the very essence of an event. By comparison, a photo essay that opens and closes with powerful photographs that are supported by a body of story-telling images in between, allows the photographer more leeway to get the message across. Not so the single image.

Walter Iooss is unequivocal about the definitive image from his acclaimed 1984 Olympic Games project *Shooting for the Gold*. "It's the shot of Greg Louganis, diving against a blazing sky with streaks of light around him and between his legs. It's one of my all-time favorite photographs," he said. That statement certainly places the shot in the higher echelons of sports photography. During the two-and-a-half year Fuji-sponsored *Shooting for the Gold*, Iooss made thousands of photographs and had photographed Louganis three or four times trying to come up with one great picture of the greatest diver in the world. "I wanted to do something special with him," he said. The opportunity came late one day when Louganis was training in Mission Viejo, California. The setting sun was a vivid orange-red against the dark of the cobalt blue sky. Louganis was diving from the high 10-meter platform and even though the impact on hitting the water from that height was hard on his hands and wrists, he was eager to cooperate, making about six dives.

As Louganis hurtled by, Iooss stood as close as he could to the path of the diver, panned the camera and fired using a slow shutter speed to streak the ambient light. The speed of electronic flash captured Louganis in mid-flight.

Iooss was shooting with film, so had to wait for it to be processed to see how he had done. He was more than pleased, especially when he flipped the transparency to make it appear as if Louganis were diving upward. The result was electrifying, the streaking sunset creating an effect like one would imagine coming from the flames of Dante's Inferno. On seeing the photographs, which Iooss had enthusiastically shown to Louganis as soon as they were processed, the champion diver's comment was not directed at the stunning visual qualities of the shot but at his dissatisfaction with his own in-flight form: "I'm bent," was his take on the image. "Of all the images I have taken in my life, no image has stood out more for me," said Iooss of the photograph. We can see why.

The photograph was taken with a Canon 1D and 35mm lens and Fujichrome 100D film. The lighting was a combination of ambient light from the setting sun and a Speedtron flash. Exposure: 1/30 at f2.8.

Points to Ponder

- Come up with an idea for a shot and work with an accomplished athlete.

- Try combinations of slow shutter speed and electronic flash.

- Pan the camera to blur the background.

- Don't be afraid to flip a photo—turn it upside down. The results can range from interesting to spectacular.

BIOGRAPHIES OF THE CONTRIBUTING PHOTOGRAPHERS

Ben Chen

That Los Angeles-based photographer Ben Chen excels at his profession comes as no surprise, given that he was as passionate as a competitor, especially in football, volleyball, and basketball, as he is today as a sports shooter. What might seem unusual, however, is that his favorite subject to photograph is not sport, but the beauty of dance! However, Ben's comprehensive portfolio of superb eye-catching sports photographs, the result of about ten years as a full-time sports shooter, is testimony to his excellence in this field. As a freelancer, Ben chases work wherever it may be, and his regular clients include colleges, universities, wire services, and newspapers. He regularly covers NBA, MLB, MLS, and NCAA events. Additionally, he is often hired by parents to photograph athletes for personal and Web usage and this is a revenue-generating adjunct to his editorial coverage of games and events. Ben has no illusions about what's needed to stay in the business of sports photography—consistently produce better and unique images. Although based in Los Angeles, he undertakes assignments and makes himself available for projects outside that area. He also teaches hands-on sports photography workshops and conducts seminars on topics such as Sports Photography 101, How to Set Up Remotes, and The Business of Youth Sports Photography. To see Ben's work and for other information, go to *www.sportspixel.com*.

Bob Gomel

During a varied and fascinating career, Bob Gomel has documented many great moments of contemporary history, photographing and working with world leaders, top athletes, and international entertainment celebrities. Born in New York City, Bob is a graduate of New York University. He served as a naval aviator during the Korean conflict and upon discharge became a photographer for *Life* magazine. During the 1960s, while with *Life*, he participated

© Jeff Lewis

© Michael Norris

in much of the history of the decade, working intimately with presidents Kennedy and Nixon, cabinet members, governors, and senators. He covered the Bay of Pigs, political conventions, and the funerals of Churchill, MacArthur, Eisenhower, and John and Robert Kennedy. He also worked with icons in the worlds of sport, entertainment, literature, and law. During the 1970s, Bob's work branched out to advertising, where he helped introduce Merrill Lynch's Bullish on America campaign and photographed for Bulova, GTE, Audi, and Renault. In 1977, Bob relocated his advertising studio to Houston, Texas, and lent his skill to campaigns for Shell, Houston Power and Light Company, Compaq, Exxon, and others. A long-time member of the American Society of Media Photographers, he continues making pictures for ads and brochures throughout the world. Bob can be reached at bgomel@houston.rr.com.

Duane Hart

Duane Hart, one of Australia's finest sports photographers, specializes in athletics (track and field), a line of work he transitioned into from his own athletic endeavors as a 400-meter runner. Over about ten years, Duane competed both in his native New Zealand and later for the Croyden and Belgrave clubs in the UK. At that time, 1990–1991, while in the UK, photographing

© Helen Amon-Hart

track was a hobby, something Duane did to pass the time while recovering from sports injuries. He soon discovered he had a natural talent and a great eye for capturing the essence of track and field. Duane's hobby became his profession. On returning to Australia, he founded Sporting Images Australia in 1992, and is still a director of the company, which is based in Redcliffe, near Brisbane, Queensland. As a pioneer in Australia of Internet sports photography archiving, Sporting Images has supplied images to most of Australia's leading sports magazines, governing bodies, advertising agencies, book publishers, sponsors, and numerous other clientele. While track and field is still a favorite subject, Duane shoots action in a wide variety of sports and constantly challenges himself to infuse a fresh look to his images. Since becoming a professional sports photographer, he has covered major events worldwide and was one of the few freelance photographers officially accredited to cover all sports at the 1996 Atlanta, 2000 Sydney, and 2004 Athens Olympic Games. In 1997, Duane received the Australian Institute of Professional Photography's Editorial Photographer of the Year Award, and that same year was among recipients of the Nikon Press Awards. To see more of Duane's work and for information on Sporting Images, go to *www.sportingimages.com.au*. His online biography is at *www.duanehart.net*.

Walter Iooss

Long acclaimed by his peers as a genius with a camera, Walter Iooss is recognized as one of the greatest practitioners of sports photography of all time. Since age seventeen, when he photographed his first assignment for *Sports Illustrated*, Walter has produced images that are as iconic as the famous subjects themselves. During a career spanning more than four decades, he has covered five Summer Olympic Games, innumerable other major sporting events, photographed the greatest athletes of his time, and created many of the

stunning images featured in the annual *SI* swimsuit issue. Every assignment, whether an Olympic event or kids playing some street game, is approached with the same unbounded enthusiasm, visual curiosity, and creativity. The fact that he has had more

© Bjorn looss

than 300 covers of *Sports Illustrated* demonstrates his ability to consistently produce stunning images. That he enjoys photographing kids playing baseball in the streets of Cuba as much as, if not more than, covering a world championship, speaks volumes for his passion for sport at its most pure. Beyond photographic skills, a key to being a great sports photographer is to understand the psyche of the athlete. As his magnificent photographs testify, Walter Iooss certainly has that understanding and more. A long-time member of the American Society of Media Photographers, Walter and his wife, Eva, live in Montauk, New York. His work can be seen at *www.walteriooss.com*.

Mark Johnson

Mark Johnson thrives in one of the toughest arenas of professional photography—as a full-time stock photographer with an emphasis on water sports and lifestyle. A native of Hawaii, Mark developed at an early age a love of the ocean environment. It came as no surprise to family and friends when he combined his passion for surfing and photography into something more than a hobby. His determination to bring back meaningful images of the ocean environment was exemplified when, as a young teenager, he took his brand new and never-used Nikonos into huge surf. Under the pounding of a massive wave, he

and his camera parted company forever. Undeterred, he went back to his newspaper run, saved up, and bought another Nikonos. Years later, Mark attended the prestigious Brooks Institute of Photography in Santa Barbara, California, from where he graduated in 1990 with a double major in commercial and color photography. Moving to Australia, he pursued a career in general assignment work while building his stock files, eventually focusing exclusively on stock photography with Corbis as his principal agency. Today, he and his marine biologist wife, Lexa, live in Brisbane, Australia. When not photographing close to home, he often ventures to French Polynesia and other exotic locales in search of new stock images. Mark's images can be seen at *www.markjohnson.com*.

© Mark A. Johnson

Bruce Kluckhohn

Bruce Kluckhohn, team photographer for both the Minnesota Wild and the Minnesota Twins, is among the best photographers of hockey and baseball in the nation, but his photographic expertise goes far beyond the confines of the ice rink and baseball diamond. An honors graduate from Harvard University, Bruce chose Minneapolis as his center of operations, and today runs a thriving multi-faceted business from that city. During his career, Bruce has worked in photojournalism, sports, advertising, and public relations, bringing a

© Bruce Kluckhohn

© Hillary Miller

mixture of talents to each job. Much of his assignment work is associated with photographing people on location for feature stories in magazines. While his Wild and Twins responsibilities are the principal focus of Bruce's sports photography, he has also covered numerous other major sporting events in the Twin Cities including the World Series, SuperBowl, the NCAA Final Four, and NBA games. His work has been published in six continents, and in numerous major publications including *Sports Illustrated*. With a keen eye for images peripheral to the main game, he is constantly searching for those humorous or detail pictures that complement action shots. Assignments have taken Bruce to numerous parts of the world, from photographing in homes in Minneapolis, to isolated lakes in the Boundary Waters Canoe Area along the Canadian border, to the French Quarter in New Orleans for Mardi Gras, and even to a bar in the Old City of Prague in the Czech Republic. An active member of the American Society of Media Photographers, Bruce has served as an officer at both the chapter and national levels, including a term as second vice president of ASMP. The range of his work and accomplishments can be seen at *www.brucekluckhohn.com* or *www.brucekphoto.com*.

Diane Kulpinski

Photographing youth sports is Diane Kulpinski's business, and if ever there were a role model for the adage about following your dream, she is it. A

graduate in photojournalism from Syracuse University, Diane's entry into the industry was with the *Bulletin*, in Bend, Oregon. Many years as a newspaper photographer gave her a thorough grounding in numerous areas of photography—from general news events to portraiture, arts, and sport. After more than a decade of newspaper work, Diane yearned to do something she really loved—photograph kids playing sports. She took the bold step of quitting the security of her full-time newspaper job to start her own business, hoping that parents would buy pictures of their children competing in Little League and similar events. They did—and Diane's never looked back. Most youth sports photographers enter the field as portraitists and then venture into the action side of the business. Diane did it in reverse—first covering kids in action and later expanding to provide team and individual portraits. But first and foremost, she is a professional sports photographer, and is as comfortable shooting from the sideline at a football or baseball game as she is setting up a team portrait. Her thriving business is based in Bend, Oregon. To see more of what she does, go to *www.dianekulpinski.com*.

Brian Robb

Brian Robb is among the most accomplished photographers on the professional ski circuit and since 1982 has been covering World Cup skiing events in North America, Europe, Japan, and Korea. His dynamic

© Stan Petrash

images grace the pages of numerous international magazines and are regularly used in advertising and other commercial purposes for a variety of corporate clients. A full-time freelance photographer since 1983, he started his photography career in 1976. The following year, Brian joined forces with a friend to shoot World Pro skiing. Their company, Ski Photo Associates, had a relatively short three-year life span but it was pivotal in the future of his career. When Brian's friend, Bruce Jackson, headed into large-format landscape photography, Brian continued with action photography. In 1979, he started photographing summer ski camps in Oregon, and this steady business is still Brian's "bread-and-butter income source." In addition to the World Cup shoots that take him annually to Europe, he undertakes travel photography and other assignments for various ski companies and publications. He covered both the 1988 and 1992 Winter Olympics in Calgary, Canada, and Albertville, France. Brian is based in Hood River, Oregon, and his work can be seen at *www.brianrobbphoto.com*.

Peter Skinner

Australian writer and photographer Peter Skinner grew up in Papua New Guinea and began his career as a sports journalist with newspapers and magazines in Australia and New Zealand. Branching into public relations and corporate communications, he combined his literary and photographic skills to produce illustrated feature stories on a variety of subjects for editorial and corporate clients. These ranged from sports and travel stories to personality profiles, real estate, property development, government and political features, and nature and wildlife articles. Many of these features were published nationally and internationally. In late 1980, at the invitation of Ernest H. Brooks II, then president of Brooks Institute of Photography in Santa Barbara, California, he completed a short course at Brooks. Subsequently, he was offered a job at the institute

© Priscilla Skinner

as director of public relations and special projects, and developed a series of domestic and international workshops in conjunction with major equipment and film manufacturers and the consulates of several countries. In 1991, Peter joined the staff of a preeminent trade association, the American Society of Media Photographers, and from then until mid-2003, was ASMP's communications director and publications editor. Among other things, he wrote for and edited ASMP's membership magazine the *Bulletin*, and was a major contributor to and editor of the fifth and sixth editions of the authoritative *ASMP Professional Business Practices in Photography* books (Allworth Press). Over the years, his text and pictures have been published in magazines such as *Islands*, *Australasian Geo*, *Rangefinder* (of which he is a contributing editor), *Outdoor Photographer*, and numerous others including airline in-flight magazines. In late 2003, Peter and his wife Priscilla, who also worked with ASMP as production and Web site editor, relocated back to Queensland, Australia, where he continues to shoot stock photography, write feature stories, and edit publications. A selection of his feature articles can be found at *www.rangefindermag.com* and some of his images can be seen at *www.digitalrailroad.net/PeterSkinner*. He can be reached at prsskinner@bigpond.com.

Steve Trerotola

Steve Trerotola represents the third of four generations of professional photographers in his family going back to the turn of the last century. He has been shooting sports for over forty years, covering a wide range of

© Ryan Kroll

events with extensive experience in Formula One auto racing, the Olympic Games, and professional football, as well as thousands of college, high school, and youth sporting events. In addition to sports photography, Steve is an experienced professional laboratory executive, having served on Eastman Kodak's Pro Lab Advisory Council, on the board of the Digital Printing Association, and the Technical Advisory Group for the Los Angeles Police Department's Scientific Investigation Division. Additionally, he is a contributor to *Rangefinder* magazine. In conjunction with a partner, Frank Long, Steve operates Personal Best, a Sports Action Photography company based in Long Beach, California, *www.personalbestphotoart.com*. He can be reached at alfa106@aol.com.

Bob Woodward

An interest in cross-country skiing and ski racing started Bob Woodward's thirty-five-year career as a sports photographer. Shooting cross-country skiing led to documenting a wide variety of self-propelled outdoor sports among them white-water kayaking, mountain running, mountain biking, backcountry skiing, and adventure racing. Along the way, Bob authored two ski books and *Sports Illustrated's Mountain Biking*, served as an editor for several national sports magazines, and photographed

© Eileen Woodward

the Winter Olympic Games in 1980, 1988, and 2002 and the Summer Olympics in 1984 and 1988. Today, he specializes in editorial photography for national magazines, undertakes assignments for a variety of corporate clients and markets his own stock. Bob lives and works out of Bend, Oregon, where he served as the town's mayor from 1997 to 1999. There he still actively participates in most of the sports he photographs. For more than twenty years, he has been a member of ASMP. To see more of his work, go to *www.woodychromes.com* or contact him at woody@bendcable.com.

RESOURCES

The following resources are just some of many that might help the reader. Their being listed here does not necessarily mean an endorsement by the author or publisher but we hope that you find them useful.

Associations and Groups

American Society of Media Photographers, *www.asmp.org*

American Society of Picture Professionals, *www.aspp.com*

Editorial Photographers, *www.editorialphoto.com*

National Press Photographers Association, *www.nppa.org*

Nikonians.org, the largest community for Nikon users, *www.nikonians.org*

North America Nature Photographers Association, *www.nanpa.org*

Picture Archive Council of America, *www.stockindustry.org*

Professional Photographers of America, *www.ppa.com*

SportsShooter.com, *www.sportsshooter*.com

Wedding and Portrait Photographers International, *www.wppionline.com*

Books

Aaland, Mikkel. *Photoshop CS2 RAW: Using Adobe Camera Raw, Bridge, and Photoshop to Get the Most out of Your Digital Camera.* San Francisco: O'Reilly Media, 2006.

Aaland, Mikkel. *Shooting Digital.* 2nd ed. San Francisco: Sybex, 2006. *www.sybex.com*

Cardinal, David and B. Moose Peterson. *The D1 Generation.* Mammoth Lakes, CA: Moose Press, 2001. *www.moose395.net*

Fraser, Bruce. *Real World Camera Raw.* Berkeley: Peachpit Press, 2004.

Iooss, Walter. *Sporting Life: The Journals.* New York: Graphis, 2002.

Camera and Lens Manufacturers

Canon, www.usa.canon.com

Casio, *www.casio.com*

Contax, *www.contaxcameras.co.uk*

Eastman Kodak, *www.kodak.com*

Epson, *www.epson.com*

Fujifilm, *www.fujifilm.com*

Hewlett Packard, *www.hp.com*

Konica Minolta, *http://konicaminolta.us*

Leica, *www.leica-camera.com*

Nikon, *www.nikonusa.com*

Olympus, *www.olympusamerica.com*

Panasonic, *www.panasonic.com*

Pentax, *www.pentaximaging.com*

Ricoh, *www.ricohzone.com*

Rollei, *www.rollei-usa.com*

Samsung, *www.samsungcamera.com*

Sanyo, *www.sanyo.com*

Sigma, *www.sigmaphoto.com*

Sony, *www.sony.com*

Tamron, *www.tamron.com*

Tokina, *www.thkphoto.com*

Cards, Readers, Image Storage, and Viewers

Digital Foci, portable storage viewers, *www.digitalfoci.com*

Epson, storage viewers, and more, *www.epson.com*

iMageTank, battery-powered external hard drives, *www.imagetank.at*

LaCie, portable storage hard drives, and more, *www.lacie.com*

Lexar, compact flash cards, memory sticks, and readers, *www.lexarmedia.com*

Nikon, portable storage viewers, *www.nikonusa.com*

SanDisk, compact flash cards, and other accessories, *www.sandisk.com*

Vosonic, multi-media viewer and other storage devices, *www.vosonic.co.uk*

Cleaning Digital Sensors

www.cleaningdigitalcameras.com

www.micro-tools.com

Color Correction and White Balance

Eastman Kodak, *www.kodak.com* (search for "Kodak: Filtration")

ExpoDisc, *www.expodisc.com*

Digital Photography Information

www.dpreview.com, comprehensive digital camera reviews.

www.LeppPhoto.com, publisher of an informative quarterly, *The Digital Image*.

www.nikonians.org, a community of Nikon equipment users.

Film Manufacturers

Eastman Kodak, *www.kodak.com*

Fujifilm, *www.fujifilm.com*

Imaging Software Sources and Links

www.acdsee.com, makers of the popular ACDSee program.

www.adobe.com, home of Photoshop, Photoshop Elements, and much more.

www.apple.com, iPhoto and Aperture and more

www.everythingmac.com, numerous Mac-related links

www.gimp.org, a shareware program

www.pcworld.com, great information on numerous topics

www.tucows.com, source of freeware and shareware information

www.versiontracker.com, software updates and releases

Photographers' Sites

Mikkel Aaland, *www.cyberbohemia.com*

Ben Chen, *www.sportspixel.com*

Rob Galbraith, *www.robgalbraith.com*

Duane Hart, *www.sportingimages.com.au*; *www.duanehart.net*

Walter Iooss, *www.walteriooss.com*

Mark Johnson, *www.markjohnson.com*

Bruce Kluckhohn, *www.brucekluckhohn.com*; *www.bruzekphoto.com*

Diane Kulpinski, *www.dianekulpinski.com*

Ron Pownall, *www.westonsportspix.com*

Brian Robb, *www.brianrobbphoto.com*

Steve Trerotola, *www.personalbestphotoart.com*

Bob Woodward, *www.woodychromes.com*

Photography Exhibits Online

Picture of the Year International, *www.poyi.org*

World Press Photo Awards,
www.worldpressphoto.nl

Schools and Workshops

Ben Chen Sports Photography Workshops
and Seminars, *www.sportspixel.com*

Brooks Institute of Photography,
www.brooks.edu

Lepp Institute of Digital Imaging,
www.leppphoto.com

The Maine Photographic Workshops,
www.theworkshops.com

Santa Fe Workshops, *www.sfworkshop.com*

Snowboarding photography,
www.hcscphotoworkshop.com

Sports Cards Packages and Processing

*www.andromeda.com/people/ddyer/photo/
albums.html*

www.sports-america.com

www.snapfish.com

www.topps.com

INDEX

Books from Allworth Press

Allworth Press is an imprint of Allworth Communications, Inc. Selected titles are listed below.

Digital Photography Simplified
by Susan McCartney (paperback, 8 1/2 x 10, 160 pages, $24.95)

Photographic Lighting Simplified
by Susan McCartney (paperback, 6 3/4 x 9 7/8, 176 pages, $19.95)

The Photographer's Guide to the Digital Darkroom
by Bill Kennedy (paperback, 6 3/4 x 10, 224 pages, includes CD-ROM, $29.95)

How to Shoot Great Travel Photos
by Susan McCartney (paperback, 8 1/2 x 10, 160 pages, $24.95)

Photographing Children and Babies: How to Take Great Pictures
by Michal Heron (paperback, 8 1/2 x 10, 144 pages, $24.95)

Creative Canine Photography
by Larry Allan (paperback, 8 1/2 x 10, 144 pages, $24.95)

The Real Business of Photography
by Richard Weisgrau (paperback, 6 x 9, 224 pages, $19.95)

Starting Your Career as a Freelance Photographer
by Tad Crawford (paperback, 6 x 9, 256 pages, $19.95)

Photography Your Way: A Career Guide to Satisfaction and Success, Second Edition
by Chuck DeLaney (paperback, 6 x 9, 336 pages, $22.95)

Creative Careers in Photography: Making a Living With or Without a Camera
by Michal Heron (paperback, 6 x 9, 272 pages, $19.95)

Photography: The Art of Composition
by Bert Krages (paperback, 7 3/4 x 9, 256 pages, $24.95)

Licensing Photography
by Richard Weisgrau and Victor S. Perlman (paperback, 6 x 9, 208 pages, $19.95)

Please write to request our free catalog. To order by credit card, call 1-800-491-2808 or send a check or money order to Allworth Press, 10 East 23rd Street, Suite 510, New York, NY 10010. Include $6 for shipping and handling for the first book ordered and $1 for each additional book. Eleven dollars plus $1 for each additional book if ordering from Canada. New York State residents must add sales tax.

To see our complete catalog on the World Wide Web, or to order online, you can find us at www.allworth.com.